HOW TO DRAW
WHAT YOU SEE

HOW TO DRAW WHAT YOU SEE

BY RUDY DE REYNA

WATSON-GUPTILL PUBLICATIONS / NEW YORK

For Marylin

Paperback Edition 1996
Copyright © 1970 Watson-Guptill Publications

First Published in 1970 in The United States and Canada
by Watson-Guptill Publications,
Crown Publishing Group, a division of Random House Inc., New York
www.crownpublishing.com
www.watsonguptill.com

Library of Congress Catalog Card Number 72-152754 Pb ed.
ISBN 0-8230-2375-3

Manufactured in the U. S. A.

26 / 12

Acknowledgments

I would like to express my appreciation to my editor, Diane Casella Hines, who was my invaluable "silent partner" in bringing this book to completion. Like a master carpenter, she patiently assembled the pictures and text, trimming here and smoothing there, until all the pieces fit. With an editor's special gift for putting herself in the reader's shoes, she scrutinized and polished each sentence until it was as clear as she could make it. She has accomplished this task with ingenuity and dispatch, and I am extremely grateful.

Contents

Part One:
Fundamentals
of Drawing

I believe that you must learn to draw things *as you see them*—realistically. That is, you must reproduce the dimensions and proportions of a given subject. To render a faithful, realistic drawing, you must be able to *observe* the basic structure of an object, regardless of how complex and obscured by detail it may be. You must train not only your hands but your eyes as well.

However, the ability to depict an object literally doesn't make you an artist. No one ever claimed that the faithful duplication of nature (an impossible task anyway) produces art. But the ability to draw things as you see them is the first step toward becoming an artist.

In other words, throughout this book you'll learn to draw realistically. The objects before you will dictate what you should do, and the result will be the literal representation of the object. When you've finished the projects in this book, you'll be equipped with the necessary skills to enable you to express yourself as an artist. Having learned the fundamentals, the *craft* of drawing, you'll have a solid point of departure from which to *create*. Then, if you wish, you can leave the literal imitation of a subject to the students behind you.

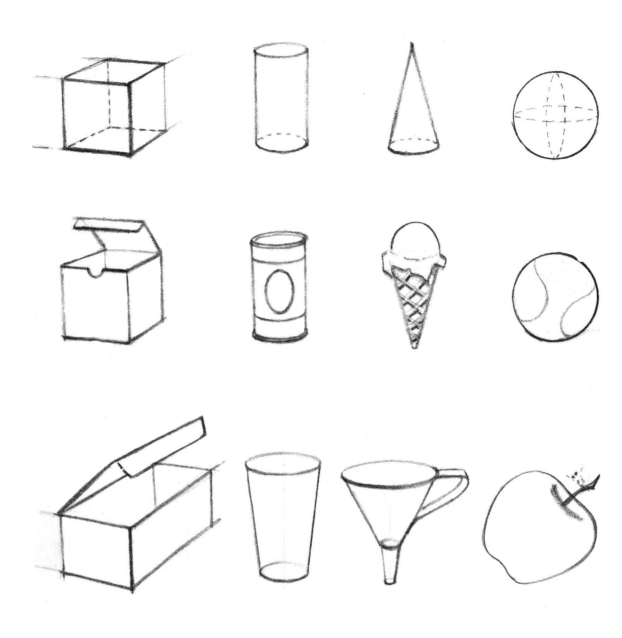

Figure A. *Actual objects can conform rigidly to the four basic forms—cube, cylinder, cone, and sphere—as shown in the top two rows. Usually, however, they're only based on these geometric forms. As shown in the bottom row, the box is elongated but still cubic. In the tumbler, the cylinder form is tapered; in the funnel, the cone shape has been truncated; and the apple, despite its bulges and indentations, is still basically spherical.*

PROJECT 1
Basic Structure of Objects

Every object that you see has a structure or form based on either the cube, the cylinder, the cone, or the sphere. Any object may be based on one or a combination of these four geometric solids. A solid, for our graphic purposes, means an object that has three dimensions: height, width, and depth.

Basic structure doesn't mean that things are geometrically perfect cubes, cylinders, cones, or spheres. (They can be, of course—for example, a square box, a round can, or an ice cream cone.) It means that objects are *based* on these four geometric solids. The shape of the object is modified in various ways that depart from the strict geometrical form (Figure A).

This principle was a revelation to me. I found that I could concentrate on overall dimensions of an object; then, at my leisure, I could add whatever details I wanted to include. In addition, because the four basic geometric forms are solid, i.e., three dimensional, you get a feeling for the bulk and the weight of everything you draw.

In the next three projects, we'll explore the first of these basic forms—the cube. We'll flatten it down, pull it up, or lengthen it, depending on our needs for representing an actual object (Figures B, C, D, and E). There are so many things that have the cube as their basic shape that it seems logical to begin with it. But before you can draw cubes, you must practice drawing the straight lines that form them.

Drawing Straight Lines

All you need to do the exercises in this project is a standard "office" pencil and a pad of drawing paper. I've used a KOH-I-NOOR #555, grade #2 pencil, and a #307 Ad Art layout and visualizing pad made by the Bienfang Company.

The range of pencils and drawing papers is so wide that I won't even attempt to enumerate them. Actually, for your first explorations, almost any pencil and any type of paper will do. Later you'll be more discriminating.

Drawing Lines Freehand

Since the first objects you're going to draw require primarily straight lines, let's look into ways of making them without any mechanical aids. I want you to draw them freehand; it's awkward and impractical to be encumbered with rulers and triangles as you sketch, especially outdoors. Besides, there's a certain life and vibrancy to a line drawn freehand when compared to the cold and mechanical line made with a ruler.

Holding the Pencil

Drawing a straight line, despite the old saw about it being awfully difficult, is easy and fun to do if you use the right approach (Figure F). Begin this very moment. Don't procrastinate. It doesn't matter in the least if the way you hold your pencil isn't the same as mine.

Hold your pencil in the usual writing position or "under the palm", whichever feels more comfortable (Figures G and H). Swing the straight lines from the elbow, not from the wrist. Swinging from the wrist will make your stroke too short and your line will be choppy and labored.

Angle and Direction of Lines

By practicing, you'll discover the best angle at which you can draw a straight line. Then, all you have to do is turn the paper to execute a horizontal, a vertical, or a diagonal line. Try them all. My own personal choice is

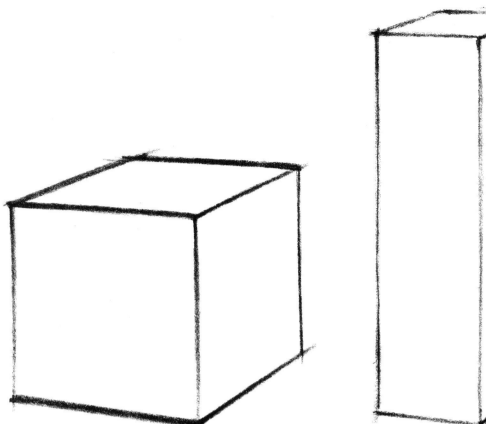

Figure B. *This is the geometric cube, with its six sides all exactly the same size.*

Figure C. *This is a cubic form. It's no longer equilateral, because four of its sides are rectangular and its ends are square, but it's still based on the cube. It's like a quarter pound of butter.*

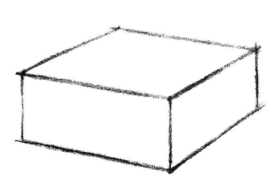

Figure E. *Joining two or three cubes together would give you a cubic form like this—something like a box of crackers. Remember that although Figures C, D, and E aren't perfect cubes, they're cubic in character.*

Figure D. *If you were to slice a cube into three sections, this is one of the cubic forms that you'd get.*

in a northeasterly direction, beginning at the southwest. Your favorite direction may turn out to be the same or it may be a horizontal line that runs from west to east. The direction of the line isn't important. It's the spontaneity and directness of the line that really matters.

Don't be timid and make short stabs at drawing lines. Dash them off with one stroke. No one is going to see or evaluate them. Relax. Let yourself go, and swing away so that you can limber up your entire arm. If you can draw a straight line in any direction—without turning the paper—you're to be envied. Find out right now if you're one of the fortunate few.

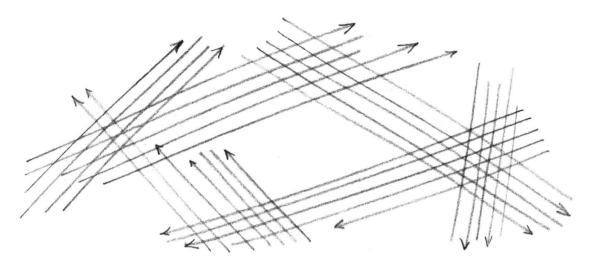

Figure F. Draw lines freehand with one motion. The arrows indicate that I've drawn all these lines from left to right, obtaining the different angles simply by turning the paper. Since there's hardly a drawing that doesn't require some straight lines, it's important to practice drawing them as often as possible.

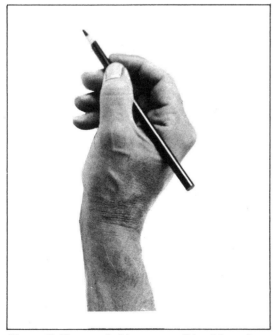

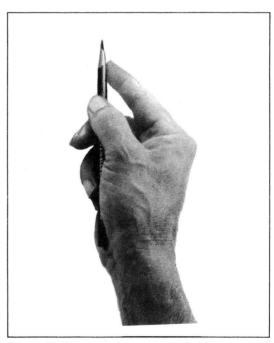

Figure G. You can hold your pencil in either of two ways, whichever feels the more comfortable. Here I'm holding the pencil in the usual writing position.

Figure H. If you prefer, you may hold your pencil as shown here in the "under the palm" position. Both positions work equally well.

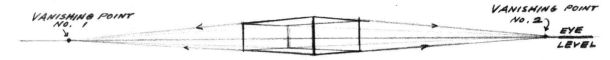

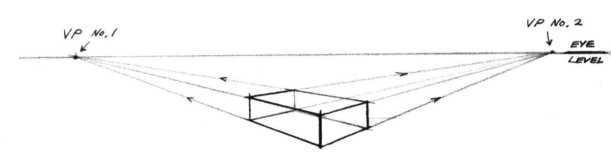

Figure A. *At eye level the converging lines of the sides of the box come down from the top edges and go up from the bottom edges to meet and vanish at imaginary points on the horizon (or eye level) called vanishing points.*

Figure B. *When the cubic object is below eye level, all converging lines go up to their respective vanishing points. The arrows show the direction in which the parallel lines extend to the eye level.*

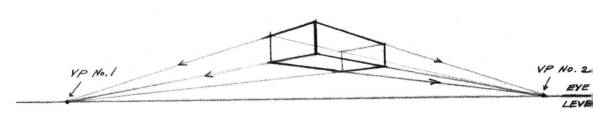

Figure C. *When the cubic object is above eye level, all converging lines come down to their respective vanishing points.*

Eye Level: Foundation of Perspective

For this project, use the same pencil that you used in Project 1, but once again, any office pencil will do. As a matter of fact, you'll use a simple pencil through succeeding projects until I ask you to change to another drawing medium.

It's my firm belief that students fail in their attempts at drawing because they're unaware of *eye level.* Actually, it's such a simple concept, so seemingly obvious, that perhaps it's this very quality that causes it to be overlooked.

Eye level refers to the *height at which your eyes observe an object.* I suggest that you write this sentence and place it where you can see it often, so that it becomes part of you. It's that important to your development as an artist.

Changing Shapes and Eye Level

To actually demonstrate what I mean by eye level, I'd like you to lie prone on the floor. Notice that you see the *bottom,* not the top, of most objects. Now sit up and notice the difference; move to a chair and again observe that as you raise your eye level, the top planes of objects come into view. If you were to climb a ladder to the ceiling, everything below you would show its top plane. Sounds simple enough, doesn't it? Well it is!

Vanishing Points

The cubic form in Figure A is *seen at eye level,* and shows only two of its six sides. Its horizontal lines converge down to and up to their respective *vanishing points.* A vanishing point is an imaginary point on the eye level, or horizon, where the parallel edges of a cubic form appear to converge and meet.

Converging lines, eye level, and vanishing points all add up to *perspective.* It's a word of Latin origin meaning "to look through." In other words, you view an object as though it were transparent and you could see all its sides—front and back.

Actually all you have to do to draw an object in perspective is to *observe closely.* What's the angle and length of one edge compared to another? What's the length and width of a plane in relation to its neighbor? Asking yourself these kinds of questions as you view an object will help sharpen your powers of observation.

The cubic form in Figure B has all its lines *rising* to the vanishing points because I've placed this cube *below* eye level. All the lines of the cube in Figure C go *down* to their vanishing points because I've placed the cubic form *above* the eye level. In short, if the cubic form is at eye level, the lines, (that form the sides of the cube) come down from the top edges and go up from the bottom edges to their vanishing points on the horizon. If the cubic form is below eye level, all converging lines go *up* to vanishing points on the horizon. If the form is above eye level, all the converging lines come *down* to vanishing points on the horizon.

Cube in Perspective

I've chosen a cubic form as your first subject because it's the easiest to draw, and you can put your straight lines to work. Furthermore, the cube demonstrates clearly the illusion of the three dimensions—height, width, and depth—that you must convey on the flat surface of the paper. If you can portray these dimensions, you'll be able to draw realistically, no matter what the subject.

So from this moment, on, remember the three dimensions inherent in everything. Nat-

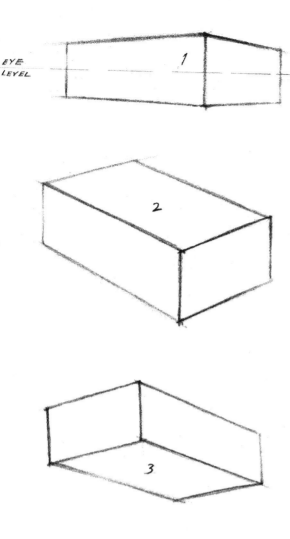

EYE
LEVEL

Figure D. These three boxes are at three different eye levels: in view 1 the box is at eye level; in view 2 the box is below eye level; and in view 3 the box is above eye level.

urally, each dimension can vary. The height of a cubic object can be greater than its depth, or the width can be the largest dimension of the three. As long as you're aware of their relationship, you'll be amazed at the progress you'll make.

Now take a box from your pantry—any box, regardless of its shape—and hold it at eye level. Turn it so you can see only two of its sides (see Figure A). If the design on the package proves distracting, tear the paper covering off it and work with the bare box.

Judging Size Relationships

Let me reiterate that drawing realistically means drawing accurately. Whatever proportions your box may have, check the relationship between one side and the other. Notice that in the box I've drawn (Figure D), its length is about twice its width. The three boxes in Figure D are seen at three different eye levels. Draw your box in the three different positions of Figure D. You'll be employing the method of drawing straight lines that you learned in Project 1. It won't matter at all if your box isn't the same shape as mine. The main thing is for you to be aware of the object's planes as you raise it or lower it above or below your level of vision.

When you're satisfied that you can draw a cubic shape at eye level, continue with views 2 and 3 of Figure D. Refer back to the diagrams in Figures A, B, and C. In the boxes you draw be sure that the lines converging to vanishing points 1 and 2 are at the proper slant, even though the lines can't extend all the way to their respective vanishing points on the eye level—simply because the paper isn't big enough.

Objects Below Eye Level

Most of the objects you'll draw (at least at the beginning) will be indoors and below eye level, because interiors—furniture, rooms, etc.— are scaled to a size that humans can manipulate. Therefore, the reason for drawing objects below eye level is quite obvious. Look around you and notice that even as you sit you can see the tops of tables, chairs, sofas, etc. When you can see the *top* of an object, it means that it's *below* the eye level or horizon. Since most

Figure E. As an object gets farther away from the eye level, its verticals get shorter and its vanishing points get farther away from the object.

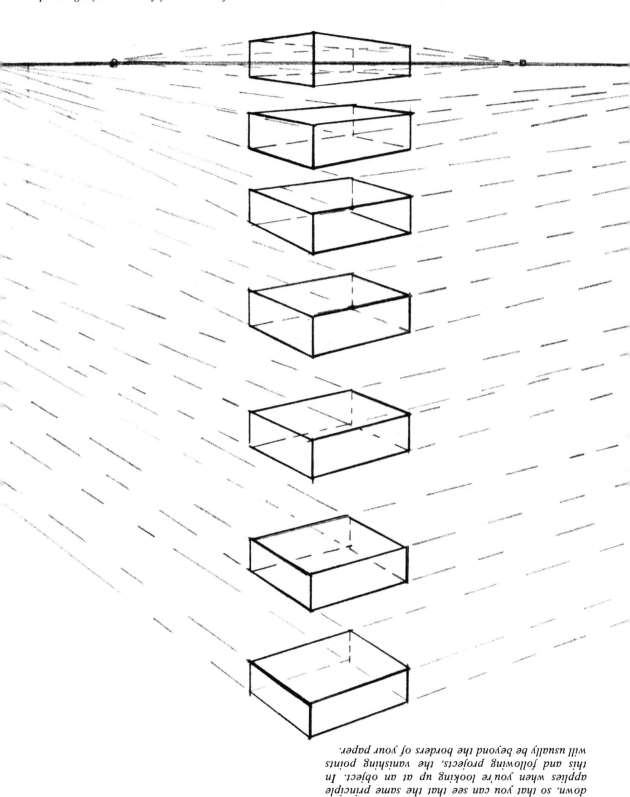

Figure F. Yes, this caption is supposed to be upside down, so that you can see that the same principle applies when you're looking up at an object. In this and following projects, the vanishing points will usually be beyond the borders of your paper.

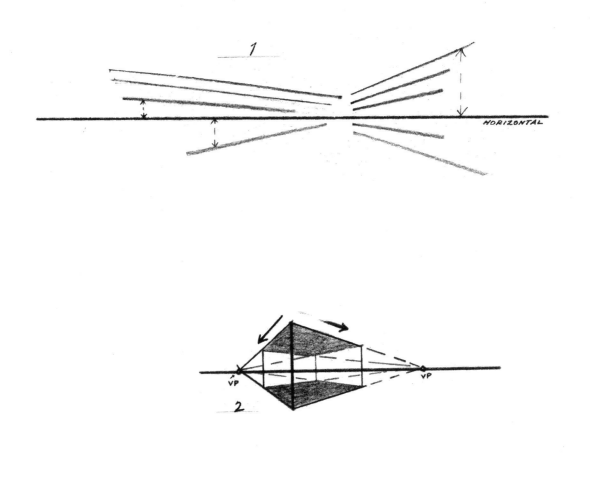

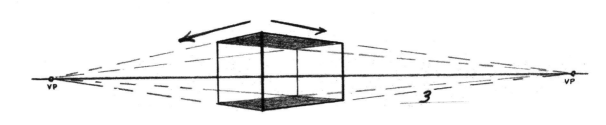

Figure G. *Ask yourself how much the line of an object departs—up or down—from the horizontal, as the diagram shows at view 1. If the diagonals are incorrect, you'll get the distortion shown at view 2. Note that the proper angle at view 3 gives you the correct form, because the diagonals run farther out to their vanishing points.*

of the work you'll do will be from a sitting or a standing position, I'd like you to observe the appearance of things from that viewpoint.

Practice Exercises

Collect four boxes and draw them at different distances below eye level. You might place them on top of one another and draw the topmost first; remove it and draw the second, and so on until you've drawn the fourth. Notice that as you come down to the lowest box, you see more of its top plane than you did on the first box (Figures E and F). Compare the top planes of all four of them when you've finished.

This one and others to follow (Figures G and H) are *practice exercises,* and they're indispensable. They aren't drawings worthy of being hung on a wall, any more than the pianist's exercises would be performed in a concert hall. Yet, as you know, the pianist submits to daily practice not only to acquire his technique, but to sharpen and control it, even after he has mastered the instrument. Flip through the pages of this book, if you haven't done so already, and you'll see that you're going to draw everything, not just boxes. But first you must find your feet before you can run.

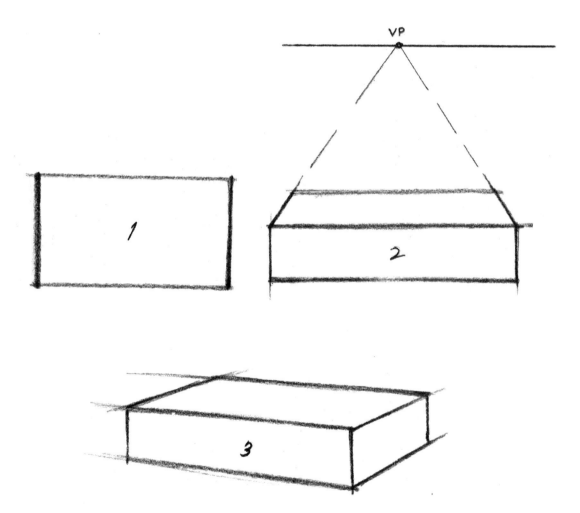

Figure H. A cubic form presents no problem at all if you place it squarely in front of you with only one side visible, as seen at view 1. The horizontals remain horizontal and there's no angle to check. But notice that you lose the cube's sense of solidity and it becomes a flat rectangle. The moment two sides are visible, as in view 2, the cube begins to convey a sense of bulk. There's only one vanishing point here; this is called one point perspective. When three sides are shown, as in view 3, the horizontals have become diagonals, but there's no question about the cube's volume and the space it occupies.

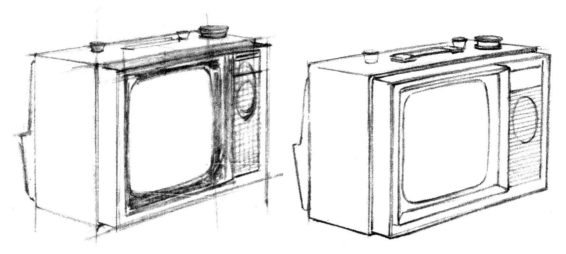

Figure A. With this television, or with any object, remember to draw the big shapes first; then you can add the details.

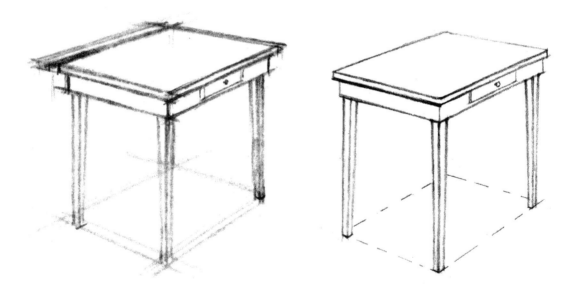

Figure B. Note that the broken "guidelines" indicate that the table is a cubic form.

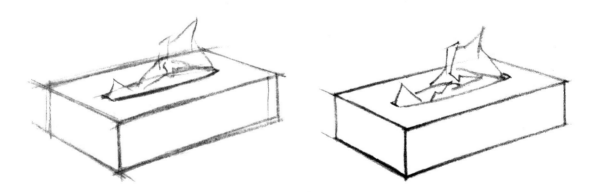

Figure C. This tissue box is the simplest form and a good one to begin with.

PROJECT 3

Drawing
Cubic
Objects

You'll use the same "office" pencil that you've used in the two preceding projects, but now I'd like you to get several drawing pads. They come in varying sizes: 9" x 12", 11" x 14", 12" x 18", 14" x 17", and 19" x 24". Don't let a salesman sell you any fancy or expensive paper; it's not necessary at this stage of your development. Besides, you're going to use reams of it in the exercises alone. So get the cheapest; it will be perfectly adequate for your purposes in these beginning projects.

Cubic Forms in Everyday Things

Now you'll see why I dwelt so long on bare boxes. I wanted you to see what happens to a cubic form as you turn it, lower it, and raise it. The figures in this project represent only some of the thousands of objects that have the cube as their underlying structure. As a rule, they won't be perfect equilateral cubes. But whether they're long, narrow, and thin or short, wide, and thick they'll still conform to the cube by having a top, a bottom, and four sides.

Searching with Lines

With this in mind, draw your television set, a box of tissues, one of your tables, and your kitchen range, etc. (Figures A, B, C, D, and E). Sit with your pad on your knees and notice the length compared to the width of the top plane of these objects. Observe the relation of the sides to each other and also to the width and height of the entire object.

As you search for the correct width, height, or depth of a plane, you'll draw many inaccurate lines. *Don't erase them.* Keep searching with other lines until you feel satisfied that you've got the right ones. Accent your correct lines by bearing down on them with your pencil. Place a fresh sheet of paper over your object and pick out only the correct lines, as I've done with the drawings in this project.

If the television set or the range prove too difficult at this stage, then draw a suitcase or a box of matches. When you've gained more confidence, you can return to the more complex subjects.

I sincerely wish you'd tackle everything. If your hand is still a bit reluctant to do your bidding, let it lag. It will catch up with your demands—it always does. The training of your eye to observe, to weigh, and to compare correct relationships is more important. For the moment, let your drawing be labored or even crude, as long as it's correct. Facility will come in time, I assure you.

Handling Detail

When you're sure that the overall proportions of your object are correct, proceed to whatever detail it may have. For example, with a television, judge the distance that a knob might be from its edge, as well as the knob's size in relation to the width of the plane that it occupies. Is the knob centered on that plane? If not, how much off-center is it?

If your object is a table and its detail consists only of legs to be added to its top, how thick are these legs in relation to their height or the width of the side panel? If your object is a bookcase and detail consists of books within it, what's the height and width of the book in the center of the shelf? How short and thick is the next one?

I must emphasize again that the large planes and dimensions must be established correctly. You can then subdivide the large shapes into smaller ones, and these in turn should be divided again until you get to the minutest detail.

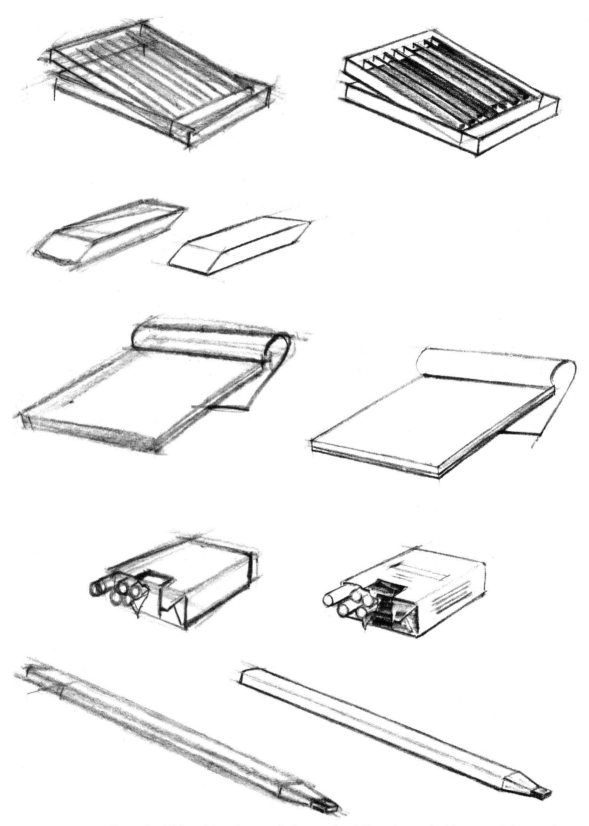

Figure D. *All five objects here are below eye level. Note that each object reveals its top plane and two of its sides.*

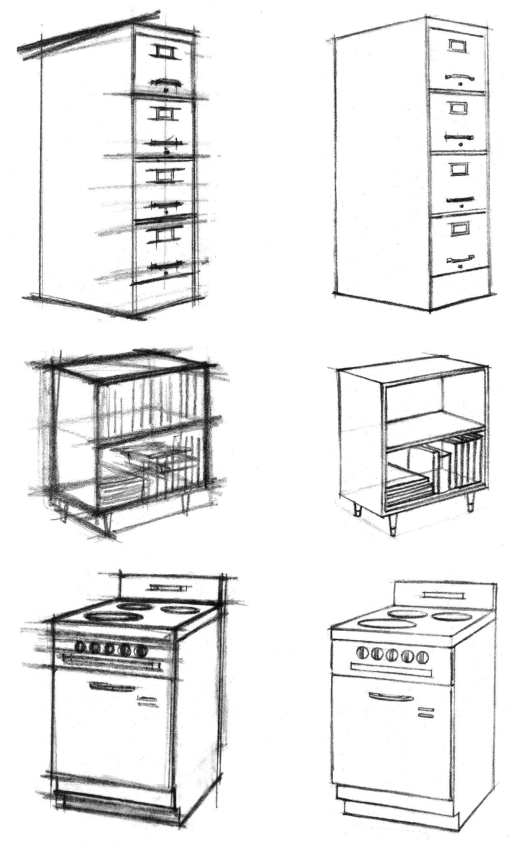

Figure E. *For these three objects I've used the Ad Art layout and visualizing pad and a standard office pencil. In each pair, the drawing on the left is tentative. I establish proportions with it. The corrected, refined drawing is on the right.*

Using the bookcase as an example, its overall proportions must be established first; then the placement of the shelf or shelves should be determined. Next, the books can be delineated in their proper width and height, followed by the detail on the spine of each book.

Refining with Tracing Paper

Begin by drawing every cubic object in the room about you. When you feel that their basic cubic proportions are correct, then, and only then, start adding whatever details the objects may have.

In Figures A through G of this project, there are objects drawn in two stages. In the drawing on the left of each pair of drawings, notice how roughly I indicated the overall shape of the object as I searched for its proper proportions. Once having found these proportions, I darkened these correct lines. Never erase. Once you begin to erase, you lose your means of comparing correct to incorrect shapes and dimensions.

Having established these corrected proportions I place a fresh sheet of paper (preferably tracing paper) over the first drawing and "clean it up". That is, I transfer only the correct lines to the new sheet of paper. Although you don't have to use tracing paper, you obviously must use paper that's transparent enough for you to see the drawing beneath it.

If some inaccuracies still remain on your second sheet, correct them with new lines. Place another new sheet of paper over them and transfer the corrected drawing. In Figures A through G of this project, the drawing on the right of each pair is the corrected, refined one.

Figure F. In each of these three pairs of drawings I begin searching for correct dimensions with the sketch on the left. I never erase. If an angle or a line is incorrect, I simply draw another. After darkening the correct lines, I transfer them to a fresh sheet and work on the corrected drawing that you see on the right of each pair.

Figure G. *If the plane of an object has rounded corners, first establish the correct proportions of that plane using square corners. Later, when your drawing is refined, you can round the corners off. If an edge curves slightly, the same rule applies. Draw it straight; then later on accentuate its convex or concave character.*

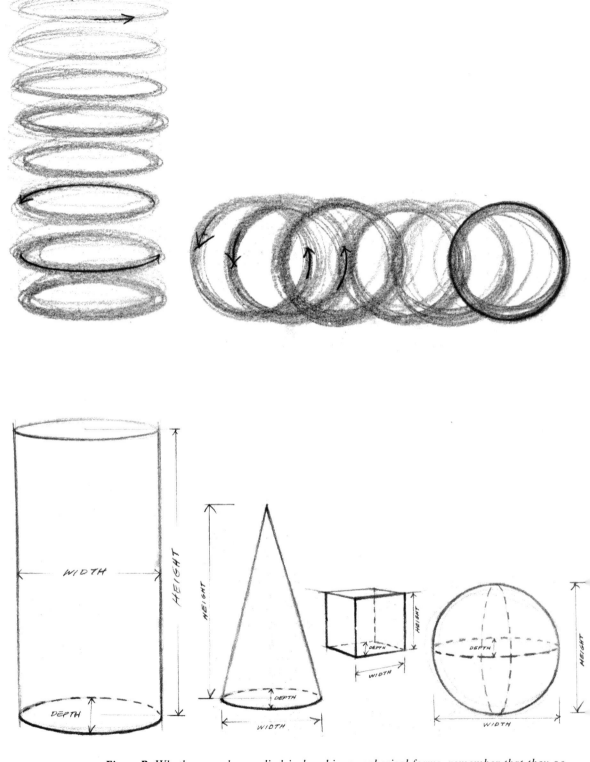

Figure B. *Whether you draw cylindrical, cubic, or spherical forms, remember that they occupy a given space (that is, they have all three dimensions). Even though you draw on the flat surface of paper, you must convey the illusion of these three dimensions. Study the dimensions of the objects indicated here with arrows.*

Drawing Cylindrical Objects

After doing so many drawings with straight lines, I'm sure that you can now do them with ease and confidence. They'll become still easier as you continue with future projects. But if you're to draw objects based on the cylinder, the cone, or the sphere, you must also practice drawing the curved lines that form them.

Drawing Curved Lines

Again, hold the pencil (still the ordinary "office" kind) in whichever position you prefer: the usual writing one, or "under the palm." Swing your arm from the elbow, and even from the shoulder, if you work big. It may feel awkward at first, but persevere until you feel comfortable. If you hamper your rendering now by working from the wrist—because it "feels more natural"—the beautiful sweep of a fluid line will never be yours.

My only consideration in this first section of the book is to convey the principles of good drawing. Later we'll explore the line and its expressive power. Here, let me repeat, the only purpose of your lines is to establish the optical correctness or "reality" of everything you draw.

Observing Cylindrical Forms

No matter what the cylindrical object, you must first *see* the cylinder itself, underlying whatever detail the object may have. In the beginning stages it's a good idea to draw the geometric cylinder first, and then make the required modifications, as I've done in the demonstrations with the pots at the end of the project. Later you can dispense with the drawing of the geometric cylinder and begin straightaway with the cylindrical object itself (Figures A and B).

Rendering Cylindrical Objects

My personal approach to drawing a cylinder is to rough in the entire ellipse (the circle that forms a cylinder's top and bottom) in a counter-clockwise direction. Then I refine the ellipse's visible side by accentuating the correct curvature with heavier strokes.

You may find it easier to rotate your pencil in a clockwise manner. Practice both and stay with your preference; the better result is what counts, not the way the result is achieved. Be sure that you check the angle of departure—any indents and bulges—of the object's sides from the vertical of the geometric cylinder.

Ellipses and Perspective

When drawing the cylinder remember that *at eye level* its ellipse appears to be a *straight line*. As the ellipse rises above eye level, or the horizon, its edge nearest you *curves up* in an arc. As the ellipse descends below eye level, the arc is reversed and the edge nearest you *curves down*.

Get a glass from your cabinet and draw it as many times as necessary to get the ellipses correct (see Figures C, D, and E). Before you draw the glass, raise it to exactly eye level, so that its top makes a perfectly straight line (the eye-level line in Figure C); notice that the bottom of the glass, being below eye level, forms an ellipse. Now lower your arm gradually and notice that the top of the glass becomes an ellipse that gets wider and wider as you lower the glass more and more. Finally, when the top of the glass is directly below you, the ellipse becomes the full circle that it actually is (see Figure D, view 1).

It doesn't matter if the glass you draw doesn't resemble mine. The purpose of this

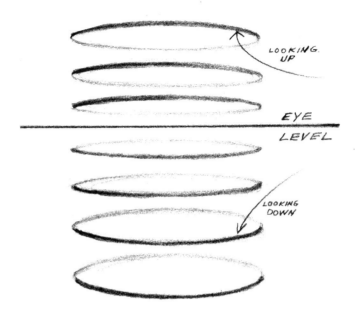

LOOKING UP

EYE LEVEL

LOOKING DOWN

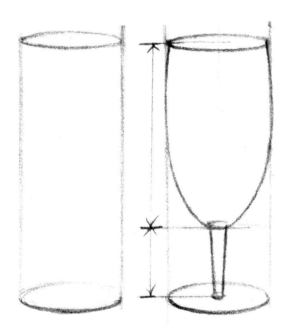

Figure C. *Always be aware of eye level; the true appearance of objects depends upon it. Notice that the top ellipses of the glasses are shallower than their corresponding bottom ones, because the top ellipses are closer to the eye level and the bottom ones are farther from it.*

project is simply to train your eye and hand to *observe* and *render* whatever modifications and departures there may be from the rigid cylinder that underlies the shape of the object you're drawing. The correct placement of a handle on a cup, the height of a stem on a glass and the different depths of the upper and lower ellipses of a glass are factors that must be considered when observing and drawing these cylindrical objects. Remember that as an ellipse nears the eye level, or horizon, it gets shallower, and that as the ellipse gets farther away, it gets deeper.

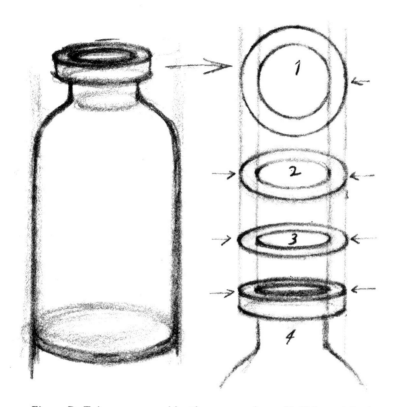

Figure D. *Take any opened bottle you may have. Hold it straight down at arm's length, and note that the lip of the bottle is a perfect circle, as in view 1. But the ellipse gets more and more shallow as you raise the bottle to eye level; see views 2, 3, and 4. Notice that while the back and front of the bottle's lip get narrower as you lift the bottle to eye level, the left and right ends of the lip remain the same width.*

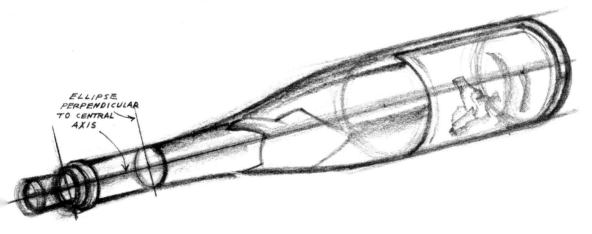

ELLIPSE
PERPENDICULAR
TO CENTRAL
AXIS

Figure E. *When a cylindrical object is placed on its side, like this wine bottle, the ellipses are perpendicular to the central axis of the cylindrical form.*

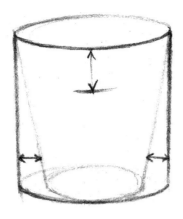

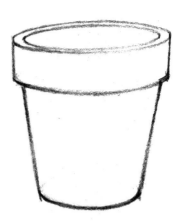

Flower Pot, Step 1: *First I draw a true cylinder. Then I determine the sides of the pot and the width of its rim.*

Flower Pot, Step 2: *I darken the correct lines, then place a fresh sheet of paper over the drawing and transfer these darkened lines, thereby "cleaning up" my drawing.*

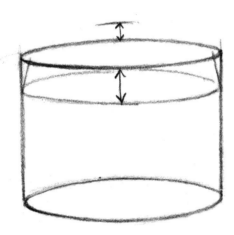

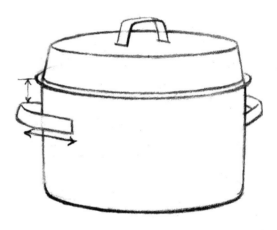

Cooking Pot, Step 1: *Again, I draw the entire geometric cylinder first. I observe the depth and the width of the pot in relation to its height, and indicate the dimensions of the lid.*

Cooking Pot, Step 2: *Here's the refined drawing. I still have to determine the distance from the bottom of the lid to the top of the side handles, as well as establish the slant of the side handles.*

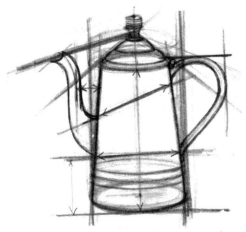

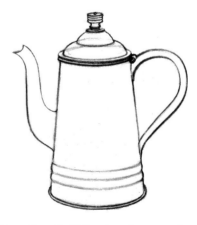

Coffee Pot, Step 1: *In actual practice, these accentuated guidelines would be very light—if drawn at all—and just visible enough to establish relationships and checkpoints.*

Coffee Pot, Step 2: *Following the procedure used in the preceding demonstrations, I place a fresh sheet of paper over the first rough drawing and draw only the pot itself.*

Drawing Spherical Objects

Besides the obvious, perfect spheres that form the structure of a ball—whether a golf, tennis, or basketball—there are those objects which partake of the sphere in one form or another. An egg, a nut, an apple, and an orange all have a modified sphere as their basic underlying form (Figure A). Objects such as a bowl, a cup, and a tea kettle can be based on *part* of a sphere.

Departures from the Geometric Sphere

The departures from the geometric sphere may be quite radical at times, but all the objects in Figure B are based upon it. For example, in the football the sphere is tapered at both ends; in the Silex coffeemaker there's one complete sphere and two-thirds of another; and in the helmet the complete sphere is shown by the broken line. Finally the light bulb in Figure B is actually a sphere with a cylinder attached to it.

When drawing any object that's structurally spherical, draw the complete sphere first; then add the required departures that your particular object demands. You should ask yourself the same questions concerning proportion that you asked when drawing other forms. How much does your object depart— flatten, bulge, or bend—from the geometric sphere you first drew as its basis?

Gather all the spherical objects you can find and draw them in any size you wish. But I advise you to draw rather large, so that you can swing your pencil freely.

Depth and the Sphere

As you draw, remember that a sphere occupies a given space; it is *not a flat disk*. Hold an apple or orange in your hand and feel its bulk. Try to convey this volume and weight in your

drawing. In the demonstrations at the end of this project, I've indicated this three-dimensional feeling by the ellipses on the apple and orange, and on the geometric spheres upon which they're based.

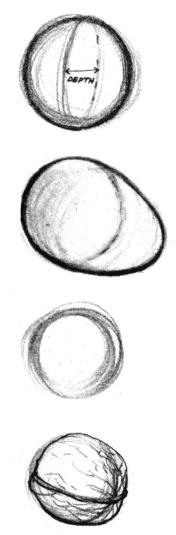

Figure A. A sphere provides the basic form for both this egg and this nut. Remember that a sphere has three dimensions. The ellipses on the egg shape help to emphasize its depth.

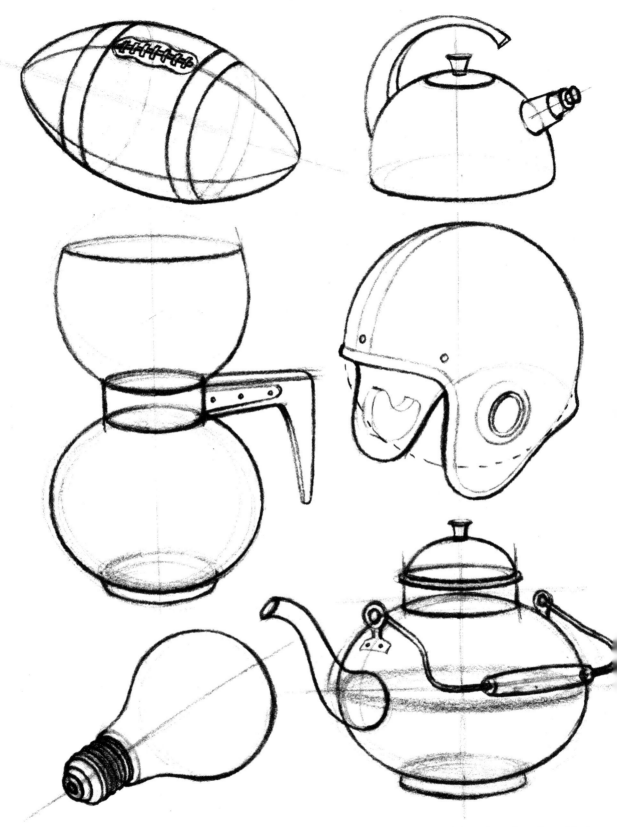

Figure B. Though modified in some way, each of these objects is based on the sphere. Notice the light pencil line through the center of each object. This line aids me in establishing the symmetry of the left and right sides of the objects. It also helps me to draw the ellipses on the football and light bulb so that they're perpendicular to their central axes.

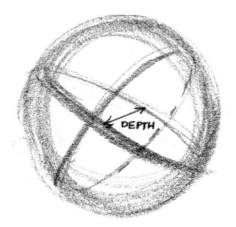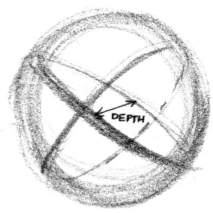

Apples and Oranges, Step 1: With these fruits, as with any piece of fruit based on the sphere, I first draw the complete, geometric sphere. I also draw in ellipses to help me establish the third dimension of the sphere—depth.

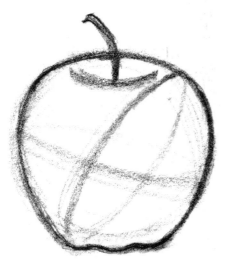

Apples and Oranges, Step 2: Once I establish the basic form, then I can add whatever departures make the particular fruit unique: its bulges, texture, and stem.

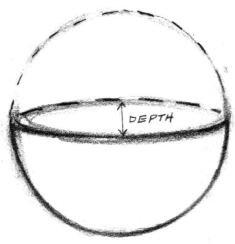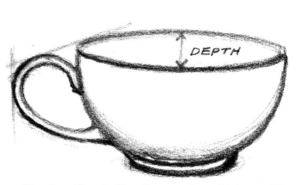

Tea Cup, Step 1: Some objects have only a part of a sphere in their structure. Even so, I begin by drawing the complete sphere, as indicated by the broken line. Notice how my ellipse establishes the depth of the sphere, giving it volume.

Tea Cup, Step 2: Now I proceed to add the modifications to the sphere that can turn it into a cup. I omit the broken line and work only with the bottom half of the sphere.

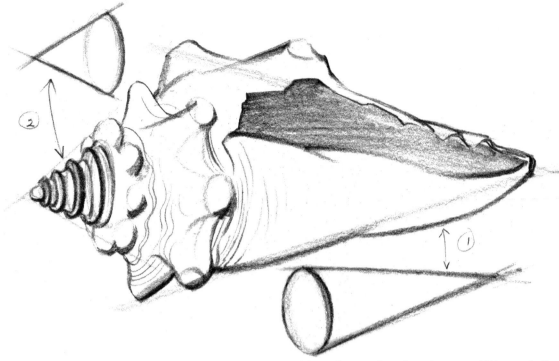

Figure A. *Nature provides us with many objects that are based on the cone. This sea shell has two cones forming its construction. In order to achieve its proper proportions, you must ignore, at first, the shell's rather elaborate detail. I have indicated the two cone forms and their relative positions within the large sea shell.*

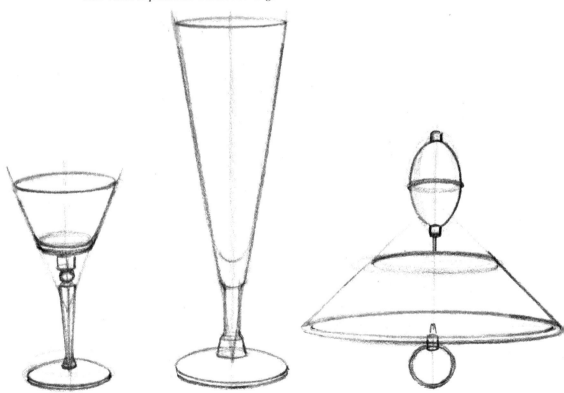

Figure B. *The geometric cone can assume any number of variations, depending upon the particular object. It can be elongated and thin, as in the beer glass, or compressed and broad, as in the cocktail glass and lampshade. Regardless of its modifications, you should first search out the basic cone shape; then begin to draw your object.*

PROJECT 6

Drawing Conical Objects

Now let's tackle the last of the four basic forms: the cone. Quite naturally, the first object that pops into mind is an *ice-cream cone.* But there are bottles, glasses, lampshades, bowls, and many other man-made objects with shapes based upon a cone. There are also countless creations of nature—sea shells, flowers, and trees—with conical shapes (Figure A).

When you begin to draw conical objects, remember that a cone is a solid mass that tapers uniformly from a circular base to a point. Look for this form *first* in the object you're drawing, whether it's long and thin like a beer glass, or short and broad like a lampshade (Figure B).

Symmetry of the Cone

The best way to draw a symmetrical cone is to begin with a center line. Then draw the ellipse at right angles to this center line. Mark the place on the center line where the tip of the cone should be, depending on its height. Having established the base and the tip, it's a simple matter to run two diagonal lines from the tip to the ends of the ellipse to form the basic cone. (See the demonstration at the right of this page.) Now you can begin to add whatever details pertain to your particular object.

Drawing Everything

Draw as many conical forms as you can find. When you're finished with the last demonstration in this project, you'll have achieved a great deal. It's really a fine accomplishment to be able to draw—in their correct proportions—all the objects I've suggested. If you've mastered the four basic forms, you can draw anything in existence. Imagine! That's exactly what we're going to do in the next project.

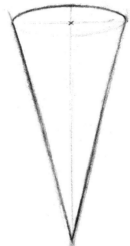

Ice Cream Cone, Step 1: I begin by drawing the entire geometric cone. Notice how the line which I draw through the cone's center helps me establish the proper proportions and thus, the cone's symmetry.

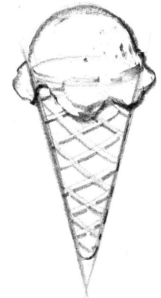

Ice Cream Cone, Step 2: Having established the dimensions of the cone, I begin to depart from the geometric form by adding detail. The detail transforms this geometric shape into a recognizable object, an ice cream cone.

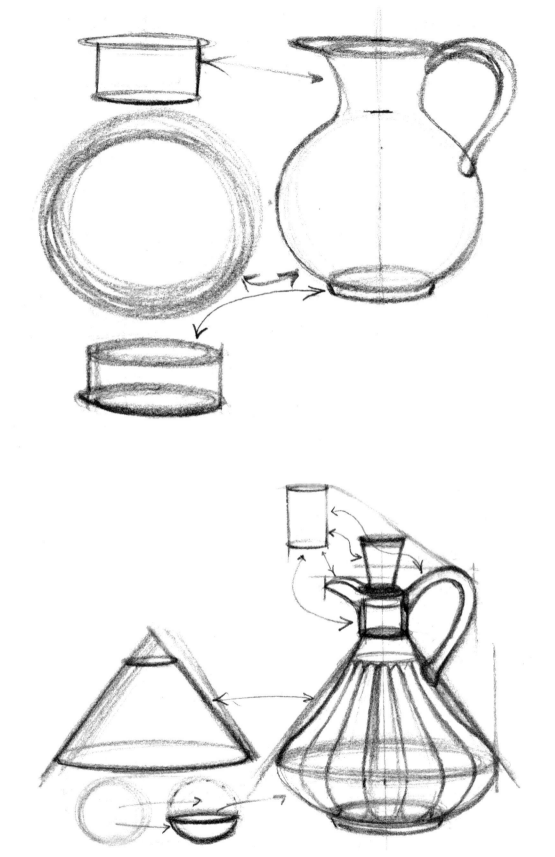

Figure B. With all its ribbing (that is, detail) this cruet seems more complicated than it actually is. However, it's only composed of three basic shapes: cone, sphere, and cylinder.

Putting Basic Forms Together

Now the real satisfaction and consequent enjoyment of drawing begins. Since you can draw all the basic forms, you can begin to put them together; now you'll be able to draw any object you wish. No matter how complex your subject may be, drawing it is only a matter of combining basic forms.

Basic Forms and Their Relationships

You must arrange your basic forms—whether complex and composed of many parts, or simple and made up of only two (Figure A)— so that they *relate to each other* in both size and position. The same questions you asked yourself when observing and drawing an object composed of a single basic form should also be asked when you draw a complex object. How high, how wide, and how deep is one basic shape in relation to another?

Search for the proportions of your basic forms with many lines; don't erase any of them. In this way you'll be able to compare and contrast proportions and establish correct shapes. Once you have the general proportions correct, you can place a fresh sheet of paper over your subject and clean up your drawing.

Drawing Symmetrical Objects

Establishing the symmetry of such objects as glasses, lamps, or candlesticks is vital to attaining their correct shape. Draw the center line through your object as I've done in Figure B. Next, draw the left contour of your object; then flop your drawing over. Register your center line and trace the contour of the right side from your left one onto another sheet of paper. Both sides of your object should now be perfectly alike—symmetrical. Then, taking still another sheet of paper, trace the entire object and refine your drawing by eliminating any incorrect lines.

Drawing and Observation

You can draw anything. With the four basic geometric shapes, the possibilities open to you are endless. But you must be able to carefully discern the basic shapes underlying objects. Sometimes they'll be almost totally obscured by a wealth of detail; sometimes one object will be composed of so many individual basic forms that it will be hard to distinguish each separate form.

Therefore, you must sharpen your visual powers. You must do more than see, you must *observe*. You must learn to think about what you're viewing and ask yourself basic questions concerning an object's relative proportions and dimensions. Observation will play an important part in the coming project where you'll draw objects in relation to the horizon. That is, you'll draw objects in perspective.

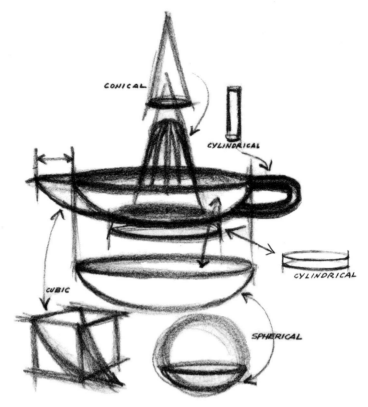

Figure C. This orange squeezer, as well as the hurricane lamp below, includes all four basic forms in its structure. Begin by drawing the largest form first. In this case, the largest shape is a sphere.

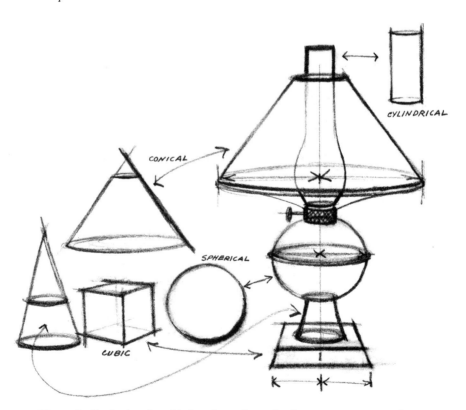

Figure D. Begin drawing this hurricane lamp in the same manner as the orange squeezer, with the largest shape first. Here the major shape is a cone.

PROJECT 8
The Horizon Plane

Now that you can draw any object, regardless of how many basic forms it may contain, let's take another look at this thing called perspective. Whatever your subject may be, you must consider its position in relation to the horizon plane. The *horizon plane* is simply the surface that extends from the horizon, as you look straight ahead, to your feet, as you lower your eyes.

Relating Objects

While its verticals remain vertical, the top and bottom of an object are affected by their relative positions to the eye level or horizon. Both the top and bottom of an object get narrower as they near the horizon.

In Figure A, I drew the grid on the horizon plane to show you graphically how the horizontal lines of an object converge to their respective vanishing points. I arbitrarily established the grid first; then I drew the forms at various distances from the eye level so that you could see how these forms are affected by their different placements.

Contours

Note the ellipse in Figure A at 1 and 2. A circular surface must conform to the horizon plane on which it rests; check 3, 4, and 5 of Figure A. The only object that never changes its contour, no matter where you place it, is the sphere. Take a ball, for example, and place it anywhere you wish. Notice that its contours remain the same.

To demonstrate this principle further, draw a circle and a square side by side; they don't have to be any larger than four inches. Place the paper on which you've drawn them at your feet. Now lift it slowly toward your eyes, holding the paper flat. As you raise the paper,

notice how the circle becomes an ellipse and the square becomes a rectangle. The closer they get to your eyes, the more shallow these objects become. The height of your eyes is the *eye level, or horizon.*

Creating a Composition

First, you must consider the height at which you'll place your objects. This may sound a bit too rudimentary, even for a student. But you'll be amazed to learn how many compositions are weakened by a placement that's either too high or too low on the horizon plane.

It's helpful to ask yourself questions similar to those asked in the beginning projects. Would my elements look better if I saw them from above? Would the composition be enhanced by lowering my eye level? Would it be better yet if the horizon were to *split* the elements? This occurs when you see neither the top nor bottom of an object, as in Figure B, view 1. Your choice regarding the placement of your objects in relation to the horizon will ultimately depend on the shape and the number of objects in your composition.

Selecting a Viewpoint

Along with the placement of a group of elements, the selection of the proper viewpoint is essential to creating a good composition, regardless of your subject. As an exercise to help you visualize the effect of your viewpoint on your composition, place four or five things on a table. They can be any objects on hand; you're not going to draw them. Stand next to the table and observe their different shapes. Bend over, placing your hands on your knees, and observe the difference as one object appears to overlap the other. Should the taller

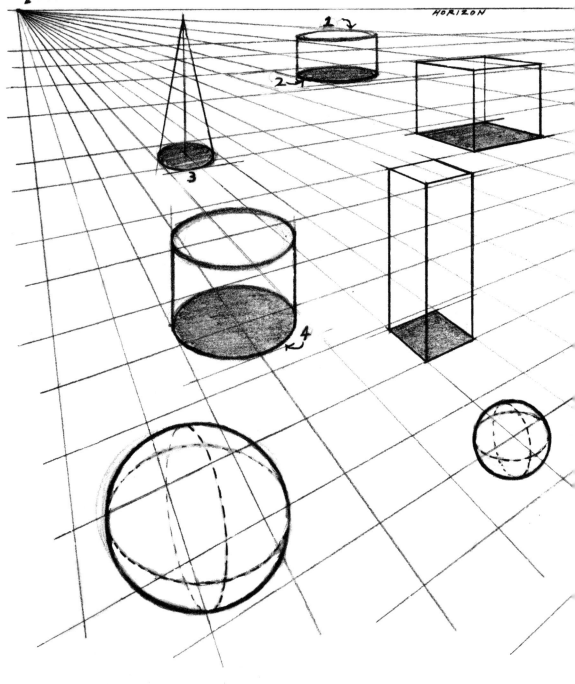

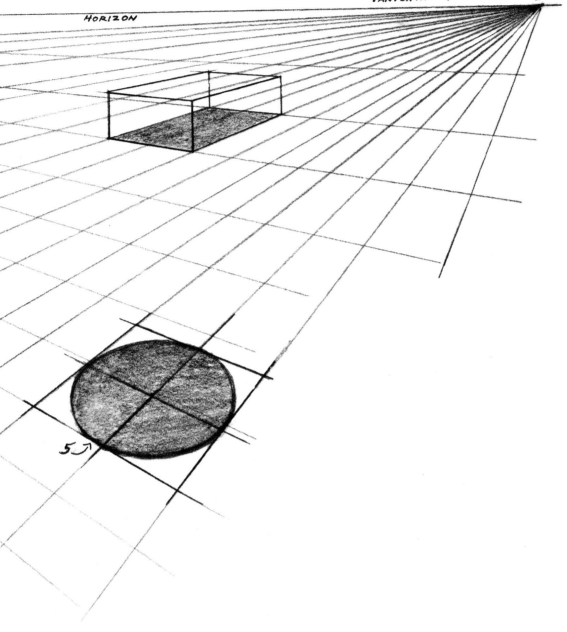

Figure A. Notice that as an object nears the horizon its top and bottom planes get shallower; conversely, as an object drops away from the horizon its top and bottom planes get deeper. Compare the ellipses at 1 and 2 with that of cone 3 and cylinder 4. Look for this principle in the world about you, even when you're not drawing.

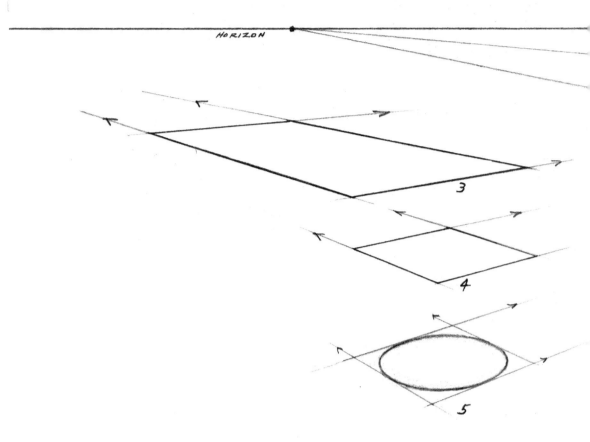

Figure B. *There are an infinite number of shapes and viewpoints that I could use for my table top. However, its shape will ultimately depend on its position relative to the horizon plane. I chose view 2 for the composition in Figure E.*

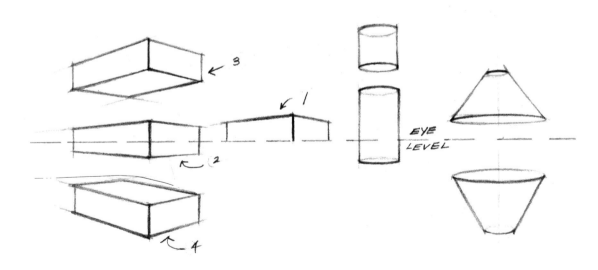

Figure C. *Always consider the eye level, the horizon. It controls the appearance of things, whether an object is on it (view 1), split by it (view 2), above it (view 3), or below it (view 4).*

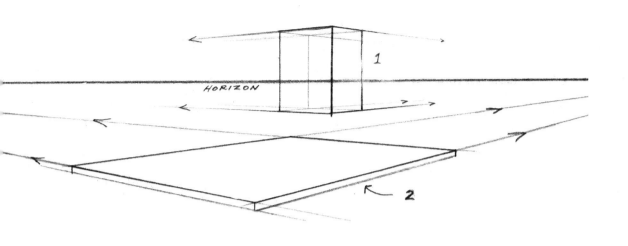

HORIZON

1

2

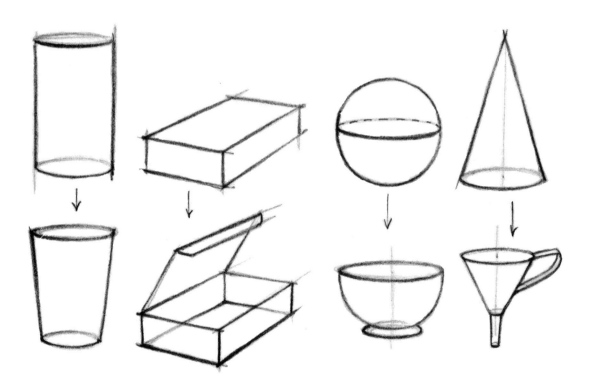

Figure D. *Keep in mind that objects have solid geometric forms underlying them. You must convey this construction, which provides depth in your drawing.*

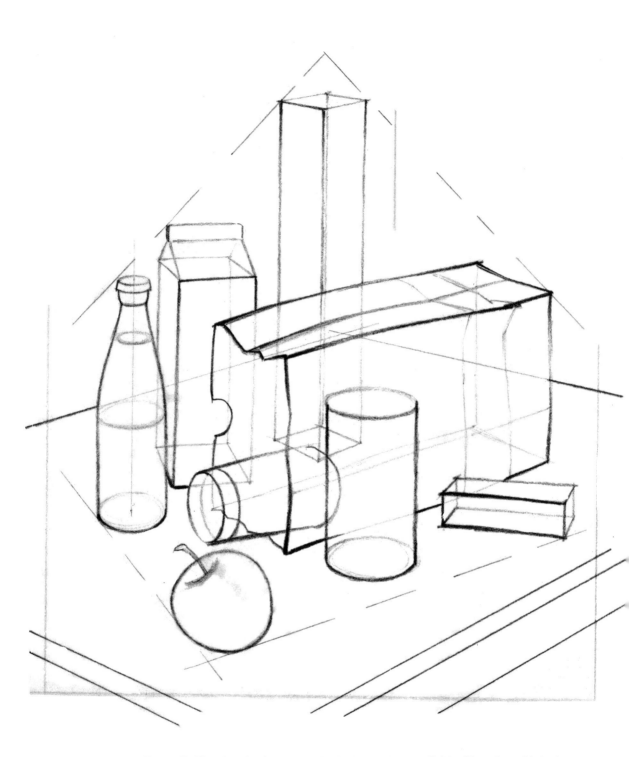

Figure E. *This drawing is an exercise in composing a still life. First, I establish the correct proportions of the main element—the open paper bag—keeping in mind its relation to the horizon plane. Then, I add three additional cubic elements. When there are a number of cubic forms in your composition, you must introduce another basic form to avoid monotony. Here I add three cylindrical objects for just such a contrast. When I feel that my objects are varied enough in shape and placement, I observe the silhouette of the entire group of objects (indicated by the triangular, broken line). I feel that the top of the silhouette of this group is interesting enough, but the bottom is too even and static. To correct this I position still another basic form—the sphere—so that the bottom of the silhouette will echo the triangle at its top.*

article be moved behind the shorter one? Now sit on a chair and observe still more changes in the group of objects. Should anything be shifted to create a better group silhouette? Fall on one knee and study the group. Was it better when you were standing? Finally, sit on the floor. Is the group still better, or does the whole composition visually fall apart?

Perspective in a Still Life

The point of view from which you decide to observe and render your objects is essential to composing and drawing a still life. On the opposite page (Figure E) I've attempted to illustrate how to go about composing a still life, although I've made no attempt at achieving a finished drawing of one. We'll come to that later on.

Of the several positions seen in Figure B, I choose view 2 for my table top. The first element that I draw is the cubic shape of an opened, brown paper bag. Although the table top is at one angle and the bag is at a different angle to it, their respective vanishing points are on the same horizon.

You can turn an object to any angle you wish, and its vanishing points will remain on the same eye level, as long as your viewpoint remains unchanged. So when you begin a drawing sitting down, don't stand up to finish it, and vice versa.

Working with Actual Objects

By merely copying all of the figures in this project, you can probably learn something. However, you'll be depriving yourself of the invaluable experience of working from actual objects. Even if you can't duplicate all the objects I've used in Figure E, use whatever you have on hand.

Be sure that one of your items corresponds to the paper bag I've used. Its less rigid contours serve as a foil to the severe straight lines of the other objects.

A Brief Summary

Every project in this book is built upon knowledge acquired in the preceding project. No single project is isolated or self-sustaining, because drawing is a cumulative art. That is, one skill must be mastered before you can be successful with the next one. For example, it would be impossible to teach you to draw a cube if you couldn't draw a good, straight line.

So far, all the drawings you've done have been in line (that is, without tone), because it was necessary to concentrate on establishing the proper proportions of objects. To have introduced the problem of light and shade and tonal values would have simply been putting the cart before the horse. But now that you've mastered some fundamental skills of drawing, you can move on to rendering light and shade.

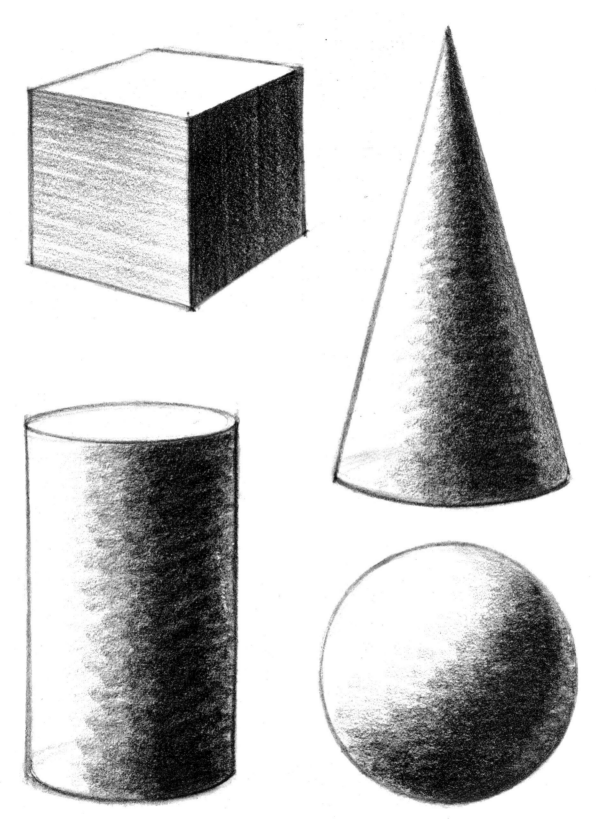

Figure A. *As your first exercise draw these four basic forms in line, as I've done here. Then add the shading. The only sharp separation between the light and shadow planes is seen on the cube. The other three objects have a soft, graduated transition from light to dark, denoting their curved surfaces.*

PROJECT 9
Light and Shade

For this project you can put aside your "office" pencil and purchase an Eagle "draughting" pencil, #314. Better yet, buy a dozen. They'll give you the rich blacks and deep grays you'll need for this project. If this particular pencil is unavailable in your town, then use any drawing pencil with a soft, black lead that will give you deep tones.

Speaking of art materials, wouldn't it be a good idea to check the projects ahead for the different materials you'll need? From now on, you'll be changing them quite often. If there are no stores in your town that carry artists' materials, I'd suggest that you send for a mail order catalog from the art supply store in the largest city near you. That way you'll have the correct supplies on hand when you need them.

Observing Light and Shadow

It's axiomatic to say that without light you would see nothing. However, only the artist observes and carefully considers the properties and characteristics of light (and, consequently, shadows) and light's effect upon virtually everything around him.

Previously you only trained your eye to see and draw the correct proportions of an object that was in line. Now you'll learn to observe and draw objects in tone, that is, light and shadow. You'll study and render the angle, density, and shape of shadows on and caused by an object. First, let's study the properties of light and shadow indoors—artificial light. Later, when we go outdoors, we'll deal with the behavior of natural light. The main difference between both types of light—artificial and natural—is that you can control indoor light, while you can't control outdoor or natural light. Too obvious to even mention? Not really, as we'll see.

Light and Dimension

For the present, let's deal only with one light source to avoid confusion. It's the clear and definite separation of *light on one side of an object and shadow on the other* that gives an object its three-dimensional appearance, of having volume as well as height and width.

The manner in which light, falling on an object, separates into distinct areas of light and dark depends upon the surface of the object. If the demarcation between light and dark is sharp, then the object has planes and, therefore, edges that turn away from the light. If there's a gradual change from light to dark, then the surface is curved (Figure A).

Tonal Values

I've done Figure B to give you an idea of how shading affects subject matter and composition. Notice that all the light areas are white and all the dark areas, or shadows, have the same intensity or *value*. Value is simply the lightness or darkness—from white through all shades of gray to black—of a tone produced by a drawing medium such as a pencil, charcoal, etc. The reason that all the shadows on the objects in Figure B are the same value, or degree of darkness, is that all the objects have been considered to be white and of the same material. No local color or texture has been introduced; we'll explore those problems in the next project. For the present in Figure B I've left the white paper itself for the lights, and rendered all the shadows in the same degree of darkness.

Using the Full Tonal Scale

However, when you begin to draw in tone, I'd like you to use the full tonal scale—from black

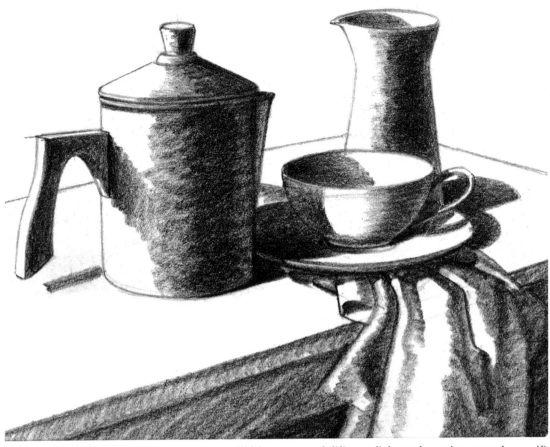

Figure B. *When arranging a still life, try several different light angles, using natural or artificial light. Here I have my light coming from the upper left, because it gives my objects the most interesting light and shadow pattern.*

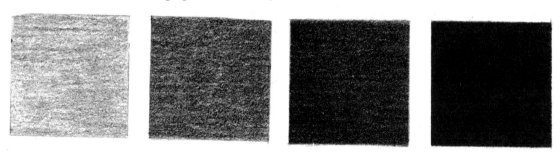

Figure C. *Simply by applying various degrees of pressure to it, the same pencil (the Eagle draughting pencil #314) creates all four values. The harder you press, the darker the tone.*

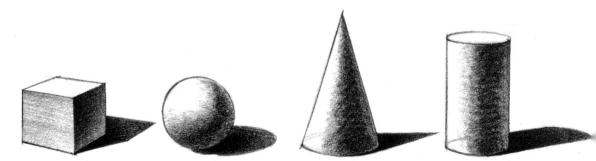

Figure D. *Remember that cast shadows are usually darker than the shadows on the object itself. The darkest part of the cast shadow is closest to the object.*

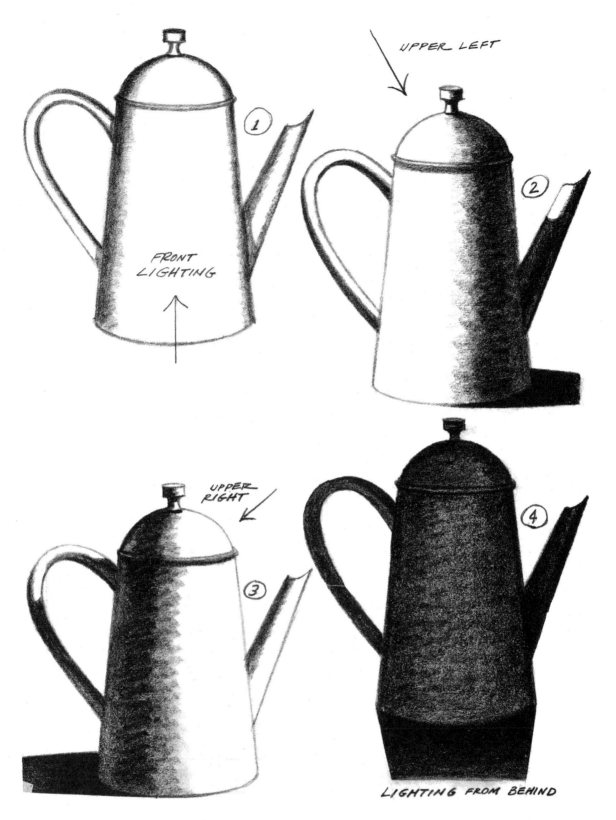

Within the illustration the following handwritten labels appear:

1
FRONT LIGHTING

2
UPPER LEFT

3
UPPER RIGHT

4
LIGHTING FROM BEHIND

Figure E. *Position your light source to obtain the desired effect on the object you're rendering. In view 1, the shadow areas are dispersed to the side, creating a flat, two-dimensional effect. In views 2 and 3, the light is coming from the upper left and right, causing a distinct shadow pattern that emphasizes the volume or third dimension of the object. In view 4, backlight provides a flat silhouette in tone.*

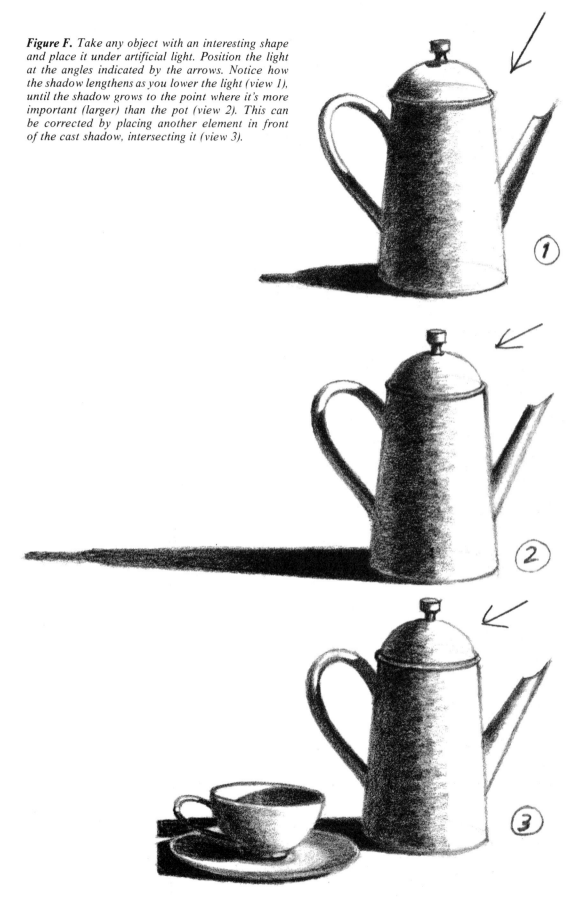

Figure F. *Take any object with an interesting shape and place it under artificial light. Position the light at the angles indicated by the arrows. Notice how the shadow lengthens as you lower the light (view 1), until the shadow grows to the point where it's more important (larger) than the pot (view 2). This can be corrected by placing another element in front of the cast shadow, intersecting it (view 3).*

through all the grays to white (Figure C). I've seen many students who made their drawings weak and pale, because they were too timid to press down on their pencils and obtain the deep blacks and dark grays that would give their drawings vitality. Always give your drawings the directness of line and the boldness of tone that reflects your confidence.

Cast Shadows

Along with the shadow *on* an object, there's another type of shadow, known as the *cast shadow*. This shadow is created *by* the object itself upon the surface on which it stands. Cast shadows aren't a flat, even tone; they're darker at their source. Their darkest portion is immediately adjacent to the objects casting them (Figure D). The edges of cast shadows can be sharp or soft; you must carefully observe these qualities.

Shadow Edges

A word should be mentioned here about the *shadow edges* in Figures B and D. Note carefully that on an angular or planed object, as one plane meets another and turns away from the light, shadow edges are sharp. However, if the surface is curved, the shadow edge is soft, because the tonal demarcation is gradual.

Place any object on a table. Shine a light (lamp, flashlight, etc.) upon it. Observe what happens to the edges of a cast shadow when the light is at different distances from your object. You'll notice that as you pull the light source away, the edges of the cast shadow will become sharper; as you place your light source closer to the object, these edges become softer. Both soft and crisp edges are valid. You must decide which you prefer and which seem more appropriate for your subject.

Angle of Light

The angle of light you choose affects your subject matter (Figure E). Place any object you wish on a table or a stool and shine a light on it from various angles. Study the shapes of the shadows and cast shadows as you walk around the object, holding the light at the same height and at the same distance. Naturally, you'll select and draw the most interesting shadow patterns.

In Figure E, the subject illuminated is a coffee pot. When the light is directly in front of it (as in view 1) notice that the shadows on the object are scattered to its edges, thereby flattening the form. This would be the lighting angle to use when you're doing a line drawing, because there are no disturbing shadows to contend with.

However, if you want to convey the solidity or volume of your object, a light from upper left or upper right (views 2 and 3) would give you this three-dimensional effect. The result of lighting an object from behind (as shown in view 4) would be a flat *tonal* silhouette. If lighting from the *front* would be the best angle when you want to do a *line* drawing, lighting from *behind* would be the best when you want to do a simple, flat shape in *tone*.

Level of Light

Now I would like you to change the height or level of your light source as you move around an object. The *lower* the angle of light, the *longer* the cast shadow (Figure F, view 1). This low angle of lighting should usually be avoided, because the cast shadow becomes too long and more important than the object itself (Figure F, view 2). However, if you prefer this angle, the long cast shadow can be cropped with a border or intersected with another object (Figure F, view 3).

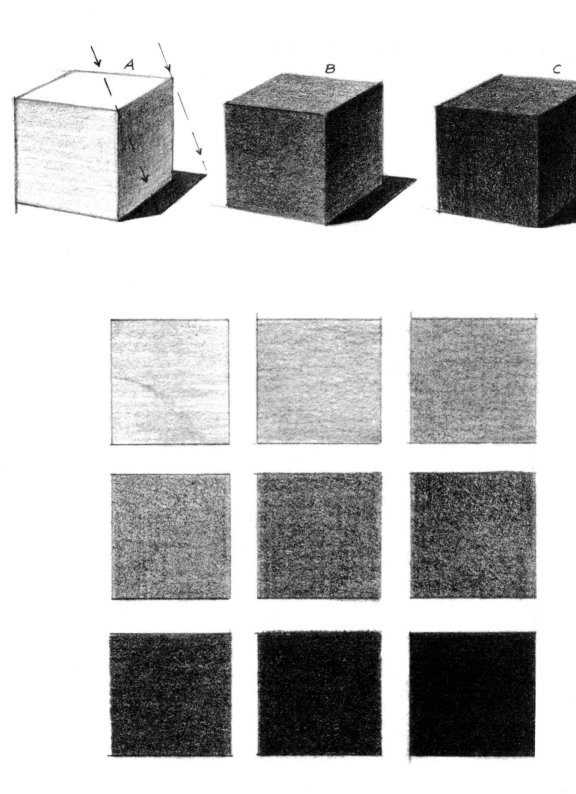

Figure A. *(Top Row) The cube on the left is actually yellow. When drawing it in black and white, its yellow would translate to a light gray. The middle cube is deeper in tone, indicating that its local color may have been red or some other deeper value. The cube on the right has the deepest tone. A local color such as brown or purple could be represented by such a value. In the set of squares (below) I've represented the tones of the entire value scale or spectrum.*

Translating Local Color to Black and White

Local color simply means the color that nature —or man—has given to an object: a red apple, a beige curtain, a green tree, a white boat, or a black cat. When drawing with tonal media, such as pencils and charcoal, you must be able to transpose this local color into some shade or tone of black, gray, or white.

For example, if you were to draw a red apple with charcoal (see demonstration at the end of the chapter), it would appear as a dark gray compared to the much lighter gray of, say, a green apple. There would be lights and shadows correspondingly lighter and darker on the middle tone of each. The shadows on a red cube would be deeper than the shadows on a yellow cube, etc. (Figure A).

Using a Middle Tone

When transposing local-color to a tone, the best procedure would be to first apply an over-all middle tone—a light, middle, or dark gray. After you establish this middle tone over the area, you can work in the deeper shadows. Finally, you can remove lights from the middle tone with a kneaded rubber eraser.

Values and Tones

When translating local color to black and white, you have the entire value scale at your disposal. That is, you have all the tones ranging from white at one end through the grays to black at the other (Figure B). If you use tones from all the ranges of this spectrum—white, some grays, and black—your drawing will be in *full contrast.*

If your drawing contains only those tones at one end of the tonal scale—for example, tones ranging from white through a medium gray—then your drawing is said to be done in a *high key.* The value key is *high* if your tones

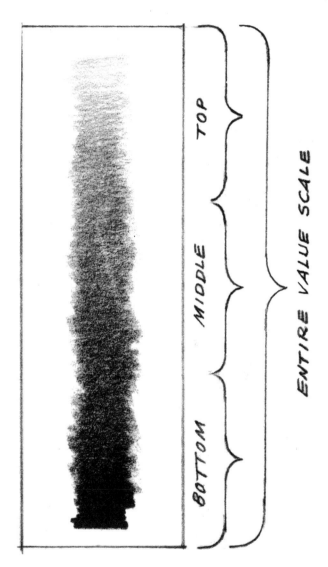

TOP

MIDDLE

BOTTOM

ENTIRE VALUE SCALE

Figure B. *Here I've drawn the tonal spectrum in a linear fashion. By staying in the upper half of the spectrum, or "scale," you could render a "high-keyed" drawing. If you use only the tones in the lower half, your drawing would be in a "low key."*

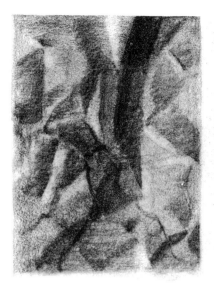

Paper: *First I indicate the "local color" of this paper bag with a medium gray tone applied with a "draughting" #314 pencil. Then, I modeled the darker configurations and picked out the lights with a kneaded eraser.*

Cloth: *Here I simply rub the side of my pencil over a "canvas board," a surface used for painting in oil. I apply medium pressure to the pencil.*

Brick: *I follow the same procedure here as I used in rendering the cloth. For the brick, I rub harder to achieve the dark tone which approximates the brick's red local color.*

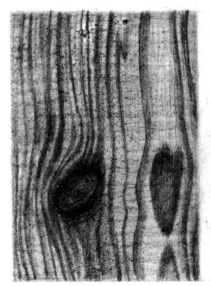

Wood: *For both the wood here and the metal no rubbing is employed. Over an even, light gray middle tone I just draw in the grain of the wood with the side of the pencil's lead.*

Metal: *After applying a light gray tone over the entire area, I smooth this tone with a paper stump. Then I draw in some dark shapes and smooth them out with a stump also.*

Figure C. *Practice doing the textures shown here. Remember that just like certain spices, a little texture goes a long way.*

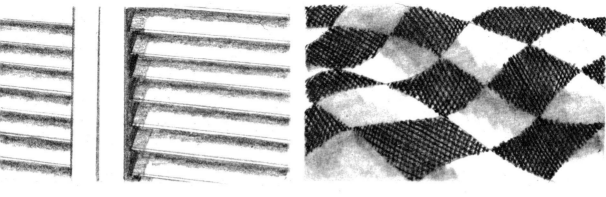

Venetian Blind *Tablecloth Checks*

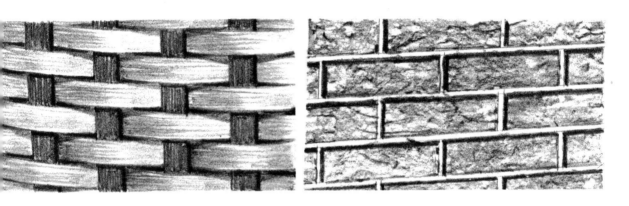

Latticework *Brick Wall*

Wallpaper Pattern

Figure D. *Visual textures help to make a drawing more interesting by breaking up large areas of tone with a certain pattern.*

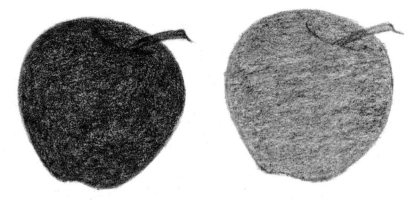

Two Apples, Step 1: *In this demonstration the red apple is on the left; the green one is on the right. In a flat manner I convey the local color of the fruit with a corresponding gray "middle" tone. Notice that the apple on the right—the green one—has a much lighter gray for its middle tone.*

Two Apples, Step 2: *Here I add the stem shape as well as the shadow areas over the flat, middle tone. Notice that the value of the shadows on the red apple at the left are correspondingly darker than those on the green apple at the right.*

Two Apples, Step 3: *Once the middle tone and shadows are correctly established, I pick out the highlights with a kneaded eraser. By compressing it with your fingers, a kneaded eraser (composed of malleable rubber) will give you whatever type of shape you need—from flat and blunt to pointed and sharp. It's better to press and lift on the area you want removed than to rub over it, as you would with a hard rubber eraser.*

are on the white end; it's *low* if your tones are grouped at the black end. An entire drawing rendered in just two or three adjacent tones is called a drawing in *close tones.*

Tonal Arrangement

It's important to arrange the tones in your picture to create a well balanced and pleasing composition. Good composition depends on more than a good grouping of objects according to their size and shape. You must also distribute light and dark in a pleasing manner. Their distribution will have a direct effect on the reaction of the viewer: stirring him to a frenzy or lulling him into quietude. You must arrange your tones with the reaction of the viewer in mind.

Rendering Texture

When drawing you must consider the texture of an object as well as its local color. Texture can give vitality and reality to your work (Figure C). A word of caution: don't use so much texture that it becomes a "gimmick."

Let's say that texture is like the spice in food. The correct amount of it will make food delectable; too much of it will spoil the flavor.

Avoid having all the elements of your drawing in the same texture—all rough or all smooth. To avoid monotony you must arrange certain passages with slick surfaces to play against rough areas. The contrast created by such a juxtaposition will make the smooth areas seem even smoother, while emphasizing the roughness of the neighboring ones.

Tactile and Visual Textures

Tactile textures (those you can physically feel) must be transposed into visual textures. Visual textures are introduced into a drawing to strengthen the realistic effect of its elements: the slick surface of porcelain, the sheen of metal, the roughness of plaster, or softness of cloth (Figure D). By making tactile sensations into visual ones, the beholder of your drawing can participate in the sensual pleasure created by your judicious placement of various textures. We'll explore the use of textures with various media in later projects.

Drawing a Still Life

I have a feeling that you're getting anxious to draw a "real" picture. Well, the time has come to release all your pent up creative energy and apply all your new knowledge by drawing a still life. For this project you'll need an "office" pencil, an Eagle draughting pencil #314 (or its equivalent), and a kneaded eraser. You can use any thin paper. I've used my Ad Art pad, #307. It has a very slight "tooth" or textured surface.

The step-by-step demonstration in this project clearly illustrates how simple a still life is to draw. It's only a matter of taking things in their proper sequence and using common sense. I suggest that you work in a scale larger than that of my step-by-step drawings. In that way, it will be easier for you to construct and articulate the textural passages.

Copying versus Drawing from Life

Rather than setting up your own, you can copy my still life following the four steps indicated. Copying can be advantageous, if it's judiciously done. Many old masters, and contemporary artists as well, copied the work of still older artists in order to analyze their solutions to various problems.

On the other hand, there's no substitute for the challenge of drawing from the real thing: the strident highlight that must be subdued or the arranging of the folds in a piece of cloth. All these variables are within *your control*. You're the sole arbiter and judge. Your knowledge and judgement, which will develop with experience, will dictate your choice of subjects for drawing.

Composition and Construction

Your still life can, like mine, consist of a coffee pot, a creamer, a cup and saucer, a napkin, and something on which to place them. The background you choose should enhance the elements that you've arranged. You can have your light coming from the upper left, as I've done. However, if it's more fitting to the shape of your particular objects, you can use an upper right lighting angle.

Regardless of the objects you select for your still life, begin by drawing their underlying geometric structure. Remember their proportions will depend on their relation to the horizon line. That is, draw your shapes with perspective, so that they'll have depth and volume and, therefore, reality.

Laying Down Correct Tones

Once you've established the correct shape and proportions of your objects, you can begin to render their tonal values. Begin with an appropriate middle tone that corresponds to the object's local color. Then add the shadows.

You can test your choice of tonal values on a piece of scrap paper. Then place this swatch of tone right next to the object you're about to draw. Too dark? Then do another swatch, this time applying less pressure. If the result is lighter than the local color you're transposing, apply more pressure.

For variety and balance in the tonal scheme of my still life demonstration, I've used a medium gray for the napkin and pot, a light gray on the counter top, a dark gray on the creamer, and white for the cup.

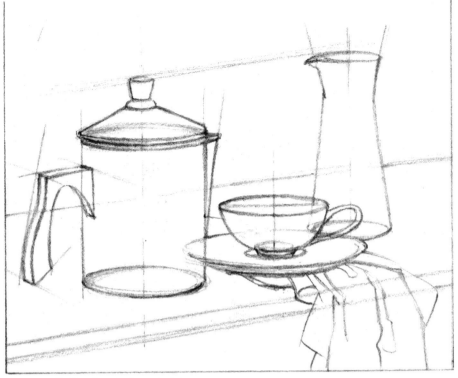

Coffee Break, Step 1: *I begin by delineating the underlying geometric structure of the objects. I'm sure you'll recognize the cylindrical construction of the pot with its conical lid. There's a modified cylinder forming the creamer; a cube underlies the counter top; while a section of a cylinder forms the saucer. The cup is spherical.*

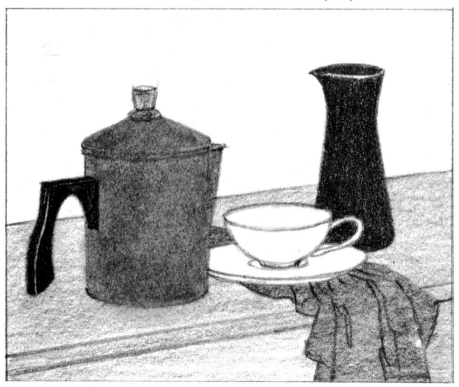

Coffee Break, Step 2: *Here you can employ your newly acquired knowledge of "local color." The local colors in this drawing become shades of gray which fall between the darkest or "lowest" value—the black handle of the pot, and the lightest or "highest" value —the white cup and saucer (and the highlights which can be seen in Step 3).*

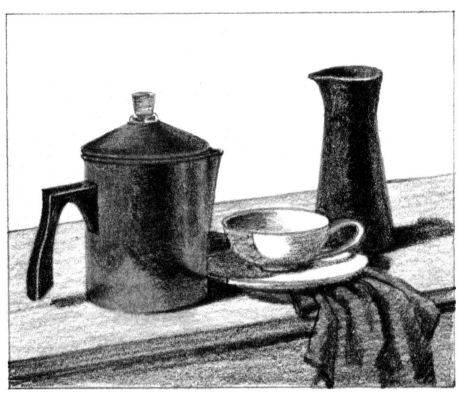

Coffee Break, Step 3: I develop the light and shadow areas on the objects themselves. I also add their cast shadows. Notice how these cast shadows follow the contour of the objects upon which they fall. There's some reflected light from the bright, white cup onto the pot and creamer.

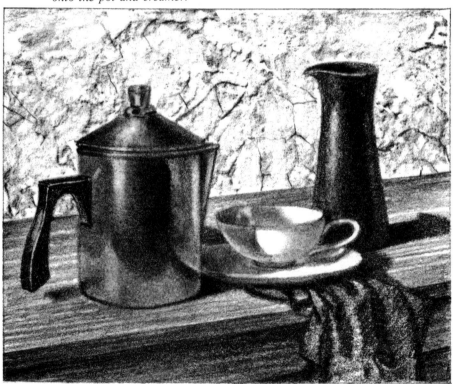

Coffee Break, Step 4: This last stage is the "dessert" for the artist. All the problems, except those concerning texture, have been solved. The best advice I can give you about rendering textures (once you've decided how much to include) is to try to "feel" with your eye the quality of each surface as you render it.

Drawing with Charcoal

In this and the following projects, I'm going to introduce you to all the different and exciting drawing media. We'll explore the different forms each medium takes and the various effects each can produce. As you experiment with each different medium, you'll learn its unique capabilities; then you'll be able to apply these capabilities to a drawing which requires those particular effects. We'll begin with that most versatile and eloquent stick—known as charcoal.

Vine and Compressed Charcoal

Various types of charcoal lend themselves to particular drawing requirements (Figure A). A stick of vine (soft) charcoal or a #2B charcoal pencil, applied with very little pressure, can be used for the first sketches of your drawing.

When you're satisfied with your initial delineation, you can start your decisive rendering with types of charcoal that produce bolder tones: charcoal sticks #2, #3, and #4, or a big fat #7 charcoal pencil. You can cover large tonal areas in a wink by laying the #2, #3, or #4 charcoal sticks on their sides and rubbing them in quick, broad strokes. The tones produced will depend on the grade—soft, medium, or hard—of the various charcoal sticks and the amount of pressure you apply.

Powdered Charcoal

Powdered charcoal is useful in covering an unusually large area—say $4' \times 6'$—with a gray tone. It usually comes in a paper container. To apply it, you lay your drawing paper down flat. Sprinkle the powder as evenly as possible over the entire surface; then rub or blend the powder with a chamois skin. The more powder, the darker the tone, naturally.

Erasers and Blenders

Charcoal can produce an endless variety of strokes. These strokes can be further modified into a wide variety of tones by using blenders, that is, tools that smooth or blend charcoal strokes into tones. A simple paper tissue or piece of cotton can be used to blend charcoal. A piece of chamois skin works well, especially with powdered charcoal. A kneaded eraser also blends and helps to lift out light passages from the charcoal tone.

There are also *paper stumps* for blending. These are nothing more than tightly rolled paper formed into a pointed tool. The small, narrow ones are called *tortillons*.

Some of the best, and certainly the cheapest, blenders are your own fingertips. Of course, if your fingers have a tendency to be wet or oily, don't touch your drawing. Use one of the other blenders that I've mentioned.

Papers

There's an endless variety of papers to choose from. Besides regular drawing paper, made specifically for charcoal, you can use ersatz drawing surfaces such as brown paper bags (see my demonstration) paper plates, and napkins.

Toned Papers

Although we usually think in terms of drawing on white paper, tinted or toned papers open up even more possibilities for various effects. Toned paper adds the illusion of both color and tone to your drawing. The color of the paper should be selected to enhance your subject matter.

Pale gray- and cream-toned papers can be used in much the same way as white paper. But as the color of your paper darkens, you'll

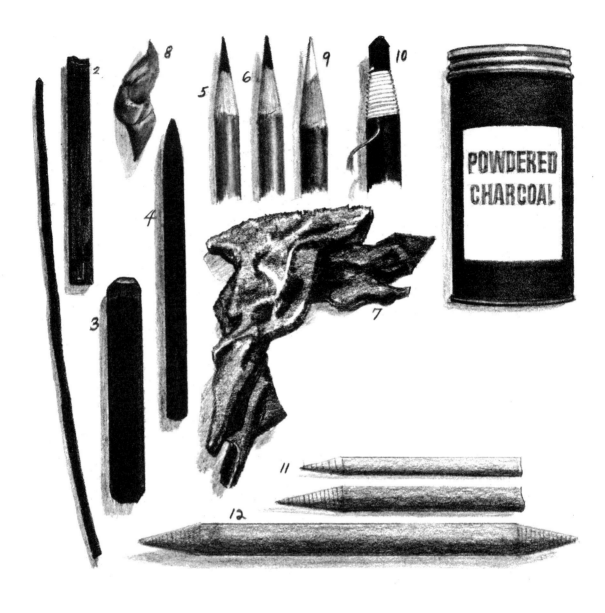

Figure A. *The thin vine charcoal stick (1) is a good tool with which to begin a drawing, because it produces a delicate line. It can also be used on its side to produce broad sweeps of tone (a). Compressed charcoal sticks (2, 3, 4) produce both thin lines and broad strokes (b, c). Charcoal pencils, grades #2B and #4B (5 and 6) produce light or heavy lines (d) depending upon the amount of pressure used. The chamois skin (7) rubbed over a spot of powdered charcoal will blend a big, soft tone (e). The light areas in the blended tone are picked out with a kneaded eraser (8). One of these light areas on the left is sharpened with a white Conté pencil (9). A fat, #7 charcoal pencil is used to produce both thin lines and broad tone (f). The tortillons (11) and large paper stump (12) can be used as additional blenders (g, h).*

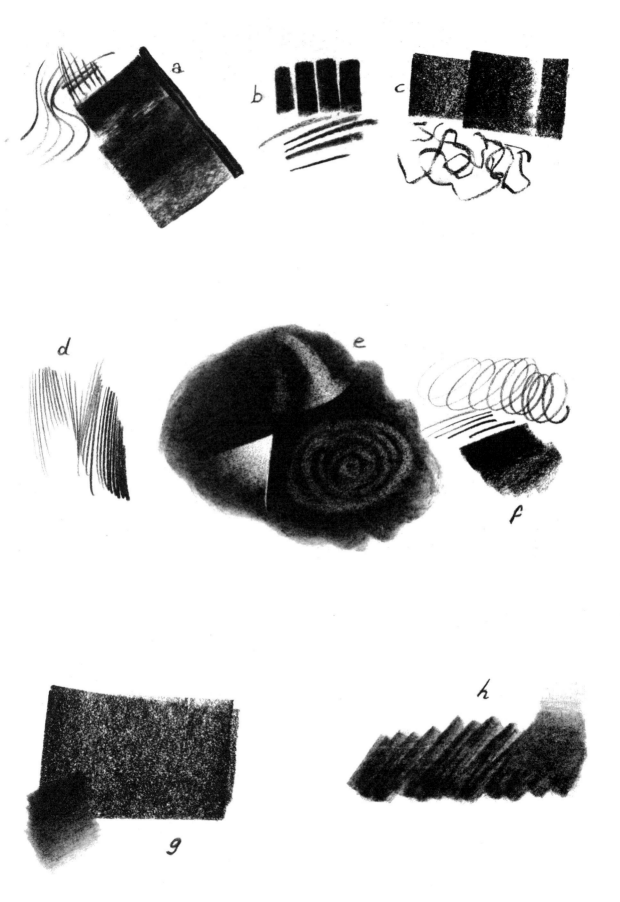

Figure B. I've used both a medium and a soft charcoal pencil for this drawing. I've blended my tones, with a stump; some of the lights I've picked out with a kneaded eraser. I've also used a white Conté pencil for the lightest values. You can, of course, use harder and softer pencils if you wish. If you prefer to work in a large scale, then you should swing over to the big pencils and the large sticks.

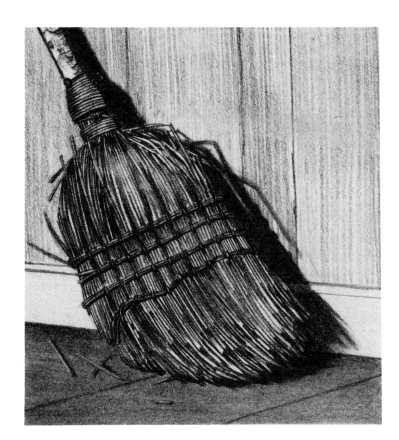

Figure C. I came upon this delightful broom quite by accident and was immediately captivated by its beautiful character. I've drawn it because I want you to see that a common object sometimes has qualities that lift it to the level of art. I've used a vine charcoal stick. With its point I've indicated the straw; the tone on the floor and walls is done with the side of the stick, blending the tone a bit with a stump.

need to create some light areas to restore your tonal range. These light or "high" tonal values can be achieved by using another medium besides charcoal, such as white Conté pencil or white pastel (see the demonstration at the end of the project).

When you use a toned paper, its tone or tint automatically produces an overall *middle* tone. By adding a few darker tones and some light values, you can create the illusion of many tonal values. This is a much quicker procedure for establishing tonal relationships than laying down a middle tone on white paper and adding or subtracting tones from it. Working on toned paper is especially useful when you're doing a large picture.

Fixative

Since most of the charcoal sticks and pencils mentioned smudge easily, you should spray your finished drawings with transparent fixative. There are several brands on the market — all of them efficient. Today most of them come in aerosol cans.

Hold your can of fixative about a foot from your drawing. Try to spray across your drawing rather than straight down upon it, and keep the can constantly moving. Make sure you do your spraying outdoors or in a well-ventilated room. The fumes from fixative are ghastly, being both toxic and flammable.

Charcoal's Versatility

Explore all the possibilities of technique that charcoal offers. The virtues of the charcoal stick aren't necessarily confined to its point. By using its entire length flat on the paper, a charcoal stick can also produce vigorous, broad passages. A square stick has eight corners that can be shaved for fine lines, and its width can be used for broad strokes as well. Of course, its length gives you wide sweeps for working in a large scale.

Find out what effects the same charcoal stick will give you when you apply different amounts of pressure to it. The countless results of charcoal can be multiplied still further by using different kinds of paper — from smooth to rough. Experiment and learn how you can put different papers to use in certain passages of your drawing.

Ease of Manipulation

Goya (Francisco José de Goya y Lucientes) exclaimed two centuries ago: "Give me a piece of charcoal and I'll paint your portrait!" I think he was speaking of charcoal's flexibility and ease of manipulation. You can easily spread a large even tone, deepen and accent it where required, pick out highlights, and reinforce the tone with line, just as you would with oils — the traditional medium for portrait painting. Actually the only element missing from a charcoal portrait would be color. And, heaven knows, there are some portraits that make you wish the artist had ignored color completely.

Charcoal used to be a favorite medium in most art schools, and it still is one of mine, because it lends itself to quick pictorial statement. Innumerable corrections can be made without torturing the surface of the paper or imparting a labored look to the finished drawing. To my mind, it's still the best medium for the student, whether his tendency is to work in thin and delicate line or bold and vigorous masses of tone.

Paper Bags, Step 1: *No matter how complex the detail of an object may be, always begin by setting down the correct planes of the geometric underlying structure, as I've done here. In this case, the structure consists of two, simple cubic forms. Once I've established the big shapes, I can easily subdivide them into smaller details such as the folds and wrinkles of the bags.*

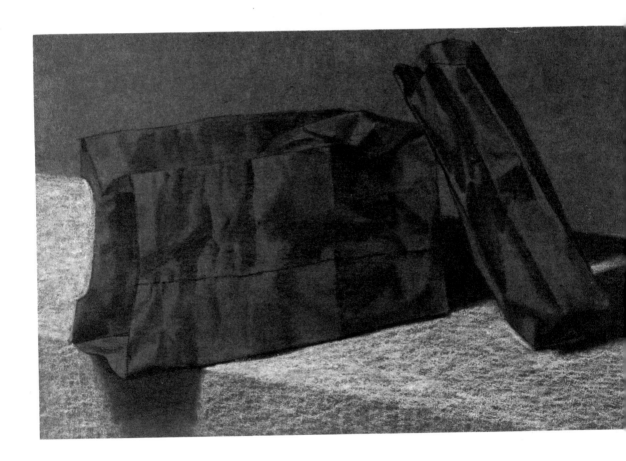

Paper Bags, Step 2: *Using a #2B charcoal pencil, I choose brown wrapping paper for my drawing surface, because it gives me both the local color of the bags and the value of the light areas without having to render them. Using a #2B charcoal pencil, I separate the darker configurations of folds and wrinkles from the areas that are to be left untouched (that is, the color of the brown paper). I'm careful from the beginning to establish the soft and crisp edges of the shadow pattern that I've already layed in. When the bags and their cast shadows are finished, I do the counter top in white Conté crayon, because this is to be the picture's lightest light. I apply more pressure, for greater contrast, and closer strokes in the areas adjoining the larger bag. If you work in a large scale, use charcoal sticks instead of pencils and substitute white pastel for the white Conté.*

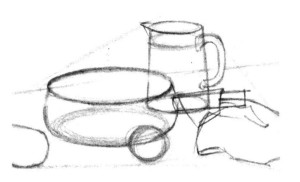

Shallow Bowl, Step 1: *I always begin the construction of the elements with line. It's at this stage that mistakes can be easily corrected. Here, some of the key proportions are: the proper ellipses—top and bottom—at this eye level, the height of the pitcher in relation to the pan, and the size of the onion compared to the potato. At first, I had only these four articles. However, they didn't come off right until my wife (who is also an artist) suggested that I wrap the dish towel around the handle. This gives me the necessary rhythm and movement the picture lacked, as well as a delightful contrast in textures. Cover the cloth with your hand and notice how dull the remaining elements become without it.*

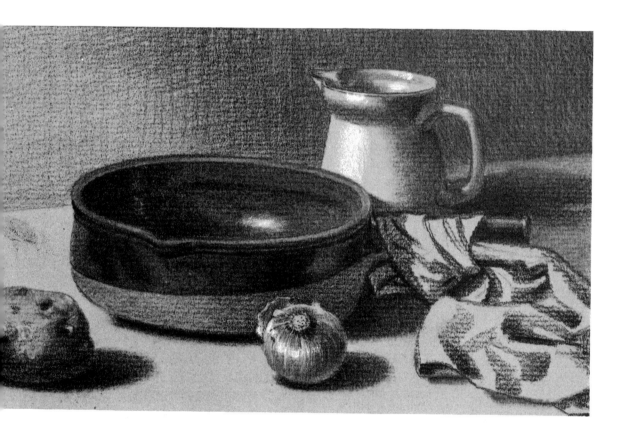

Shallow Bowl, Step 2: *Here, as in the preceding demonstration, I use the #2B and the #4B charcoal pencils. With the #2B, I first indicate the arrangement, the proportions, and the lighter grays. With the #4B, I create the darker grays and blacks. This time I use a cream-colored, charcoal drawing paper. I establish the lightest areas with the white Conté pencil. You can see these areas on the highlights of the pitcher, the pan, and the onion.*

Figure A. After the complexities of the preceding drawing, I'm sure you'll find this one child's play. Select two simple objects that you may have around and see that they complement each other in size and shape. It doesn't matter what they are as long as they aren't the same size. Find the most pleasing arrangement; trace or do a line drawing on dark gray charcoal paper as I've done here. I've rendered the shadows and cast shadows with #2B and #4B charcoal pencils. I've used a paper stump to smooth these passages and rendered the highlights with the white Conté, using the side of its point. This technique brings out the linear pattern of the paper itself, and introduces another texture as well.

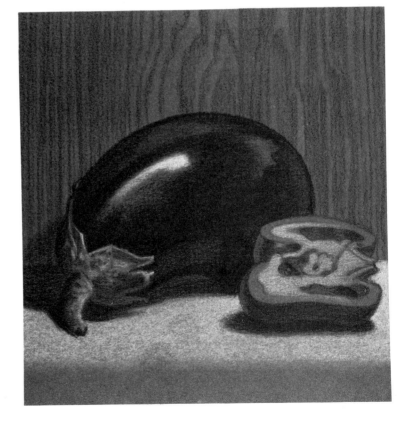

Figure B. One of the things you'll find interesting about drawing papers is that some of them have two different surfaces—smoother on one side than on the other. I've used the same (Strathmore) dark gray paper on this drawing of the eggplant as I did on the drawing of the two owls. However, for this drawing I've used the paper's reverse side which has a smoother surface, yet still has enough "tooth" to take the charcoal.

PROJECT 13
Still Life
in Charcoal

No matter what your still life may consist of, you must first draw the construction of its elements correctly. In this project you'll render a still life in charcoal. You'll be able to try it in other media as well in the projects to come. Before proceeding, I'd like to emphasize once more that any drawing begins with the careful delineation of the underlying structure of its objects.

I stress this point because I know many students begin by *finishing* a drawing (concentrating on detail) rather than laying down a solid foundation for it. Just as a builder doesn't worry about a roof until he has a framework to support it, an artist must establish the big shapes, proper proportions, and relationships before he can begin carefully adding detail to his drawing (Figures A, B). A true artist doesn't hang shading, local color, and textures on an ill-constructed drawing.

Four Drawing Principles

In drawing a still life, or any subject, there are four vitally important points to consider: the overall silhouette of the grouping, the tonal scheme (the balance of lights and darks), the textures, and the edges (Figure C). In Projects 10 and 11, I discussed the importance of establishing a well-balanced tonal scheme, rendering textures, and providing an overall, pleasing silhouette. In Figure D, I'll stress the value of these principles once more, while graphically illustrating each one.

But before I talk about actually rendering a still life in charcoal, I'd like to discuss edges and the role they play in a drawing.

Hard and Soft Edges

The edge of an object describes the character and texture of its entire surface. An edge is usually hard or soft, depending on its compositional makeup. For example, in Figure D, the edges of the bottle are hard but the edges of the bread, as well as the folded napkin, are soft.

Of course, you can alter edges a bit to suit your own artistic purposes. By sharpening up the edges of objects you can make them seem nearer, closer to the viewer. You can make objects recede into the background by giving them soft, smudgy edges. You must render your edges to suit both the character of the object and your own compositional requirements.

Working from "Roughs"

There are times when an artist approaches his drawing board with a clearly conceived image of the picture to be done. But these lucky flashes seldom occur—to me, at least. As a rule, the artist must develop and refine his drawing through many "rough" sketches, like those shown in Figure C. Since his concept of his drawing is tenuous, he must solve the problems of his picture through these visual "roughs." Often what appears perfect in his mind's eye needs modification when set down on paper.

Take a well-shaped bottle, a stemmed wine glass, a loaf of bread, a bread knife, and a napkin, as I've done for my still life (Figure C). Arrange them in as many variations as possible. Do at least a dozen of these rough sketches, concentrating on the big shapes and overall silhouette, rather than on finicky detail.

Charcoal is admirably suited to this kind of exploration, because it's so easy to manipulate. You can quickly darken and strengthen a good line or lift out a bad one with a kneaded eraser. The best way to work broadly (and

Figure C. The composition of a picture must be sought out in preliminary sketches. I'll describe my series of "roughs" individually and explain why six of them were discarded.

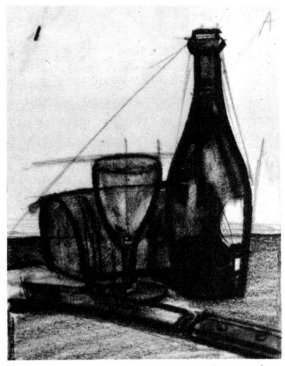

1. All of the elements here are vying for attention. The diagonal from the top of the bottle down to the bread is too insistent.

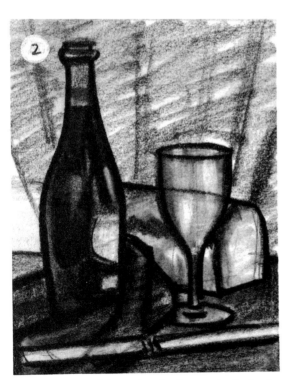

2. This has possibilities, but the drapery in the background, combined with the napkin, steals the show from the center of interest.

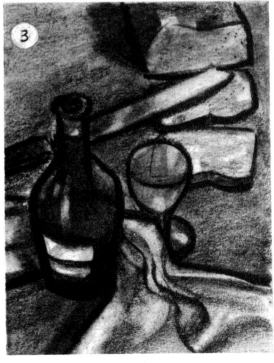

3. I like this as an arrangement of shapes but the bird's eye view seems too contrived.

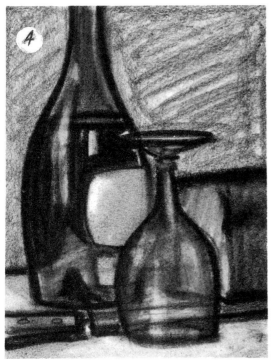

4. *I get too close on this one, and I don't like the negative suggestion of the inverted glass.*

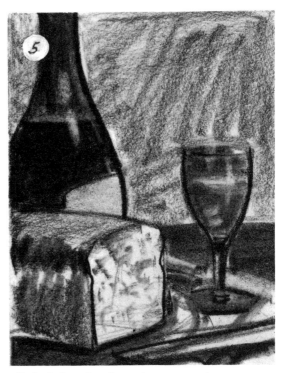

5. *Isolating the glass gives it undue importance. The loaf of bread and the bottle make the picture heavy on the left.*

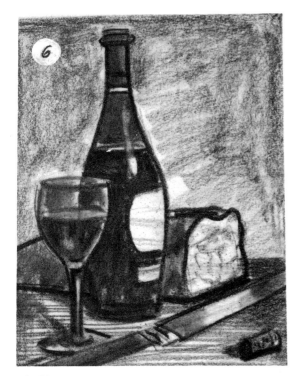

6. *This is a very bad arrangement. The three main elements are lined up, and the knife only serves to accentuate the monotony.*

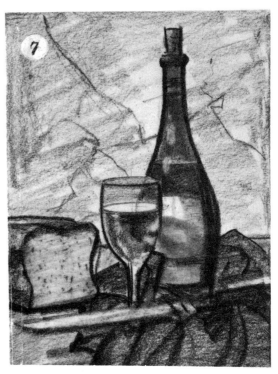

7. *This is it! I feel that with a few minor changes this composition will provide the foundation for a very nice drawing. See Figure E.*

STILL LIFE IN CHARCOAL 71

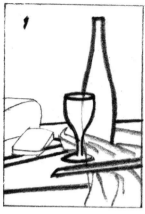

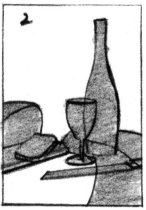

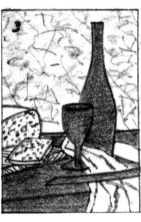

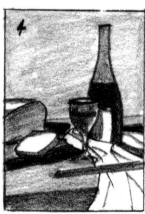

Figure D. By using these diagrams rather than a verbal description, I can better explain the function of the various elements in a good still life. (1) Here I've accentuated the hard edges (contours) of the bottle, the bread board, and the counter. Notice the juxtaposition of these edges and the soft edges of the bread and the still softer ones of the cloth. (2) Here I've silhouetted the objects in a flat tone. Note the silhouette of the objects as an integrated shape. The untoned shapes form an integral part of the drawing as well and are called negative shapes. (3) I've applied a flat gray tone to the elements of this still life. This tone points out the placement of smooth textures in relation to rough ones. (4) Here I've shown the distribution of tones. Notice how the white areas sweep across the darks in a countermovement. The gray tones support both these extreme values, providing visual balance.

avoid niggling detail) is to use a blunt charcoal pencil or a thick charcoal stick.

Composing a Still Life

You have noticed, I'm sure, that I took the last rough (view 7 in Figure C) as a basis for my still life. It doesn't necessarily follow that the last sketch is usually the best. There are times when the first rough is far superior to the ones that follow. But you owe it to yourself to explore all the possibilities of any subject.

In this particular case, although I liked the one chosen, I knew it had certain flaws that had to be corrected. Mainly, the objects were too "lined up", and the diagonal folds on the napkin weren't strong enough to counteract the alignment. In addition, the placement of the dark tones was "heavy" on the lower right corner. Mind you, these are things that you notice *after* the rough is set down in "black and white." I think this, more than anything I can say, proves that these first visual attempts are invaluable. As you do them yourself, you too will find that it would be rash to begin any drawing without their aid. See Figure E for my finished drawing which incorporates the solutions of the problems presented in the "rough."

Practice versus Theory

Up to this point I've emphasized the "why" of a procedure, because you must know the reason for following any prescribed sequence of action. It's important to know the fundamentals of drawing first, even if your rendering is awkward. Facility in handling charcoal, or any medium, comes to everyone through constant practice.

Eventually a particular drawing technique takes so little thought that if you asked an artist "how" he did a certain passage, he probably wouldn't remember. But if you asked him "why," he'd eagerly and most vociferously tell you. In fact, you might be sorry you asked! I'll continue to explain the "why's" as the need arises, but I'd like you to concentrate now on "how" to draw.

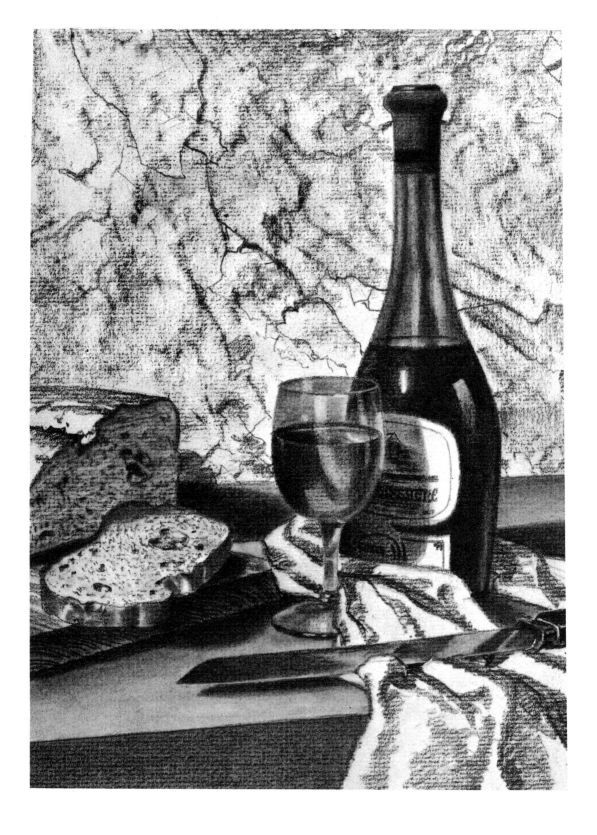

Figure E. *This drawing was done at night; the light is artificial, coming from the upper left. I applied the deepest tone to the bottle. The lightest tones are taken care of by the white Strathmore charcoal paper itself. Highlights are well shaped and lifted out with a kneaded eraser. Where I needed a sharp edge on a highlight, I used a white Conté pencil.*

Figure A. *In this seascape, done mainly with the side of a graphite pencil point, the light is coming from the upper left. This type of diagonal light, characteristic of mid-morning or afternoon, creates clearly defined cast shadows. This light and shadow pattern creates a solidity of form that's needed for rendering rocks.*

Figure B. *The angle of light is coming from the upper right on an angle that is indicative of late morning or afternoon. Notice that although the roadway is partly in shadow, the grading on the side of the road is still picking up the sun. Note also the presence of other drawing fundamentals such as the parallel lines of the roadway that merge as they recede to the horizon and the variety of textures that are present.*

Drawing Outdoors

All the principles of drawing that apply to still life hold true also for landscape drawing from nature. They apply to drawing the figure as well, as you'll see when we come back indoors. As a matter of fact, the drawing principles we've been discussing from the very beginning apply to *everything* you draw.

Natural Light

One of the fundamental differences between drawing indoors and outdoors is the difference in light. Light outdoors plays a vital part in landscape drawing. After searching for the best angle of artificial light on a still life, it was you who made the decision about the light's direction, its distance, and even its intensity. Now you're going to work outside with whatever natural light is available. You cannot change its distance or intensity.

Light at Different Times of Day

However, you won't be in a completely helpless position. You can still select the angle of light you may prefer. In the morning there's horizontal light which creates long cast shadows that can unify a composition better than most other devices (Figure A). The diagonal light of mid-morning imparts solidity to the elements of a landscape, and the cast shadows it creates clearly define the ground plane. With the overhead light of high noon, cast shadows almost disappear. There are diagonal angles of light in the afternoon (Figure B) until once more the horizontal light of the setting sun is reached.

Observing the Effects of Light

When you find a motif that you think has the makings of a picture, study it at different times of the day. Make rough sketches just to see which angle of light gives you the most interesting or descriptive shadow pattern.

Observe the cast shadows of elements in nature—trees, rocks, etc. (Figure C). Remember a cast shadow is sharpest and darkest at its source. Study the crisp edges of a cast shadow as it leaves the base of a tree, for instance, and how the shadow's edges become softer and its value becomes lighter as the cast shadow travels away from its source. Note that the shadow on the trunk of the tree isn't a flat, even tone, because light, reflected from the ground, is bouncing back into it. Remember to give this luminosity to your shadows; if you render them in a flat, even tone this luminosity is lost and your shadows will look lifeless and dull.

Reflected Light

Reflected light occurs outdoors just as it did in your still lifes. The difference is that you can control the intensity of reflected lights indoors by changing the value of the surface off which they bounce—from a white piece of paper, through several grays, to black.

Outdoors you must abide by the tone of the ground reflecting the light. Its color depends to a great extent on the seasons, from the white of snow which has the greatest reflective power, to bare ground, or green grass.

Searching for Basic Forms

You started by drawing boxes, canned goods, and bottles because these were things I knew you had within reach and could observe and analyze anywhere in your room. Now we're going out to study the form, shape, and texture of trees, houses, boats, etc. (Figures D and E).

Figure C. *For this sketch I use the side of the pencil (at the right) to achieve the crisp, broad planes of the rocks. Rocks are generally lighter in tone on top, regardless of the angle of light, because they face up toward the sky—the source of light. Their sides are generally darker in tone except when the angle of light is extremely horizontal—as in early morning or late evening. Then one side is illuminated while the opposite side is in darkness.*

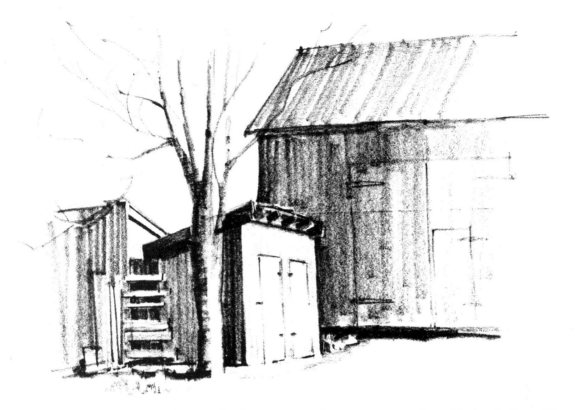

Figure D. *It's primarily the shapes present that prompt me to draw this sketch. From this viewpoint the elements have the most interesting variety of lights and darks. Notice that the cylindrical tree introduces variety to what would otherwise have been a rather monotonous arrangement of cubic forms.*

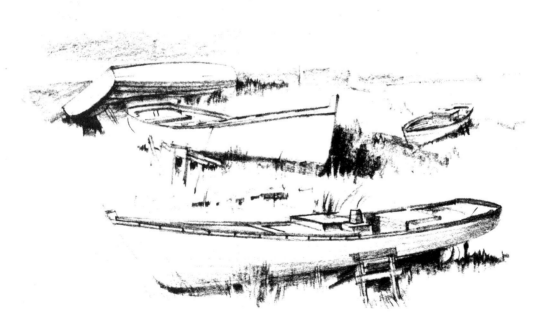

Figure E. *As the water rat said in* Wind in the Willows: *"There's nothing so marvelous as messing about with boats." When I came upon these, arranged so beautifully and gleaming white against the grass, I just had to draw them. Notice, especially, the wonderful counterpoint of the curves of one boat against another.*

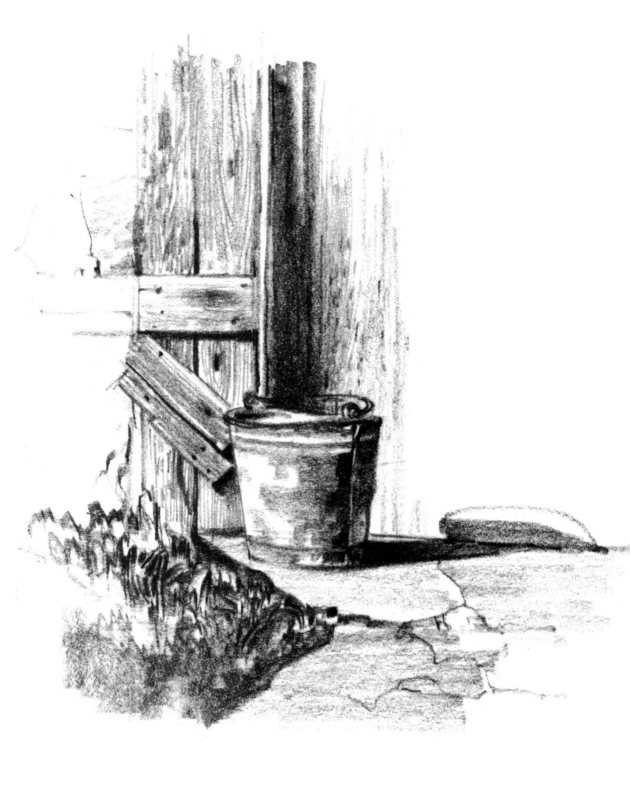

Figure F. *I've done this sketch because of the contrast of textures present. The juxtaposition of the wood grain, as well as the stubbly grass, to the smooth metal bucket is especially pleasing.*

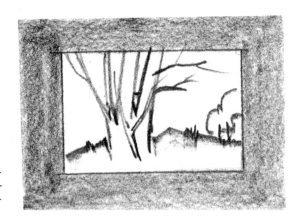

Figure G. *If you have difficulty in finding a subject, make a viewfinder by cutting an opening, or "window," about 3" × 5" in an 8" × 10" piece of cardboard. This is an old trick to simplify nature's profusion. Try it.*

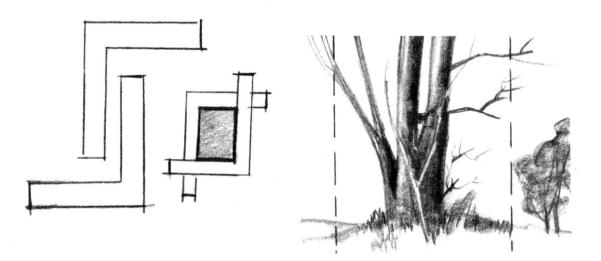

Figure H. *Back in the studio, you may find that you've included too much in your sketch. If so, cut two L-shaped pieces of cardboard as shown and try placing them over sections of the drawing that you think would make better compositions by themselves.*

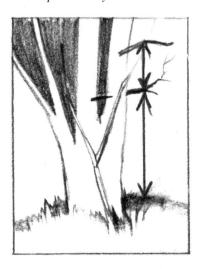

Figure I. *As you work, remember to look beyond the positive shapes of your subject to the negative shapes (shown here by gray tone).*

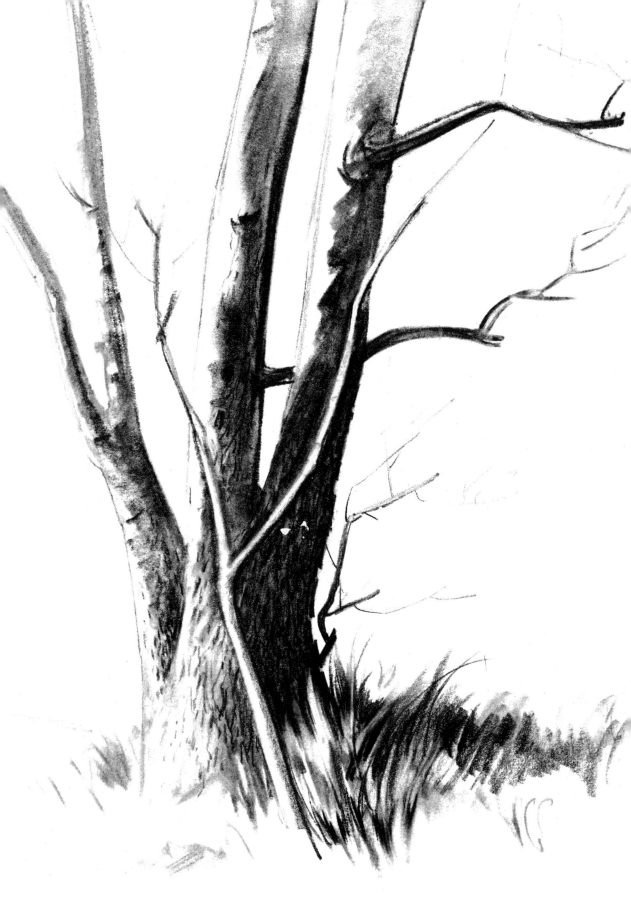

You mustn't forget that these, too, are subject to the same laws of drawing. A house is cubic, no matter how complex; a tree is an arrangement of cylinders; a hill is usually half a sphere—modified greatly sometimes, but still based on the sphere.

When you draw nature and outdoor objects be aware of the eye level and the quality of light and shadow. Consider also the textures (Figure F) and negative versus positive shapes. Put into practice these and all the other drawing principles we've explored.

Using a Viewfinder

Confronted by the seeming confusion of nature's ever-changing forms, the student may find it difficult to isolate a suitable subject for his drawing. A *viewfinder* is a useful device that you can make yourself which mechanically cuts down this confusion.

There are two types. One you can make by cutting a 3″ X 5″ opening in an 8″ X 10″ piece of cardboard (Figure G). A more flexible type can be fashioned from two L-shaped strips of cardboard held together by paper clips to form a square opening (Figure H). The paper clips allow you to adjust the size of your viewing area.

By holding the viewfinder before your eye, either type will block out distracting elements and allow you to focus on an object or simple group of objects. It will "frame" possible subject matter for you, creating a "picture" from amid the confusion.

Drawing on the Spot

Enough talk. Let's go outdoors now and breathe some fresh air. I've just picked up my Ad Art pad and sharpened six "office" pencils and jumped in the car. I haven't the remotest idea what I'm going to sketch, but I do promise to show you my sketches (Figures A through F) exactly as they turn out.

The countryside where you live has all the material that you'll ever need to put into practice the principles of drawing that you've already learned. If my outdoor sketches have a different look than yours, it's only because they reflect the character and atmosphere of what I see and respond to around me. Whatever subjects I find probably won't resemble yours, but I'll describe the qualities that attracted me to them. On your first excursion, take only the #307 Ad Art pad and six ordinary pencils; remember the fewer materials you encumber yourself with outdoors, the better.

Figure J. I've left the top of this drawing untextured so you can see the basic cylindrical shapes of the tree trunks. The rendering of these cylindrical forms precedes the execution of the tree's bark. The tree's tone is produced by the side of a charcoal pencil which I rub with my finger; the bark is done with the pencil's point. I've discarded the other trees that surround it, because the single tree makes the drawing more forceful.

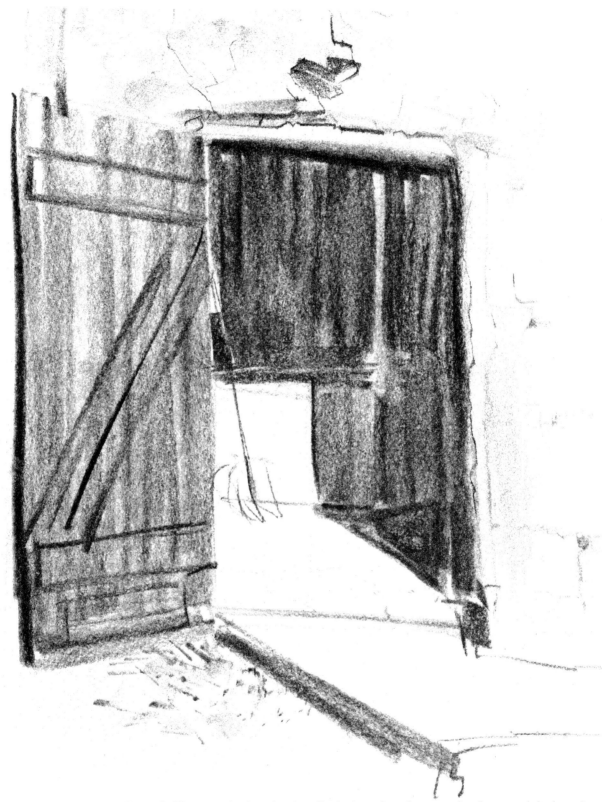

Figure A. *The attraction here is primarily the interplay of rectangular shapes and the beautiful cracking plaster on the wall. Charcoal is ideal for putting down quick impressions like this. In no time at all with the side of a piece of charcoal, you can indicate big shapes in the broadest terms. With the point of a charcoal stick, you can record just enough detail to create certain textures or interesting elements.*

Drawing Outdoors with Charcoal

Just as we took a pad and some office pencils out on our first sketching trip, let's now take the same pad and some medium grade charcoal pencils, a kneaded eraser, a rag, and a can of fixative. Charcoal is well suited to drawing outdoors. It's pliable and versatile, producing a wide range of tones and effects—from delicate to bold.

Advantages and Disadvantages of Charcoal

Charcoal's ease of manipulation and simplicity in handling (no brushes, water, or other mediums are needed) are clearly advantageous when drawing outdoors. The only drawback resides in charcoal's pliability.

Because a charcoal drawing can be changed at the slightest touch, you must be careful when handling your finished drawing. Indeed, because a charcoal sketch is so easily disturbed, you should spray it with fixative the moment it's finished.

Capturing the Moods of Nature

Because nature's forms are endlessly changing, the artist working outdoors must be prepared to quickly note her fleeting moods. Charcoal provides the speed necessary for such rendering. For example, you can quickly jot down the most fleeting aspects of light and cloud formations. You can quickly spread charcoal over a large area to produce a tone. The charcoal can be lightened by rubbing the tone with your fingers or a chamois, or you can easily eliminate it altogether.

Rendering Specific Objects

Outdoors in nature, just as indoors with man-made objects, the simple, underlying geometric forms must be sought out first. Charcoal's ease of manipulation lets you quickly indicate the large shapes; then you can go on to judge the proportions and inter-relationships of these larger shapes to other, smaller ones. Once you've captured your tree or rock in the broadest terms, you can work down toward the smaller shapes and the intricate details (Figure A).

There's one danger to watch for when rendering the large shapes of a particular subject, such as a rock (Figure B). Because you're so engrossed in establishing correct proportions, you may forget about placement or composition. The result might be a monotonous arrangement as in view 1 of Figure B. However, the compositional problem is easily solved (view 2 of Figure B).

Rough Charcoal Sketches

I've done the rough charcoal sketches of Figures C and D to emphasize charcoal's particular suitability for capturing the quick impression of nature. I also want to point out that most drawing on the spot (outdoors) produces these charcoal "roughs" or *sketches* rather than *studies*. In the latter, you try to *study* the character and detail of a subject. In the charcoal rough or sketch, you're trying to capture only the fleeting impression of the moment.

Finished Drawings in Charcoal

In your rough sketch you establish the basic proportions and relationships of the elements in your landscape. The rough should be executed quickly in a simple, flat outline of the basic forms. Only minor attention should be given to rendering the particular tones or textures. They should merely be hinted at.

When you're happy with this first impression, you can then concentrate on the edges of shadows, gradation of tonal values, and specific textures. As you work on your finished drawing or *study,* you can erase your sketch's first broad, contour lines. I prefer to slip my charcoal rough, or outline, under another sheet of paper on my Ad Art pad, and then begin the final rendering. (See the demonstrations at the end of the project.)

Figure B. When I did this sketch I became completely absorbed in rendering the scene before me exactly as it was. But when I returned to the studio I noticed the monotony of the rock's contour. Since the drawing was already "fixed," I slipped it under another sheet from my Ad Art pad, traced it, and replaced its rock with the one you see in view 2. Notice that slant A of the new rock provides the needed counterthrust to diagonal B of the tree-trunk.

Figure C. *All I've done to change the original scene is enlarge the shape at the right to balance the composition a bit better.*

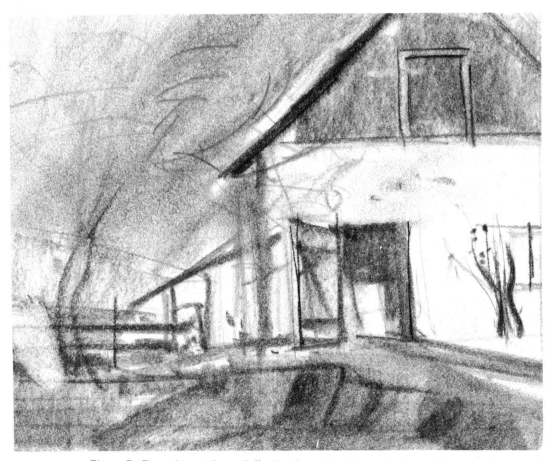

Figure D. *Everything is beautifully distributed in this rough charcoal sketch: the tones, the textures, and the linear thrusts.*

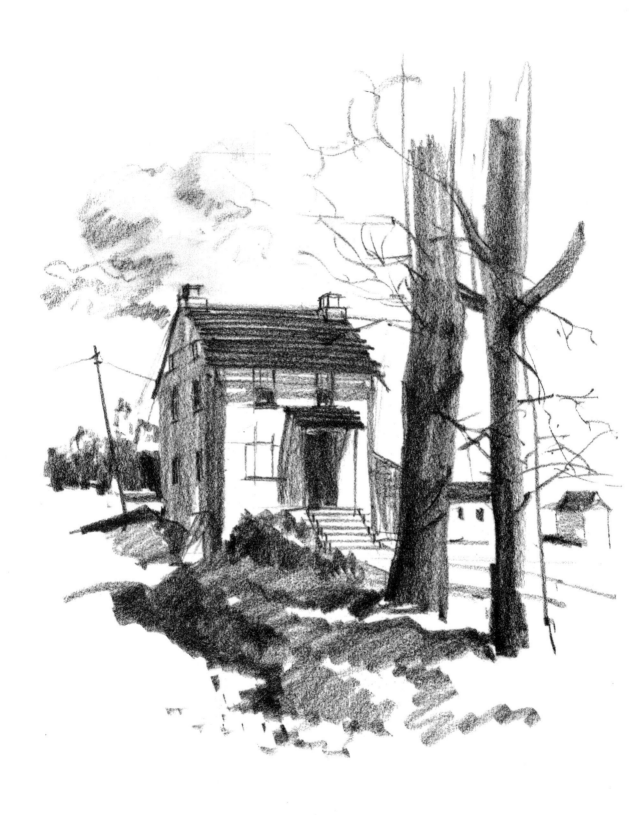

Figure E. *Here's another rough sketch done in charcoal pencil. If I was going to do a finished drawing of this scene, I would do the trees a bit smaller, so that they wouldn't compete with the center of interest—the house. I'd also make them a bit more slender.*

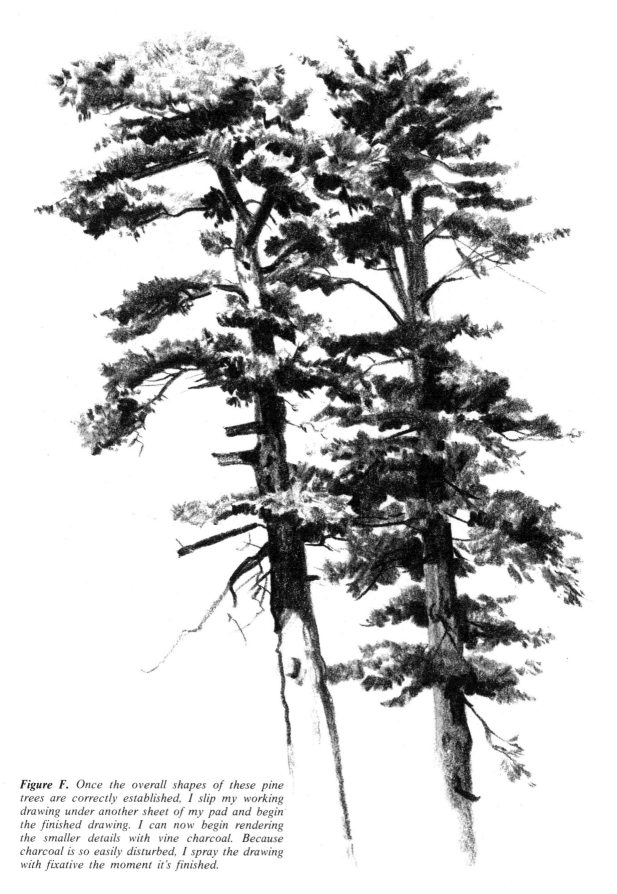

Figure F. *Once the overall shapes of these pine trees are correctly established, I slip my working drawing under another sheet of my pad and begin the finished drawing. I can now begin rendering the smaller details with vine charcoal. Because charcoal is so easily disturbed, I spray the drawing with fixative the moment it's finished.*

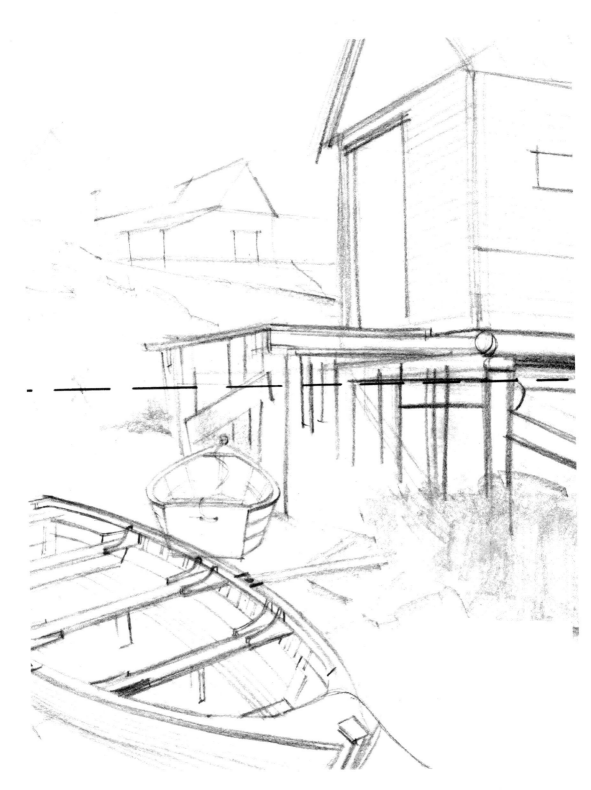

Boathouse, Step 1: *I've promised to show you everything that I've done on my sketching trip whether it's turned out well or not. Here's one sketch that doesn't work. I started with great enthusiasm because the shapes and textures were so exciting. I quickly blocked in the line arrangement you see here, and then it happened! I noticed there were too many things; the background and the boats were competing for attention. I suppose I could save this one by concentrating on the boats only, or just showing the distant horizon with the dock up front, as indicated by the broken line. But sometimes a drawing just doesn't come off.*

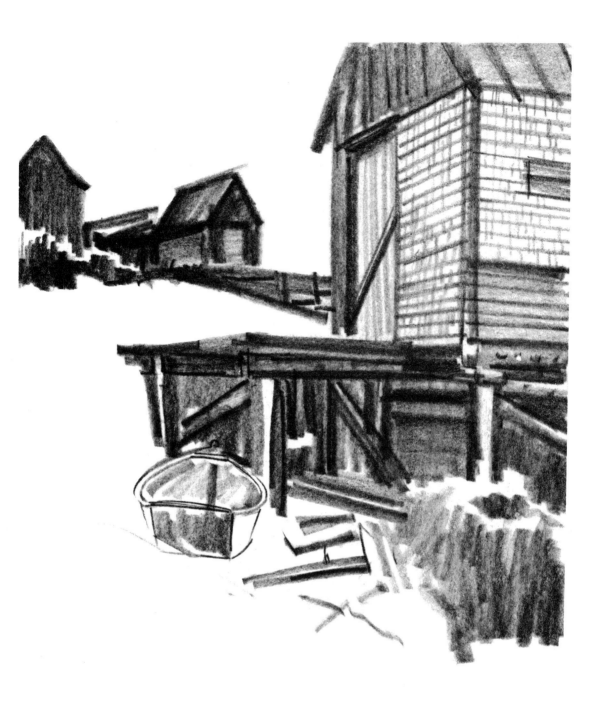

Boathouse, Step 2: *Reluctant to give up on this drawing, I slip the line sketch under another sheet of paper and start applying tone. I only get as far as what you see here, because my tones come out flat. Still, the color and textures of the scene before me are so beautiful! Everything is pearly, iridescent, and crying out to be* painted! *That's the key word,* painted, *not drawn. The first thing you should ask yourself is: what is it about the spot that attracts me in the first place? If it's color, and you're equipped with only charcoal, forget it. Make a notation to come back to the spot later with your paints.*

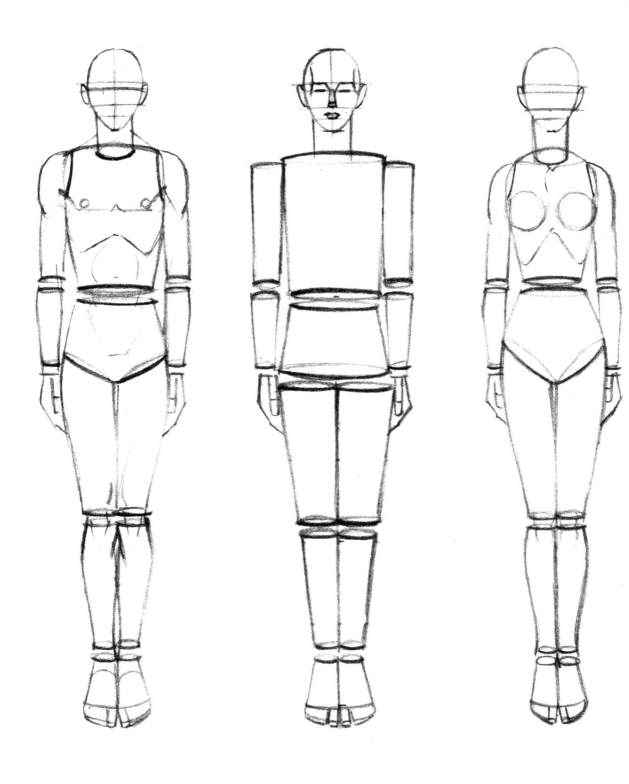

Figure A. *I want you to consider and apply the principle of cylindrical construction as you draw the human body. You can begin by indicating the geometric cylinder first. This should only be a preliminary step. As you articulate the actual human contours, you'll be conscious of all three dimensions in the forms before you. Later you can dispense with the geometric cylinder altogether and begin with the actual contours of the figure.*

PROJECT 16

Drawing the Figure

Up to this point you've been learning to observe and draw proportions of everything you see. Establishing proportions is also a vital consideration when drawing the figure. You must constantly check one part of the body against another in order to draw a faithful reproduction of the human form.

Basic Body Proportions

I've no idea who first advanced the notion that a figure has a height based on the length of eight heads. But we'll use this measurement as a *basic foundation* for the real figures we're going to draw. However, this measurement is only a point of departure.

The diagrams in Figure A (male on the left, cylindrical form in the center, female on the right) are only "ideal" figures, to be used as yardsticks against which to measure the real figures you'll be drawing from. As you draw from life, you must be aware of how the figure before you differs, and by what degree, from these "ideal" proportions.

Cylindrical Human Form

I've done the central shape in Figure A to show you that the human figure also has an underlying geometric form—the cylinder. By drawing a human body in cylindrical form, you become aware not only of the body's contours, but its dimensions as well. The body, like the cylinder, is a three-dimensional object. Even when drawing solely in line, you must convey the body's weight and bulk.

To fully experience this fact, I want you to grip your arm, your leg, and run your hand around your rib cage. When you draw, remember to both feel and convey this volume and weight that you've just experienced. A good way to achieve volume and weight in your figures is by searching out and drawing cylindrical shapes.

Some Body Measurements

Learn to construct the basic cylindrical figure by beginning with the rib cage; remember that it includes the neck. The rib cage is fundamentally a cylinder with its contours modified to approximate the human shape. The rib cage is about two heads high, when viewed in an upright position.

The pelvis section is about one head high. The arms extend half a head below the crotch; the lower leg, including the feet, is two heads in length. Of course, all these proportions are relative. They apply only when the body is viewed straight on. When parts of the body recede from the viewer or come forward, there are additional considerations.

Foreshortening

Just as an object *appears* to diminish in size as it moves farther away from the viewer, so do parts of the body. In other words, the body has perspective, just as objects and landscapes do. When this phenomenon, *perspective,* is applied to the body, it's called *foreshortening.*

I think that it's a very descriptive word, because whether an arm or leg "goes back" or "comes forward" it *appears* to be *shorter* than its actual dimensions.

In Figure B you see the bulk of the body and what happens to the body's cylindrical forms when they're foreshortened. Copy this figure. Notice how the torso "breaks" at the waist when the figure bends from side to side or back and forth. Notice also how the hands and feet relate in size to the length of the head.

When I learned to construct the basic

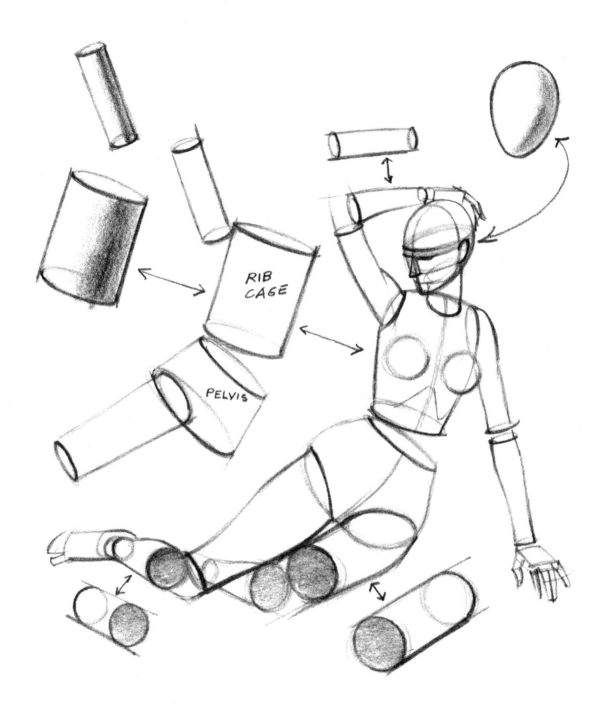

Figure B. *(Above) Here I've constructed a female figure with its basic cylindrical components drawn separately. Their relative positions within the whole figure are indicated with arrows. Besides the cylinder, notice that the sphere plays a part in the shape of the breasts. The sphere that forms the head is modified into an egg shape. Remember the cylindrical figure is only a means to an end—drawing a correctly proportioned human figure.*

Figure C. *(Right) Try to spend at least fifteen minutes every day drawing the basic cylindrical figure in every position and from every angle. As with the other fundamentals of drawing, "practice" is the key to facility of execution.*

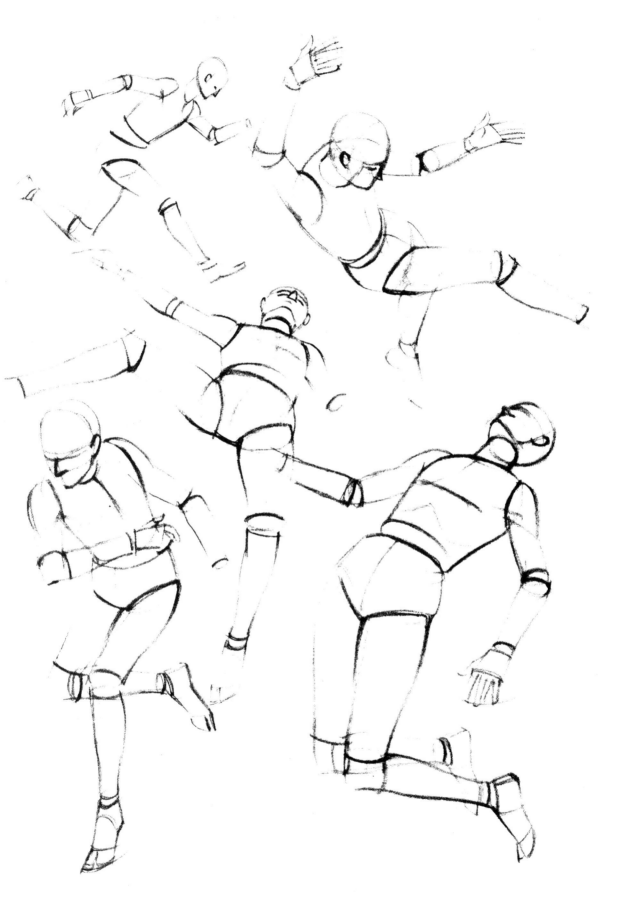

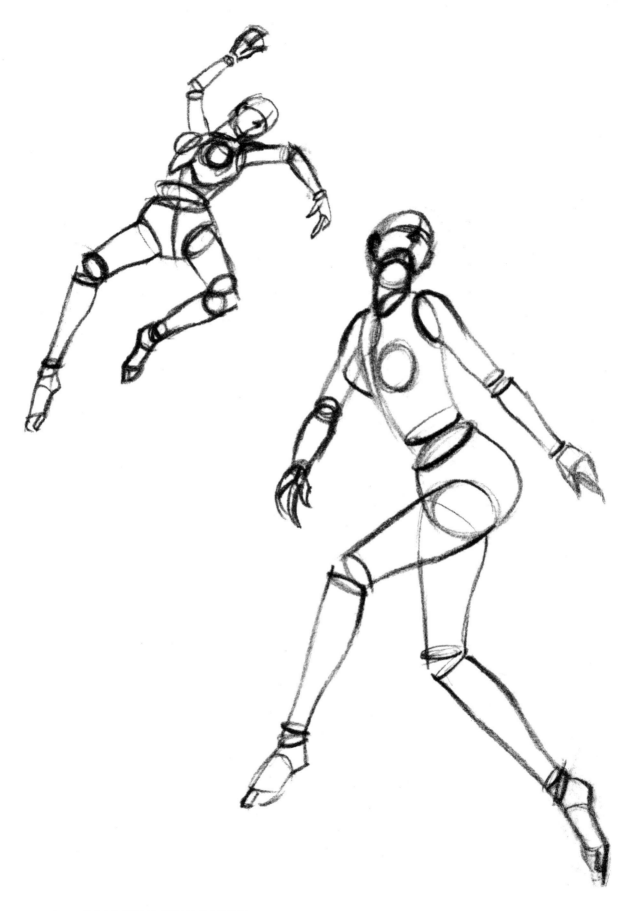

figure, my joy knew no bounds. I could sit down anywhere and draw it in any position I wished, no matter how complicated the pose. I did hundreds upon hundreds of figures— dancing, jumping, running, pitching a ball, etc. (Figure C).

Drawing from Life

Even if you can't afford your own live model, most fairly large towns have some type of life drawing class where a live model is present. If you're working with your own model, pose him (or her) in a relaxed position that won't be a strain. Even so, about every fifteen minutes, ask your model if he would like to rest. He'll think you most considerate and put his best foot forward—no pun intended.

Follow the same drawing procedure that you've used for rendering other subjects. Look for the relationship of one part to another and block in the large forms. Make a mark for the top of the head and another for the feet; then you can easily judge where the torso belongs and what its length, angle, and girth should be. From here you can go on to the placement of the limbs. The length of the legs, already determined by the mark made for the feet that you indicated earlier, shouldn't be much of a problem. Then check the angle and the length of the arms and whatever foreshortening they may have. (See the demonstrations at the end of the project.)

Working Over the Whole Figure

Concentrate on correct relationships and proportions of individual parts of the body. As you begin blocking in your figure, be sure that there's enough room to do it *entirely*. There's nothing more distressing than to see a student absorbed on a torso of a figure, finishing it to the minutest detail, and then discovering that there's no space left for the figure's legs.

Always work on the *entire* drawing, no matter what the subject. If you were to stop five minutes after beginning, your drawing should be *unfinished* but not incomplete.

Light and Shadow on the Figure

Place your model in a light that will bring out the solidity of the body forms. Even if you decide to do only a line drawing in the beginning, your figure must convey the illusion of the volume, of three dimensions.

The play of light on the human figure creates the patterns of light and dark that can convey its solidity and dimensions. When you feel confident about basic proportions, then add shading. Render the shadow areas of your figure in pencil or charcoal (the most suitable media at this stage). You can use the stump on the tone of these shadow areas to further enhance their smoothness. The kneaded eraser is good for lifting out highlights and emphasizing contours.

Figure D. Eventually, you can dispense with the basic cylindrical figure, provided you remain constantly aware of the volume and weight of the body's components.

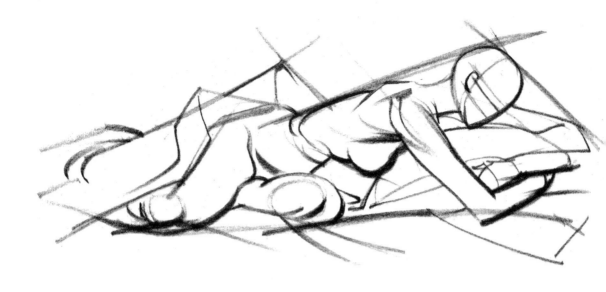

Reclining Nude, Step 1: I begin by trying to capture in block form the graceful rhythms of my model's body. I work carefully on proportions and in achieving a sense of dimension. Notice the foreshortened leg bent underneath her. I also consider composition as I work. I break up the almost straight line of her back by introducing some folded, curved drapery behind her.

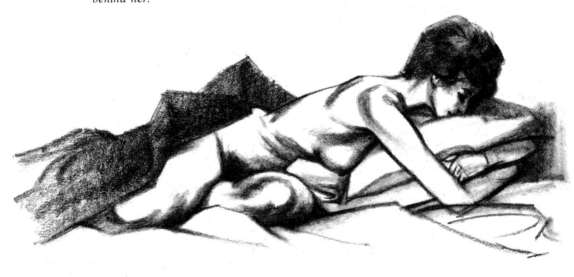

Reclining Nude, Step 2: Here I consider the tonal scheme. The positioning of the lights and darks helps to give her body volume. Also, the shading on her bent leg emphasizes the fore-shortening. I use a regular office pencil in the first step, and add shadows here.

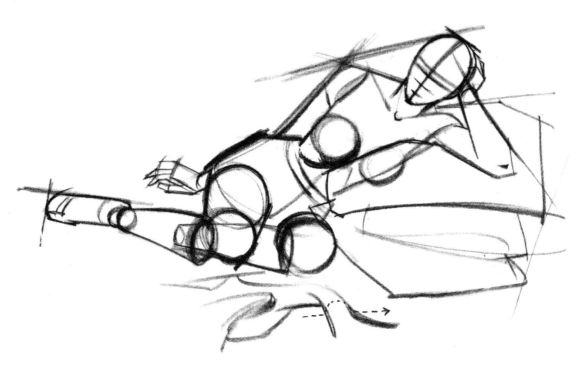

Seated Nude, Step 1: *Here I use my Ad Art pad and a charcoal pencil. I first block in the large forms and proportions of the model's figure. I use cylindrical construction to clarify the proportion and direction of her body's individual forms. Note that her left leg is directed almost squarely at you.*

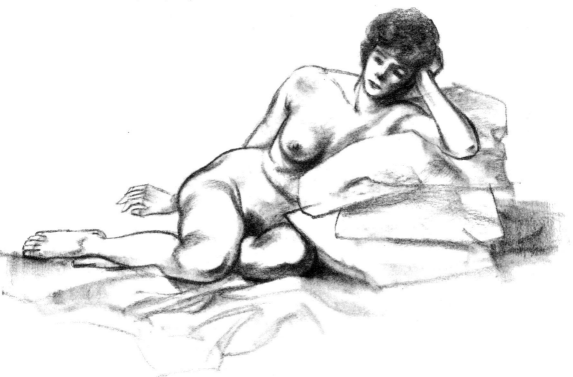

Seated Nude, Step 2: *As you render lights and shadows, as I've done here, imagine that you can touch the resiliency, or the firmness, of the body's surface. Note the sharp delineation of my model's clavicle and knees. In these areas the bones come close to the skin's surface. There are softer transitions on her breast and thighs.*

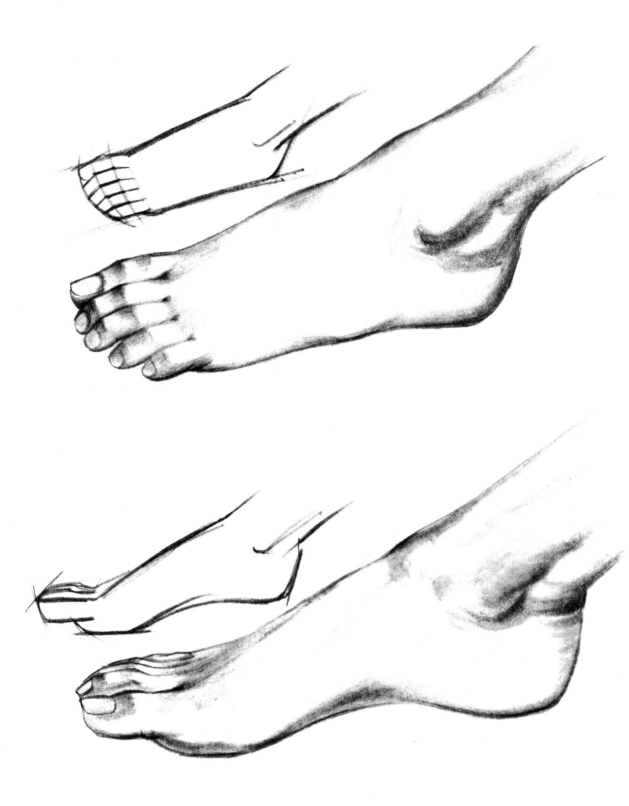

Figure A. *The best approach in drawing hands and feet is to consider them as separate entities. Concentrate on them, forgetting the rest of the body for the time being. Begin drawing a foot with a simple outline of its overall shape. Then, make the necessary subdivisions between the heel and the top of the toes. Ask yourself such questions as these: How long are the toes in relation to the entire foot? Where is the ankle bone in relation to the heel?*

Drawing Hands and Feet

I've noticed over the years that the students tend to disregard (or completely ignore) feet and hands. They'll do an adequate job on legs and arms, but by the time they reach the extremities their enthusiasm has waned and their vision is spent. Here I'd like you to reverse this trend and concentrate on drawing nothing but hands and feet at every chance you get for at least a month. They aren't any more difficult to draw than a coffee pot; they're more complex, yes, but that only means more practice, not a greater demand on your artistic resources.

Drawing Feet

I wish I could give you specific diagrams for dealing with feet and hands, but since the basic forms involved here are so varied (changing with each person), it wouldn't be practical. Simply begin by establishing the foot's overall shape first—as with any other object. Then, start the subdivisions. Always keep an eye on the large masses of the bones and the tendons. Begin your own drawings in line, then develop the contours and model the forms (Figure A). If no one can pose for you, then draw your own feet and your left (or right) hand in as many positions as possible.

When you're finished establishing the correct proportions, place your drawing under another sheet of paper and begin its refinement. Pay attention to the sharp and soft contours of the feet, depending on how close the bones are to the skin's surface. These passages can be differentiated by using different tonal values. Discover where the foot's contour *dips* and where it *rises* on the straight line that you have set down in your original line drawing. You can apply the very same approach to the drawing of hands.

Drawing Hands

I'll ask you again to feel your fingers, your wrist, and your arm. The volume and weight that you "feel" I'd also like you to experience as you observe your model. Begin drawing the contour of the hand in line without modeling. Just concentrate on pinning down the correct relationships; be aware that hands (and feet) occupy a certain space.

The fingers are basically cylindrical; the hand and wrist are cubic and the beginning of the arm is also cylindrical (Figure B). I've used these basic shapes to make you aware of their volume, not just to inculcate their basic construction. If you wish, you can just as easily visualize the fingers as cubic and the wrist as cylindrical, as long as you convey their three-dimensional character. I can't help stressing this point, because many students tend to flatten everything they draw.

When you begin the rendering of details be sure to indicate the joints, knuckles, and any other places where the bone comes close to the skin's surface. The knuckles of the hand are about halfway between the tips of the fingers and the end of the back of the hand.

Finding Your Niche

The demonstrations and figures in this project are really just to get you started. The principles I've pointed out are only part of the discoveries you'll make for yourself. I've no way of knowing if life drawing appeals to you. Perhaps landscape is your cup of tea, or maybe you plan to specialize in still life. Or do you rejoice in drawing anything under the sun? Whatever your inclination, I urge you to do every project in this book. It will be fine training, no matter what area you'll eventually "specialize" in.

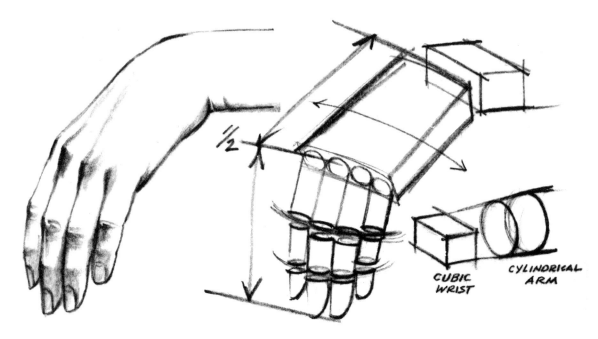

CUBIC WRIST

CYLINDRICAL ARM

Figure B. Blocking in the main forms of the hand, or any object, is the beginning and the foundation of realistic drawing. These simple "maps" or line drawings help you determine the length, width, thickness, and correct relationships of one part of the hand to another. Slip these preliminary indications under a fresh sheet of paper and begin your realistic drawing. At this stage you can look for the subtleties of contour and the refinements of detail, because the problems of correct proportions have already been solved. I've used an ordinary office pencil for all the drawings in this project.

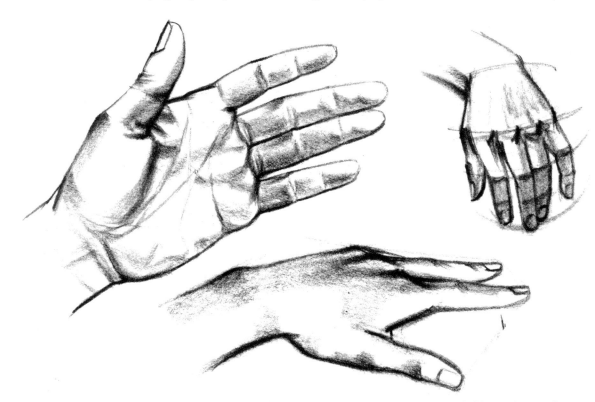

Figure C. To practice drawing hands and feet for thirty days sounds like an imposed sentence but, believe me, it's not. If there aren't any models available when you need them, then draw your own left (or right) hand in every position you can manage.

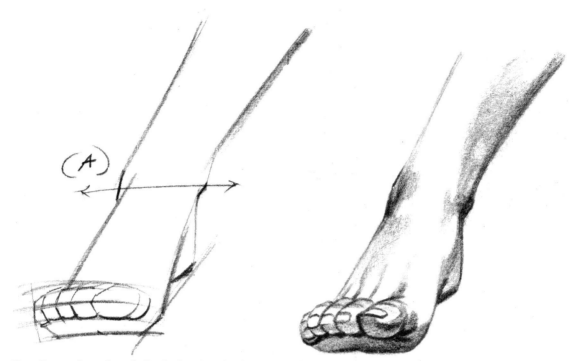

Foot Proportions, Step 1: *Begin drawing the foot by blocking in the large shapes first. Feel your ankle right now and you'll discover that the inner ankle is higher (A) than the outer one.*

Foot Proportions, Step 2: *To create a more finished rendering, you can slip your line drawing under a fresh sheet of paper and then concentrate on the detail, as I've done here.*

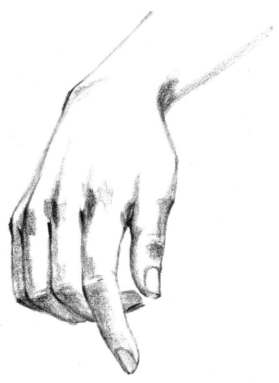

Hand Proportions, Step 1: *I begin my drawing of the hand by establishing the big shapes and correct proportions of its component parts. Notice that the back of the hand is usually curved (B) unless it's pressed down upon a plane; then it's flat.*

Hand Proportions, Step 2: *In the more finished drawing, I concentrate on the shadow patterns. I pay particular attention to those parts where bones come close to the skin's surface: the wrist and knuckles.*

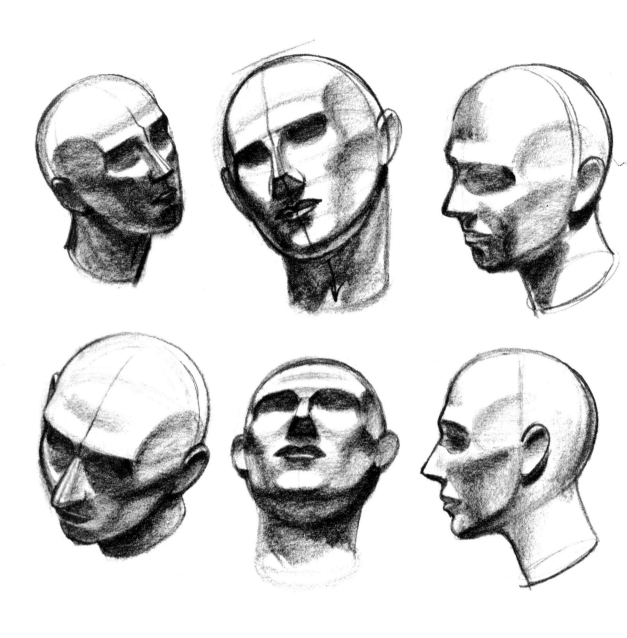

Figure A. Never lose sight of the head's framework with its simple planes, ridges, and depressions. It provides a foundation which you can modify later to suit the particular characteristics of the individual you are drawing.

Drawing Heads and Faces

Drawing the head can be perpetually fascinating. Wherever you may be—at home or at work—there'll be someone for you to study. You don't actually have to draw these people, but *observe* them. Try to remember the arrangement of the planes of their heads, the relationship of the features, the construction of the eyes, the nose, the mouth, and the angle of the neck. These are all valuable points to recall before you're ready to pick up the pencil and begin drawing. Of course, while you're *observing,* you're already drawing, even though you haven't made a mark on the paper. It would be even better yet to carry a small sketch pad in your pocket or purse and actually draw these people while you watch them. Try for a total impression rather than a perfect likeness.

A General Procedure

You can't draw a head properly, even in line, if you're not acquainted with its slopes, protuberances, and cavities (Figure A). Feel the slope of your forehead, the cavity of your eyes, and the ridge of your nose. As you draw the head and facial features, feel how they "come out", "go in", or turn onto a flat plane. Also notice how the features and the entire head itself change in shape depending on the angle from which they're viewed.

There's a simple four-step procedure for drawing the head which I'll state briefly here and explain in detail further along in this project.

Begin by drawing the basic egg shape of the head. Then, draw the guidelines to help you position the facial features. Next, render the individual features. Finally, sketch in the large hair mass. Once these four steps are done, then you can return to the rendering of minute detail.

Angles and Planes of the Head

As you draw the egg-shaped head, notice whether you're looking at it from below or from above, and to what degree the head is slanted. Notice what happens to the straight lines on the head in the upper left corner of Figure B. They now curve up because you're looking at the head from below. Since the head is also tilted, its center line (A) is also at a slant.

Study how the guidelines follow the particular angle and viewpoint of the heads in Figure B. These male and female heads were done to show you that the head's planes are the same on both sexes, but softened on the female. Let me point out that these drawings are only diagrams to serve as points of reference. They *aren't* drawings of live people.

Facial Guidelines

When you begin to draw the head and face, don't immediately try for a likeness. Block in as quickly as possible the basic egg shape (Figure C). Now draw the "egg" head at a 45° angle (Figure D, left.) Halfway between the top and bottom of the egg, draw a line for the placement of the eyes. Draw another line halfway between the eyebrow and the chin; this is the position for the base of the nose. Halfway between the base of the nose and the chin is the edge of the lower lip.

In Figure D, I drew the side view of the face or *profile*. The "half" measurements that apply to the profile view also apply when the face is viewed straight on (Figure E). The only additional consideration is the placement of a line down the center of the oval, bisecting the face. This line will help you to align the facial features vertically and create the symmetry of the face.

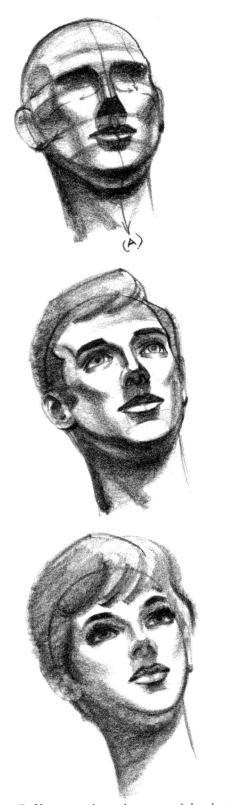

Male and Female Features

The proportions just mentioned apply to both the male and female head. Male features tend to be a bit more angular while female features are characterized by a softer contour. However, their placement within the face and their relative proportions are the same (Figures F and G).

The placement of the features, as you see them in profile and front view, are indicated by straight lines. However, the moment you slant and tilt the head these straight lines *curve*, because they follow the contour of the egg shape of the head.

Drawing the Head and Face from Life

Before we proceed too much further, let me say that the measurements and proportions that I give you are relative. They're only guidelines. When you draw an actual person (when you draw from life) his particular head structure and features will depart from these "ideal" dimensions. That's why you shouldn't adhere slavishly to these "rules". Simply train your eye and hand to observe and render faces and features in terms of how they differ from these ideal dimensions (Figure H).

Drawing the Nose

Just as you can now easily visualize the entire head as an egg with definite divisions for the placement of features, I should like you to know just as well the construction of each feature itself: the eye, the nose, the mouth, and the ears.

The nose rises cubically in four distinct planes: the top ridge, two side planes, and the base (Figure I). Notice how the realistic nose (right) conforms to this simple basic construction of the blocked-in shape (left).

Light plays an important part in delineating the basic contours of the nose. Note that the top, flat ridge in Figure I is receiving most of the light, while the sloping sides are in shadow.

Drawing Ears

The divisions to check concerning the ear are in thirds. The center third of the ear is occupied by the "bowl". Match the divisions of

Figure B. You must always be aware of the slant of the head. Whether you're doing a front or three-quarter view, the first line to indicate on the head's egg shape is the center guideline (A). Then, you should place your horizontal guidelines at right angles to it, no matter how the head tilts.

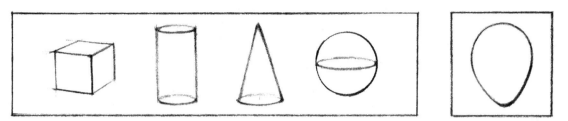

Figure C. The basic forms here are so familiar that they need no comment. The new basic form I'd like to introduce as the basis for drawing the head is the egg shape at the right. Take a real egg from the refrigerator and hold it in your hand. Feel its volume and weight! Remember this when you begin drawing.

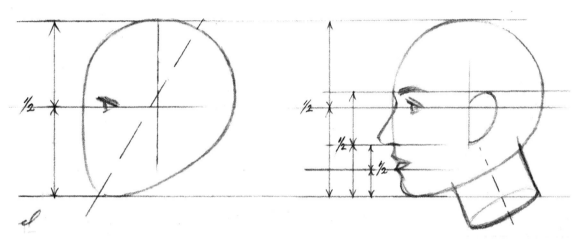

Figure D. Draw the egg at about a 45° angle. The guidelines here will help you position the features and are quite simple to remember. It's just a matter of "halves." Halfway down is the eye. Halfway between the eyebrow and the chin is the base of the nose, and halfway between the base of the nose and the chin is the edge of the lower lip.

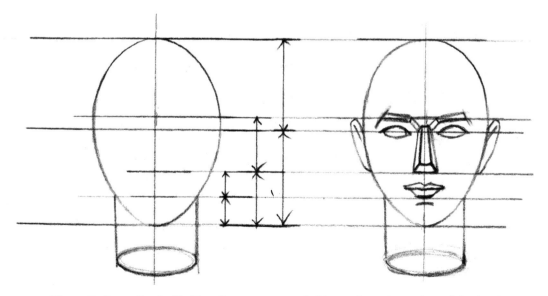

Figure E. Naturally the "halfway" measurements hold true for a front view of the head as well as a profile or three-quarter view. Notice that the egg here is upright. Although the neck is actually considered part of the upper torso, try to include it and the shoulders.

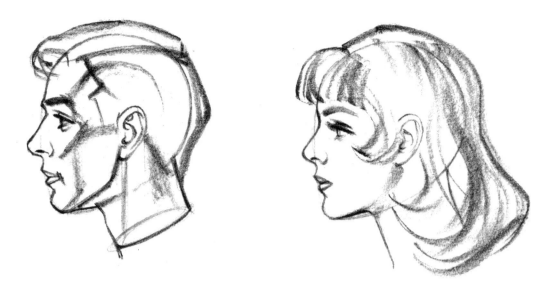

Figure F. *The basic divisions for the features apply to both sexes. The planes are a bit more defined and accentuated on the male. His chin and jaw are more angular; his nose, forehead, and mouth more "chiseled" in contrast to the softer contours of the female. However, the features of both still fall in the same places on the face. Remember these facial relationships when you draw the actual head. Check the departures of your model's features from these points of reference.*

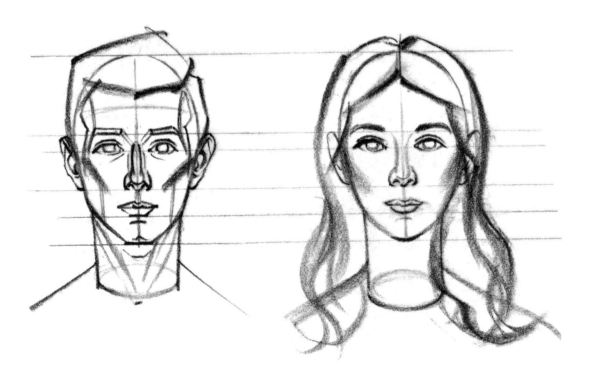

Figure G. *The relationships of the male and female features are the same when viewed from the front as when viewed in profile. Copy these diagrams until the prescribed measurements are engraved in your mind.*

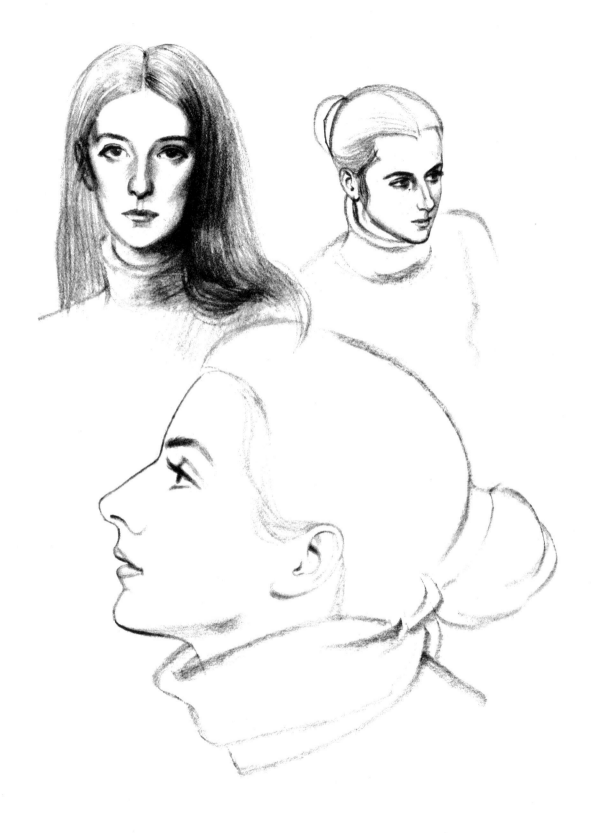

Figure H. Draw the same person in every conceivable position. If the model is a girl, ask her to fix her hair in different ways, as I've done here with Holly. Try drawing in both line and tone.

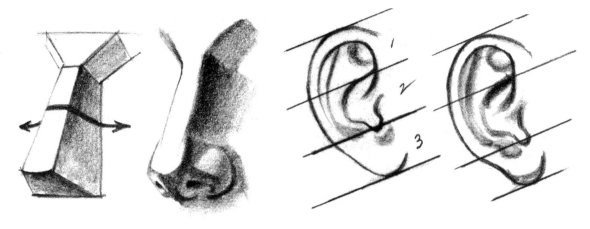

Figure I. *The basic structure of the nose consists of four distinct planes: the top ridge, the two side planes, and the base.*

Figure J. *The ear falls into three major divisions.*

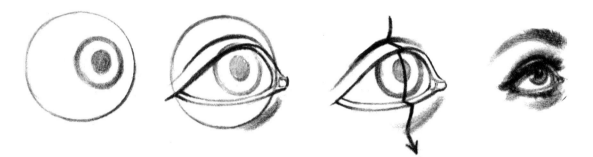

Figure K. *Despite its eyelid, makeup, or any other "extra" shape, the eye is basically spherical in construction.*

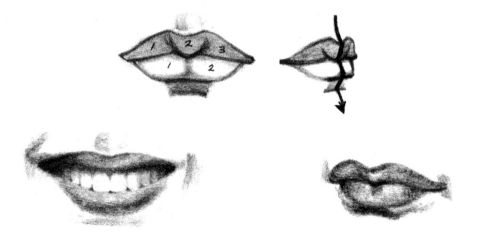

Figure L. *The mouth consists of two parts: upper lip and lower lip. These two parts have further divisions. The upper lip has three distinct divisions or areas; the lower lip has two. Notice that the lip, like the eye, follows the cavities and protuberances of the head (indicated by the arrow).*

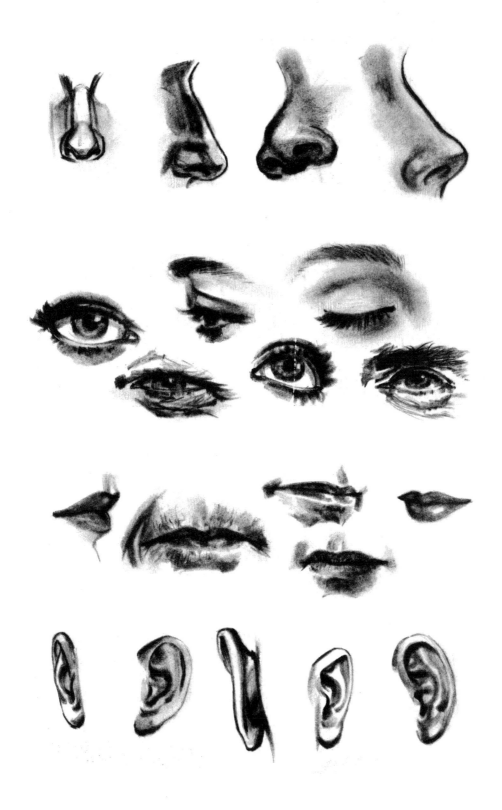

Figure M. *The facial features shown here illustrate that no matter how old or young their owners may be they must still conform to their basic geometric construction. Draw noses, eyes, mouths, and ears whenever you get the chance. Then, when you draw the features of a particular person, you'll be thoroughly familiar with basic shapes of features.*

Figure J against the model before you. You may find that the actual ear you're drawing is as unequally divided as the diagram at the right of Figure J. However, the three divisions of the ear are always present, regardless of the exaggerations in proportion that may occur among individuals.

Drawing Eyes and Eyebrows

If the nose is cubic, the eye is spherical. In the diagram on the far left of Figure K you see the entire sphere, because I want you to be aware of the entire eyeball when you draw the lids over it. When you add the eyelashes—and even "make-up"—never lose sight of the eye's fundamentally spherical construction. Study the diagram; the arrow follows lid, and dips down on the curvature of the eyeball below it. This arrow graphically describes the protuberances and cavities of the face itself. All the features of the face must conform to its bony structure.

Although eyes may be camouflaged by "make-up" or old age, they're still subject to the same fundamentals of drawing as the eyes in Figure K. Fashion may tamper with eyebrows in countless ways, but all you have to remember is that they follow the brows' bony ridges.

Drawing the Mouth

As you can see in Figure L, the upper lip consists of three parts. Parts 1 and 3 are the "wings" on its sides; part 2 is the swollen center of the mouth in the shape of a shield, called the tubercle. The names of these three parts aren't really important. What does matter is that you must be aware of these divisions: the three divisions on the upper lip and the two divisions of the lower lip.

Life Drawing from Memory?

If the heads you draw turn out to be portraits, so much the better. But the purpose of the heads you're going to do in this project is primarily to train your hand, eye, and memory. Isn't there a contradiction in terms here, you ask? How can drawing from life utilize memory? After all, the model is right in front of you.

It's a matter of memorizing the image before you. When you take your eyes away from the model to look back at your paper to record what you've seen, you hold an image of the model in your mind. You've *memorized* the model. It follows that the more you draw, the more you'll memorize; eventually you may do your best work without a model at all. But right now I'd like you to do all your drawing from life.

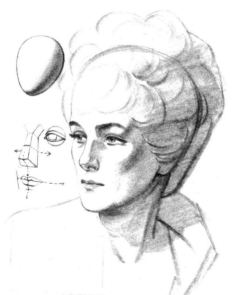

My Wife, Step 1: *I begin by indicating the egg shape that forms the underlying structure of the head. Pose your model in a light that clearly separates the shadow areas to bring out the solidity of the forms you're drawing.*

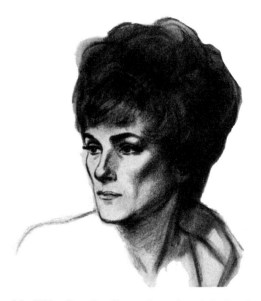

My Wife, Step 2: *Always keep in mind the planes, the cavities, and the ridges that are beneath your realistic rendering. I've done this finished portrait of my wife with charcoal on newsprint.*

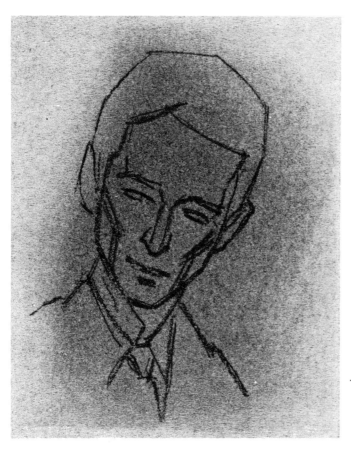

Male Study, Step 1: *I've done this demonstration on a gray tinted paper. When you draw, try not to work smaller than a head five inches high. Perhaps, at this stage of your development, it would be better to prepare a working drawing and then transfer only the line structure to the tinted paper. You can blacken the back of your working drawing with a #4B or #6B pencil. But better yet, use a separate transfer paper.*

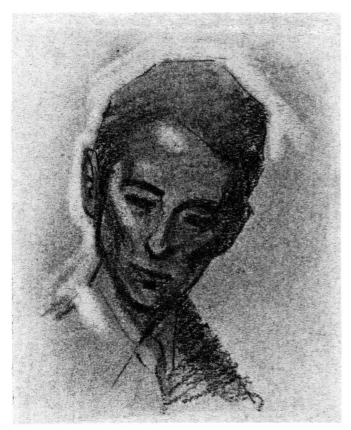

Male Study, Step 2: *Now I take a piece of vine charcoal or a #2B charcoal pencil and begin the rendering of details and shadows. Then I take a kneaded eraser and mold it to the required shape. I use it to pick up the highlights on the forehead, the nose, cheekbone, mouth, and chin. You'll find that you have to press the eraser to a point for some areas. But in larger areas you'll need a round, broader edge.*

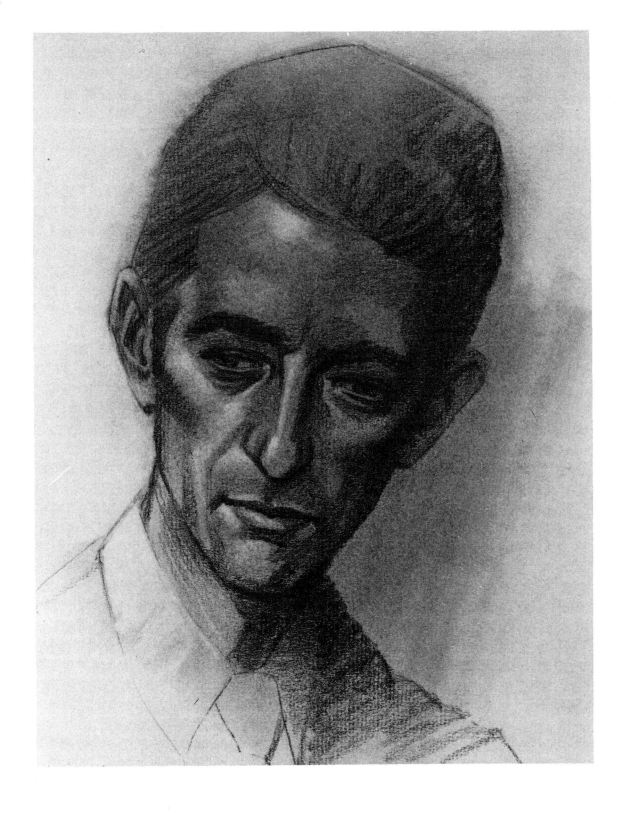

Male Study, Step 3: *Try using paper in different tints of gray. Always make sure that the gray tone is deep enough so that the highlights will show when you pick them up with a kneaded eraser. The reason for using a toned paper rather than white is that the middle value is already established by the paper itself. All you have to do is to render the darker shadows and pick out the highlights.*

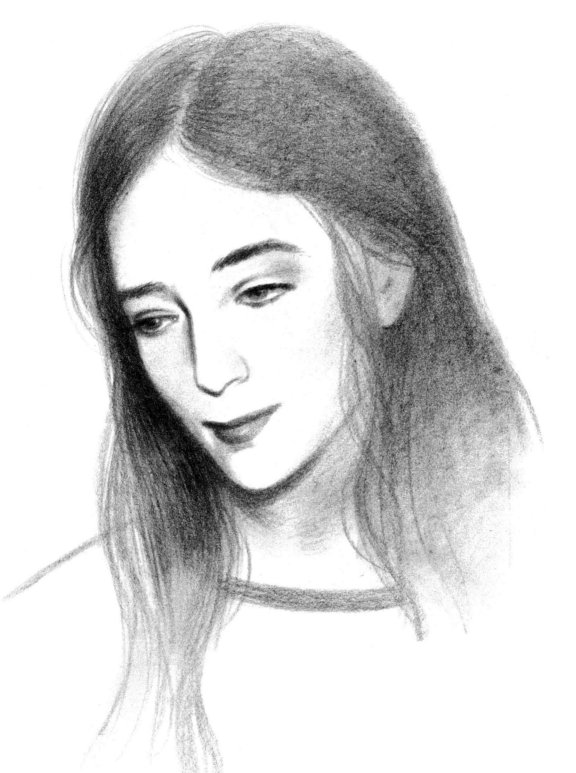

Figure N. *Ladies predominate in my drawings because it's my good fortune to be surrounded by them. If there's no one around, look in the glass and draw yourself. When you get tired of front views, use two mirrors and draw your profile from the second mirror. This drawing was done with an office pencil on an Ad Art pad.*

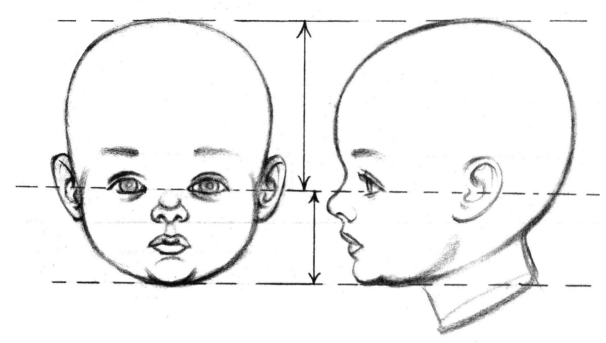

Figure A. Notice that in both front view and profile the proportions of a baby's head differ markedly from those of an adult. The baby's eyes are well below the halfway mark that is used as a guideline in the adult face.

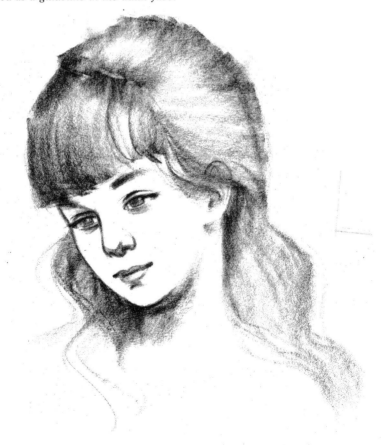

Figure B. In the adolescent (male or female), the facial proportions return to the "halfway" measurements of the adult face.

PROJECT 19
Drawing Children

I've left the drawing of children and young people until last because, in my opinion, they're the most difficult to do. You can ask an adult not to move and he'll usually comply. But when you ask a child not to do so, it's usually only a signal for him—or her—to start fidgeting. Besides, it takes a special approach (always beyond me) to make children understand that what I'm doing is deadly serious. In their mind (bless them) all the sound and fury of the artist signifies nothing. What wisdom beyond their years they show!

However, it's the artist's business to record everything that's beautiful. When you consider the irresistible loveliness of a child's face, then, no matter what the price, you must find ways of capturing that innocence, promise, and that appeal that dwells in a child's, or young person's, face.

Drawing the Infant's Head

There are two important points to remember when drawing babies. First, an infant's head is larger than an adult's in relation to his features. Also, a baby's eyes fall below the middle line that serves as placement for an adult's eyes (Figure A). You can't, I'm sure, escape noticing the "button" nose, the fat cheeks, the short neck, and the high and light eyebrows that further characterize the baby and small child's face.

Learning to observe these differences between child and adult will help you immensely in capturing the special quality of children. As children grow, check how their features become more clearly defined.

Drawing the Teenager

The proportions of the child's face change as the child grows older. By the time he reaches

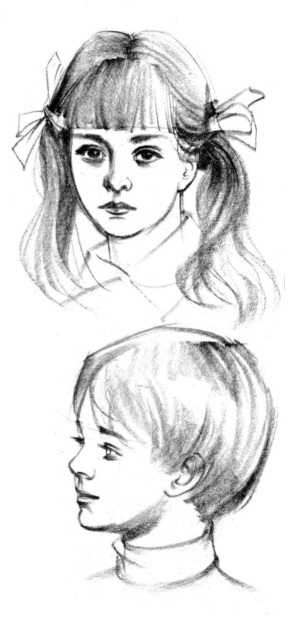

Figure C. *There are few distinctively male or female characteristics in the child. The shape, style, and length of hair (in the young child only!) can help establish the sex of a child's face; while clothing can help distinguish the child's figure.*

Figure D. *With a pad and pencil I've followed my fourteen-year-old around the house while she was doing her reading homework. When she would fall into various natural attitudes I'd ask her to "hold it" for a few minutes. These natural positions are far more satisfying and expressive than studied "poses."*

Figure E. Here are more sketches of my daughter in natural poses. All drawings in this project have been done with an "office" pencil on the Ad Art pad #307. You'd think I get a commission from the Bienfang Paper Company mentioning their product as often as I do, but I don't. I just think their pad is the greatest surface for drawing in dry media.

his "teens," the child has matured and is almost fully developed. The eyes of the adolescent reach the halfway line, just as they do in the adult. In fact, all the "half" measures that govern the placement of features in the adult face can be used to delineate the features in the young adolescent (Figure B).

Male and Female Characteristics in Children

How often have you mistaken the identity of that cute baby boy—whoops, I mean girl—in the carriage. There aren't many distinctions between the male and female features of the baby and young child.

The school age child has the beginnings of distinction in the length and style of hair (Figure C). Of course, in infants this isn't a valid distinction. And nowadays around thirteen the length of hair also ceases to be a sexual distinction. But by then nature has taken over, and sexual differences become apparent in both face and figure.

Capturing a Child's Character

Children, being restless creatures, will perhaps give you a spot of trouble in posing. But since you're not yet worrying about a client or a patron, do the best you can with those around you. The result doesn't have to be an exact likeness or a work of art.

I find that the natural gestures of children are far more expressive than any arranged pose. Follow some children around and capture them "doing their thing" (Figure D).

Working as quickly as possible, first try to get the gesture of the child's entire figure and his overall general proportions. Try to capture an impression of the total pose—the child's action. Don't be concerned with establishing a perfect likeness.

Slip this "rough" impression under another sheet of paper, if you wish, and begin refining contours and shapes. You can then develop textures and their feet and hands. But don't try for any meticulous "finish" anywhere. Let the whole drawing remain direct and spontaneous.

Part Two: Drawing in Various Media

So far you've been learning to observe and draw the proportions of everything around you: still lifes, landscapes, and people. You've drawn these subjects in the regular drawing media such as office pencils, charcoal, charcoal pencils, and Conté pencils. Now I'd like to introduce you to some new drawing media: watercolor or *wash,* as I'll call it, *opaque* watercolor (called *gouache* by the French) and *acrylic.*

Since brushes are used to apply these media, they aren't usually classified as drawing materials and don't usually appear in a drawing book such as this. Watercolor, gouache, and acrylic are usually employed for the colors they're capable of producing. However, I'll use these media only in a drawing frame of reference — black and white.

The reason I have stressed only their black and white forms is that I want you to concentrate on training the eye and hand to capture the solidity of things and their correct proportions. I want you to learn such fundamentals as distribution of textures in a pleasing manner and arrangement of elements in a composition. The introduction of color would only get in the way of this learning process. You can add color later, since it's a phase unique in itself.

I think that all artists no matter how many media they dabble in finally get settled into one favorite. I'd like you to try as many media as possible. It's the only way to find out which one best suits your temperament.

The ideal approach, of course, is to choose the medium that suits the *subject itself.* There are some subjects that would be most difficult to render in wash, but would present no problem if rendered in opaque. Naturally, you can always combine your media to get the desired effects that you want in a particular drawing. We'll come to this stage later. Eventually you'll begin to see the objects around you, not just for what they are, but as renderings in one or a combination of media.

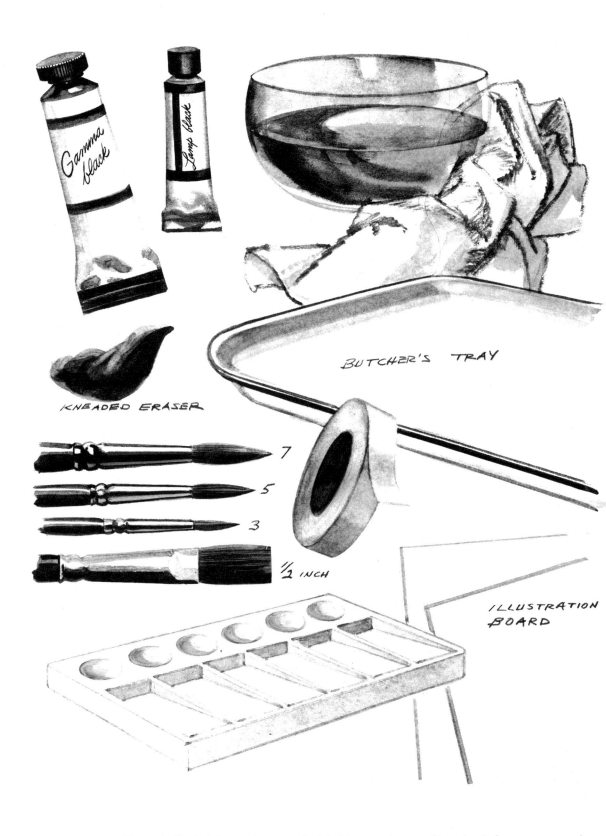

Figure A. Don't delay getting started with this marvelous medium simply because you can't get all the equipment recommended. A large white plate can temporarily replace the butcher's tray. Instead of the slant-and-well palette, white saucers can be used for mixing the various tones. All you really need is pigment, water, a brush, and something to draw on.

Wash Techniques

There's been a hue and cry about watercolor being a difficult medium, better left to the hands of a master; any student attempting it would only find grief and disappointment. Did you ever hear worse nonsense? No one, no matter how talented, is born with a brush in one hand and a pot of paint in the other. Actually, watercolor is an easy medium to handle once you get acquainted with its characteristics.

Pigment and Mixer

The phase of watercolor that we're concerned with is called *wash*. It requires only a tube of black pigment and water; *that's all*. With Gamma Black or lamp black—both prepared by Grumbacher—and varying amounts of water as a medium, you can get *any tone you need* from the palest gray to the darkest black (Figure A).

The more water you add to the paint, the lighter the tone; naturally, the more pigment and the less water, the darker the tone. But even for black passages, the paint must be thinned down since it's too thick for easy handling as it comes from the tube.

Surfaces

Illustration board provides a good surface for a drawing (Figure A). A good board at your stage of development is Bainbridge #80, single thickness. A good size would be about 11″ × 14″. Another good illustration board is Grumbacker's #150, medium texture. It comes in a 20″ × 30″ sheet that can be cut into two nice 10″ × 15″ boards. I recommend the single thickness at this time; later you can graduate to the double thickness and more expensive boards.

As a matter of fact, for the exercises in this project, you could use a pad of Aquabee #664 H bond paper. It's thin and will crinkle, but if you don't find these characteristics annoying, you could save a substantial sum compared to the price of even the cheapest illustration board.

Brushes

The brushes I use and recommend for the exercises in this project are Winsor & Newton #3, #5, and #7 pointed, red sable brushes, as well as a ½″ flat sable (Figure A). They're the best. I've suggested that you can skimp on other materials, but I'd like you to always get nothing but first-rate brushes. They do your bidding without coaxing and last longer, if you take care of them.

Always rinse them thoroughly in clean water when you're finished; dry them on a rag and reshape them to their original point before you place them back in the brush pot.

Additional Equipment

You'll need a butcher's tray in which to mix a large puddle of wash and to flatten and shape your brush (Figure A). A palette is also needed, one with slants and wells which easily keep your various tones separate. You'll also want a container for water that's large enough so that you won't have to change the water too often.

You'll find that a roll of ½″ masking tape is useful. You can stretch it along the borders of your drawing for clean, even edges. Rags, of course, are necessary to wipe off your brushes after rinsing. A kneaded eraser is used for lightening areas that come off too dark. More about that later.

Figure B. *Leaving the white paper showing through the center, the lightest gray is applied first. Next, the two darker grays are applied, and finally the black, all of them skirting the white rectangle of paper. This is one of the medium's shortcomings. You can't achieve a fresh, crisp, light tonal value by lightening up a dark tone.*

Figure C. *You can "pick up" a lighter shape from a darker ground. With a damp brush, while the wash is still wet, you can get a degree of lightness as shown. But the tone you get is just lighter gray, never pure white.*

Figure D. *You can get a dark tone a bit lighter in value by rubbing it with a kneaded eraser, as I've done here in the top square. However, you can never get back to a really crisp white as seen in the circle and triangle, where the paper's surface is left untouched.*

Properties of Wash

With watercolor, or wash, you must begin with the light and work down to the dark values. A tone can always be darkened, but it cannot be lightened, at least not very effectively.

Like all transparent watercolor, wash uses the *paper itself* for the white shapes. Whatever areas you want to have white in your drawing must be left untouched. The necessary tones must be applied around these white shapes. (Figure B). Once your wash is applied, you can "pick up" or lift out a shape with your damp brush. However, it will be a lighter gray, never pure white (Figure C).

There are times when, through a miscalculation, an area turns out too dark. Then you can make it lighter by the laborious process of rubbing it with a kneaded eraser (Figure D). Even though you can get somewhat the desired lighter tone, I don't recommend this practice. It's *contrary* to the properties of the medium. The other alternative—which I've never liked—is to throw the entire drawing away and start again.

Flat Wash

Dissolve some lamp black (or Gamma Black) with water in the slant or well of the palette. Use a brush to mix it. For your first exercise, mix and match the four grays that appear in Figure E. With the white of the paper and black, you'll have a tonal range that's wide enough for the drawings coming up in future projects.

When you've tested the four grays, take the #7 brush and load it generously with wash. Tilt your illustration board (or #644 H drawing pad) about six inches from the horizontal. Begin at the top of the board, and without lifting the brush, bring your puddle of wash down in a zigzag manner (Figure F). What you've just executed is called a *flat wash.*

Wet-in-Wet Technique

An indefinite blending of tones can be obtained with a wet-in-wet technique. First, lay your drawing surface down flat. Wet your paper or illustration board thoroughly and let the water spread over it. Load your brush with pigment and apply it to the wet surface.

Experiment with different degrees of wetness—from a flooded surface to just barely damp. You can force a certain pattern into the blends by picking the paper up and tilting it in the desired direction (Figures G and H).

Graded Wash

You can achieve a gradual change in tone from light to dark, or vice versa, by using a graded wash. Squeeze a dab of pigment on the butcher's tray (or a large white plate). Dip your #5 or #7 brush (the larger the brush you can handle comfortably, the better) in clear water. Dissolve part of the black into a large puddle. Rinse your brush. Dip it into clear water again and work your brush into the outer fringes of the puddle.

In Figure I begin, as I did, at corner A. Zigzag your brush about a half inch down your paper. Dip into a denser part of the puddle and continue downward another half inch, slightly overlapping the first strip. Repeat the process adding darker grays until you dip into the black itself.

To do a graded wash from dark to light, simply reverse the process. Begin with the darkest value and add more and more water as you zigzag your way down the paper. To do a vertical graded wash, you turn your paper.

Drybrush

There'll be times when, for textural reasons, you'll want some drybrush passages. These effects are created when a brush that's fairly dry (not loaded with pigment) is rapidly skimmed across paper. The brush deposits pigment only on the ridges of the paper. The effect produced is that of pigment with many gaps through which you see the paper's surface.

Dip your brush into whatever tonal value you want to reproduce on the paper (Figure J). Empty it by discharging most of its load of pigment on a piece of scrap paper. Work the brush in any direction that will flatten and fan the point.

Linear Effects

There'll also be times when you'll want some linear definitions over a graded or flat wash.

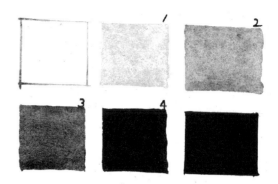

Figure E. Mix and match the four gray tones numbered 1, 2, 3, 4. Since even the light tints appear dark in the well of the palette, test your tones on a piece of scrap paper. If a tone turns out too light when dry, add pigment; if it's too dark, add water.

Figure F. Practice the flat wash I'm doing here. It's quickly done, once you gain proficiency in handling it. When speed is essential, wash is the medium to choose.

Figure G. "Lucky accidents" happen in the process of wet-in-wet blending that sometimes can enhance your entire drawing. With this technique, you can quickly execute clouds, rain, mist, fog, and anything that requires soft edges.

Figure H. If you want a soft edge, the surface must be wet or damp. If you want a crisp edge, the surface must be dry. Try a few strokes of a gray tone while your paper is still wet (Left). Try the same strokes after the paper has dried (Right).

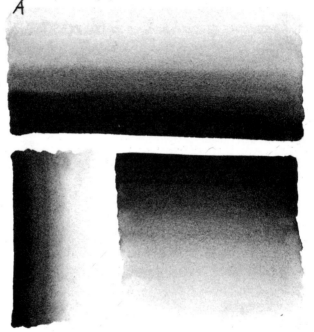

Figure I. There's no easier or faster way to do the graded tones of a sky or render the shading on a cylindrical form than by using a graded wash.

Figure J. Take a half-inch brush that's fairly dry; run it quickly over rough watercolor paper. You'll get a sparkling effect produced by the gaps of white paper showing through the pigment. This effect, known as drybrush, is good for depicting water or the fresh, crisp mood of a morning scene.

Simply by varying pressure, you can do the thinnest line or the thickest strokes with the same (#5) brush. Thin lines can be done with the tip of the brush; as you apply pressure thicker lines, will appear. Practice the strokes shown in Figure K.

I can't urge you too strongly to practice the exercises demonstrated in the figures until you can do them with ease and spontaneity. Please don't be timid. Let yourself go. Relax and splash away. It's marvelous to see the various effects that you can get with only black and varying amounts of water. Remember that you can apply the techniques of these exercises to the still lifes and to the landscapes coming up in subsequent chapters. Master them thoroughly so you won't be groping your way when confronted with actual subject matter.

Figure K. *Linear effects can be applied over flat or graded washes. For fine lines use the point of the brush with very little pressure, as I've done here. The thick lines require more pressure.*

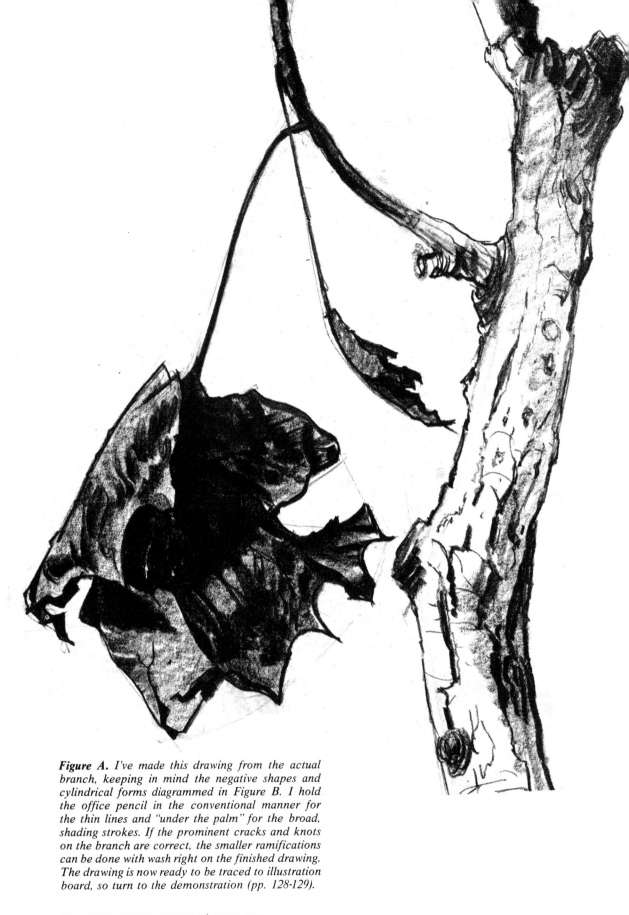

Figure A. *I've made this drawing from the actual branch, keeping in mind the negative shapes and cylindrical forms diagrammed in Figure B. I hold the office pencil in the conventional manner for the thin lines and "under the palm" for the broad, shading strokes. If the prominent cracks and knots on the branch are correct, the smaller ramifications can be done with wash right on the finished drawing. The drawing is now ready to be traced to illustration board, so turn to the demonstration (pp. 128-129).*

PROJECT 21

Drawing with Wash

Since you're now familiar with some basic techniques let's put your newly acquired knowledge of "wash" to work. For your first wash drawing, you'll begin by preparing a "working drawing" in pencil. This working drawing will be traced onto illustration board and finally rendered in wash. This is "behind the scenes" work; the public never sees it. The charcoal drawings you did were an end in themselves—ready to be framed and hung; these working drawings are not. Their only purpose is to serve as a guide for your finished drawing in wash or any other medium you wish. They record only the salient points you'll want to transfer, leaving the minute details of the finished drawing to be rendered in the particular medium you're working in, in this case, wash.

Working Drawings

Follow the demonstration I've done in this project. Go out and pick up a branch that has several leaves and bring it into the house. Set it up in any position you wish and begin your "working drawing." Your drawing doesn't have to be true to the last detail. Just establish the big, overall proportions and a suggestion of the lights and shadows. See my Figures A and B for examples of such drawings.

Realism First

At present you're concerned with creating a factual representation of an object. Later, the object—animate or inanimate—will only serve as a point of departure for you. As you let your sensitivity and your reactions take over, you'll become more subjective. The more you submerge the cold, calculating eye of correct proportions, the more you'll change, exaggerate, and distort in order to express visually the emotions you want to convey.

But remember this stage comes later, after you have mastered the fundamentals. It's only when you *know* why you throw away or bend certain drawing principles to your own needs that your art will rise above the factual and have the power to impress your spectator.

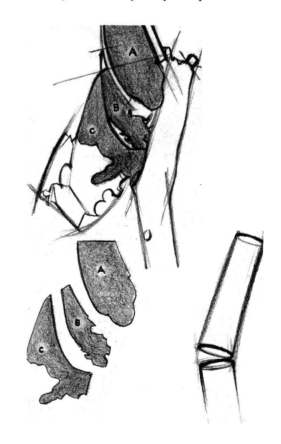

Figure B. One of the requisites for sound drawing is the accurate observation of both the positive shapes and negative shapes of objects in a composition. In case you've forgotten, the positive shape is the object itself, and the negative shape is any area left vacant. Since the positive shapes of the branch and its leaves are so obvious, I've diagrammed and "pulled out" the negative shapes (A, B, and C) and toned them gray so you can see them clearly.

Maple Branch, Step 1: *When your working drawing is correct, blacken its back with graphite, then transfer the big shapes and the large details onto an 11" × 14" illustration board.*

Maple Branch, Step 2: *Prepare four tones of gray (as in Project 20). Charge your #5 or #7 brush with the lightest value and bring the wash down from top to bottom of branch and leaf. Make sure white details are left untouched.*

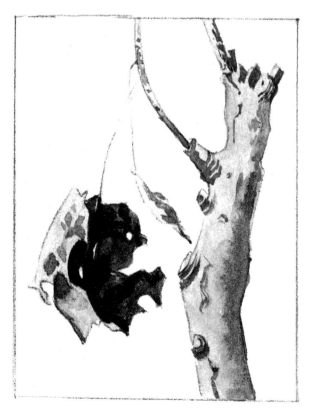

Maple Branch, Step 3: *(Left) When this first wash is dry, begin the modeling. Run the #7 brush with clear water down the center of your big branch; it won't disturb the flat wash if the wash is completely dry. Before the water drys, apply the graded washes that give the branch its cylindrical form. For soft edges, work on a damp surface; for hard edges, work on a dry surface.*

Maple Branch, Step 4: *(Opposite Page) Work over the whole drawing. While you're waiting for one part to dry, keep working on another until the most minute details are finished, as I've done here. Incidentally, I'm sure you've noticed that the smaller leaf was shifted down from its original position in the working drawing. When I was tracing the big shapes, I noticed that it was just too centrally located between the twig and the big leaf. Since the negative shapes should be as varied and interesting as the positive shapes, I decided to move it.*

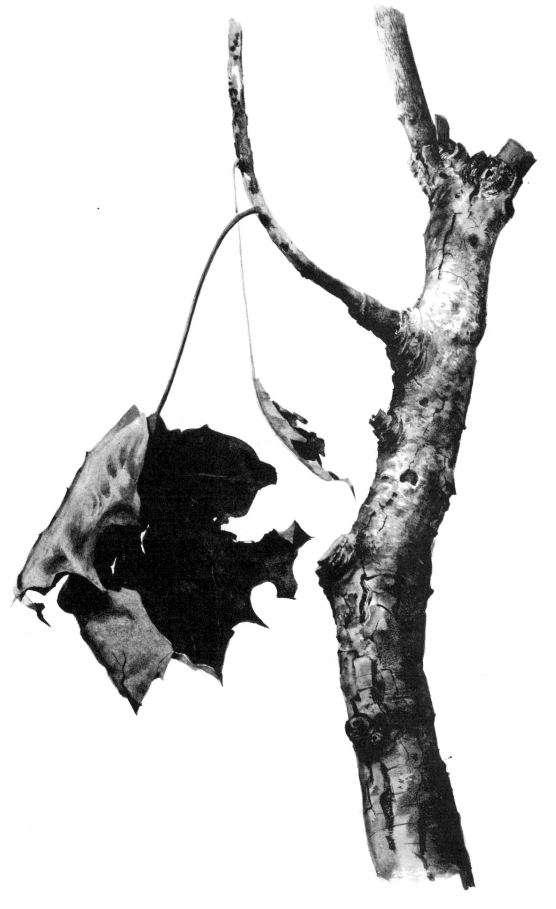

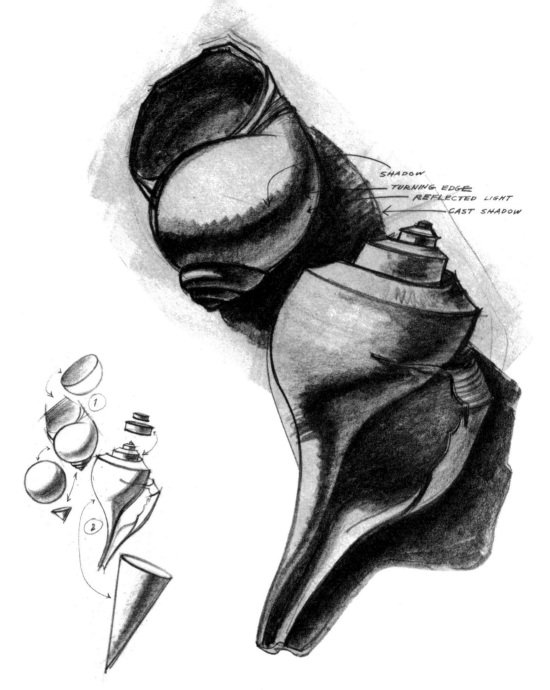

SHADOW
TURNING EDGE
REFLECTED LIGHT
CAST SHADOW

1

2

Figure A. *I've placed the basic geometric forms that comprise the structure of the shells alongside the shells, themselves, so that you can clearly see the modifications that occur. Half a sphere represents the upper part of shell 1; the entire sphere is used for its body. The cone comprises its tip. Sections of the cylinder couldn't be more evident than at the top of shell 2. The body of shell 2, in spite of its undulations, is clearly based on the cone.*

Figure B. *Here, I follow the same procedure as in the drawing of the branch. First, I do a line drawing with the office pencil to get the correct proportions and relationships of one shell to the other. Then, holding the pencil "under the palm," I model the shells in this order: first, I render the shadows, watching their soft edges on the spherical, conical, and cylindrical forms. Then I work on the cast shadows to better judge the value of the reflected lights. The darker "turning edge" over the shadows comes next. Finally, I darken the reflected lights in some areas with the side of the pencil, or lighten them by tapping with the kneaded eraser. Turn to the demonstration to see how I render the shells in wash.*

PROJECT 22

A Still Life in Wash

The one thing I would deplore as we get absorbed in the handling of a particular medium is for you to forget the basic fundamentals with which we started. Correct drawing is the foundation of a good piece of work in any medium. Always be aware of the underlying geometric forms that are the basis of your realistic objects.

Arranging and Lighting

I hope you have some shells that you've brought back from your excursions to the beach. But if you don't, then use a cup and saucer and a milk jug. They'll pose the same problems in rendering with graded washes.

I arranged the shells exactly as you see them here. I taped them in position on 11″ × 14″ white illustration board so that they wouldn't shift as I reclined the board at about a 30° angle against a stack of books. Then, I threw a spotlight on them from several directions until I decided on the best direction for the light. I chose the upper left, because it gave me the best forms and the best cast shadows. It also brought out the texture of the shells to the best advantage.

Using a Graded Wash

Now let's continue with the main purpose of this still life—the handling of a graded wash. The materials used in this demonstration will be the same as those used for the wash drawing of the branch. I chose a branch and leaves for your first drawing in wash because that subject didn't demand perfect control of your medium. If something came off a bit too sharp or too soft—or perhaps a bit too light or too dark— I'm sure it didn't disastrously affect the appearance of your subject.

Now that you're better acquainted with the

medium, I'd like you to render the shells I've drawn in the demonstration. It's an exercise mostly in curved, graded washes from white to gray to black. Notice the shading on the body of both shells: white (the paper itself) for the light areas, graded wash for the shadow areas, and gray for the reflected lights on the shells.

Eliminating Pencil Lines

If certain passages in the handling are a bit puzzling, check again the exercises you did for Project 20; everything you require about technique is there. Just one more word of advice. When the tone is going to be light, be sure the traced drawing is light in that particular area. A dark pencil line around a light wash value is most unpleasant. If the tracing on the illustration board has to be lightened for just such areas, take the kneaded eraser and tap the pencil line with it until it's just visible enough to serve as a guide. See Figures A and B for examples of working drawings.

In Figure A, I've diagrammed the underlying structure of the shells consisting of the cone, the sphere, and the cylinder. You can begin your drawing by establishing the basic forms first and then modifying their rigidly geometric contours to conform with actual objects before you. Or, at the outset, you can draw the actual objects, keeping in mind (and "feeling") the solidity of their forms.

Preparing Tone

Before you begin your rendering in wash, prepare enough of your four tones so that you won't exhaust any of them before you're finished with the job. It's better to have some pigment left over than to start mixing while you're busily engaged in the rendering.

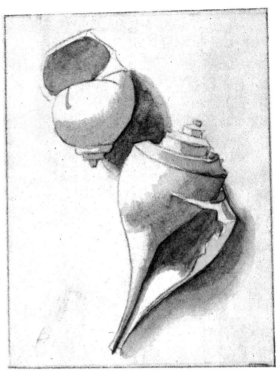

Shells, Step 1: (Above) Trace your working drawing (see Figure B)—whether it happens to be shells, or cups, or jugs—as I've done here. Just carry over the big, important shapes, leaving the small details for the rendering in wash. When the big divisions are correct, the subdivisions can't help but fall in their proper place.

Shells, Step 2: Here, I've applied preliminary light washes to the entire drawing (except where I want white). With a brush and clear water I dampen the contour of a soft-edged shadow. If you apply the light values beside the dampened contour, the pigment will spread into the moisture producing a soft edge. I bring the shadow down to its required width. After rinsing my brush, I start the same procedure in another area.

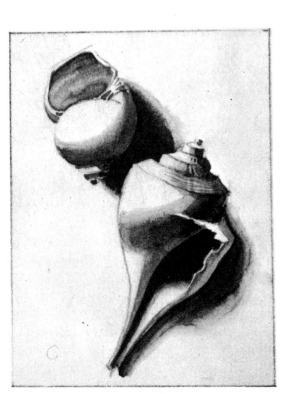

Shells, Step 3: (Left): I follow the same procedure as in the final stages of the branch: darker and darker washes are applied one on top of the other. I take care that the previous wash is completely dry before applying the succeeding one. If, in trying to whip a shadow into shape, you end up with a value darker than you intended, let it dry and then start the laborious process of rubbing the tone with a kneaded eraser.

Shells, Step 4: (Opposite Page): The edges of the washes of Step 2 become soft near the light areas. When these soft edges dry, I dampen them again with clear water and apply the darker "turning edges" by adding pigment to my brush. Then, I rinse my brush, dip it into clear water, and finish off with a soft "turning edge" next to the reflected lights. For the cast shadows, I run my brush, loaded with clear water, only where the edges are soft. The faint striping on the smaller shell and the tiny corrugations on the larger one—being small details—should be left until the last, naturally.

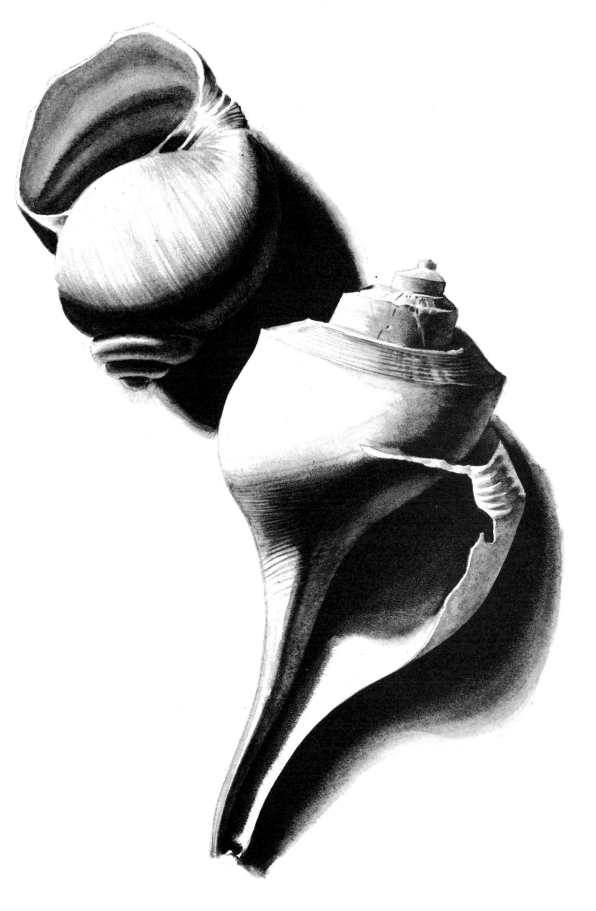

Figure A. *I mentioned before that nature hardly ever gives you a perfect picture. Well, this is the exception; all I had to do was to determine how much of the scene to include, and how much to leave out of this rough charcoal sketch.*

Figure B. *It wasn't until I was ready to render it in wash that I noticed the grotesque "monster" I'd drawn here! The rough bark was rendered over the flat wash, as demonstrated in the smaller sketch.*

Outdoors with Wash

Now, let's go outdoors and try our new medium. The procedure I've used in the demonstrations in this project is to make both a charcoal "rough" and a more detailed pencil drawing on the spot. Then, back at the studio, I've rendered the subject in wash. Of course, you can use wash right on the spot as well, but you must have all the right equipment along with you.

Transporting Your Materials

When you draw outdoors, the most convenient way of carrying materials is to put the supplies required for each particular medium in individual boxes. For example, label one box *charcoal* and put everything in it that you'll need for that particular medium. This saves you the bother of looking for a piece of sponge among the pencils, or for a stick of charcoal among the paints; I hate to waste time when I'm out sketching. I think you'll like this methodical approach.

But don't rob Peter to pay Paul. When sketching in charcoal, if you find that there are no stumps in the box, make a note to put them in on your return. The only things I don't put in boxes are a folding stool and a 20″ × 26″ drawing board that I hold on my knees when I sketch. These I just leave in the trunk. Everything else is boxed individually.

Suiting Your Medium to Your Subject

When I came upon the barn doors that you see in this project's demonstration, I knew that they deserved more than a brief sketch. First, I did a charcoal sketch (Figure A) only as a preliminary step. Then, I used a working drawing (over the charcoal sketch) to pin down more accurately the smaller details.

I took both drawings back to the studio and, armed with the tonal scheme I'd layed in with charcoal and the accurate line drawing in pencil, I started the wash. I chose wash for this drawing because I pictured in my mind the graded wash on the doors covered with a drybrush texture. The entire ensemble said "wash" to me. This is what I mean when I say that a certain subject will cry out to be done in a particular medium. Not that it couldn't have been done in opaque, for example, but I felt that wash had the necessary characteristics to do this particular job best.

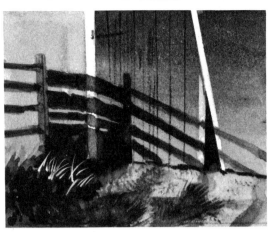

Barn Doors, Step 1: *From the charcoal rough seen in Figure A, I've done a pencil drawing to pin down the smaller details. Then I've traced the pencil drawing onto illustration board. Next, I lay in a light, flat wash followed by a darker, graded one which you see here.*

Barn Doors, Step 2: *After the two underlying washes are dry, I place the pencil drawing back over them and trace the fence and its shadow on the barn doors and the ground. The grass texture in the foreground is done with a fine sponge. The highlights on the grass and the door's trim are white opaque.*

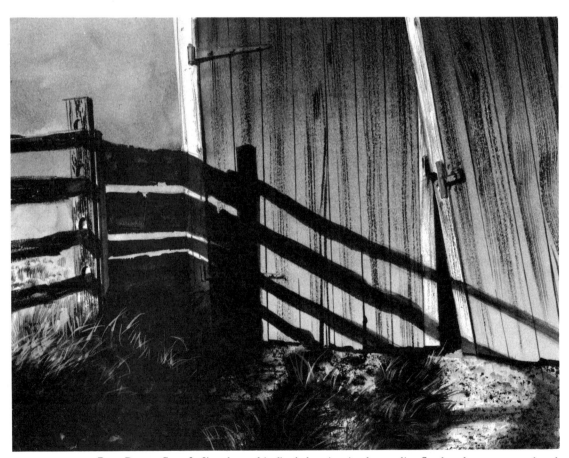

Barn Doors, Step 3: *I've done this final drawing in the studio. Study whatever you sketch outdoors to see if it deserves further development in the same or a different medium. Notice the wood grain texture of the barn doors. I've achieved this texture with a dry brush that was well "fanned" over the graded wash. One more point: you can work freely past the borders of your picture and then trim them back with opaque white.*

Farmhouse Window, Step 1: *(Left) Here's another drawing that began as a charcoal sketch done on the spot. It's a special type of "landscape" that's become very popular in recent years. It's known as a "closeup." I've followed the same procedure here that I've used with the barn doors. I trace a pencil drawing on to illustration board. Then, I begin the rendering by laying in a flat gray wash that you see here. Notice how I've left the paper untouched for the curtains.*

Farmhouse Window, Step 2: *(Below) Here's the finished drawing. I've put down successively darker washes to achieve my shadows. The texture of the weatherbeaten clapboard contains some drybrush work. The broken strips of putty are put in last with white opaque.*

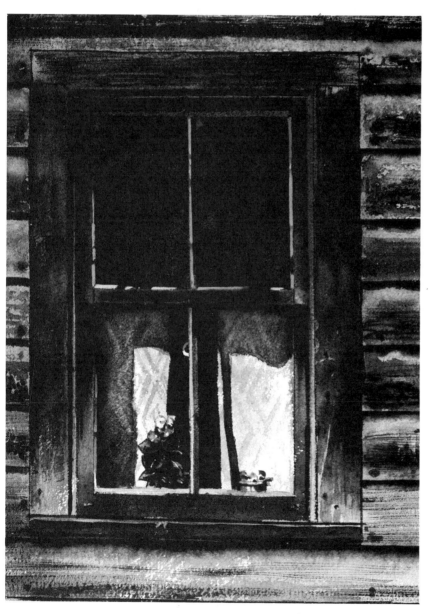

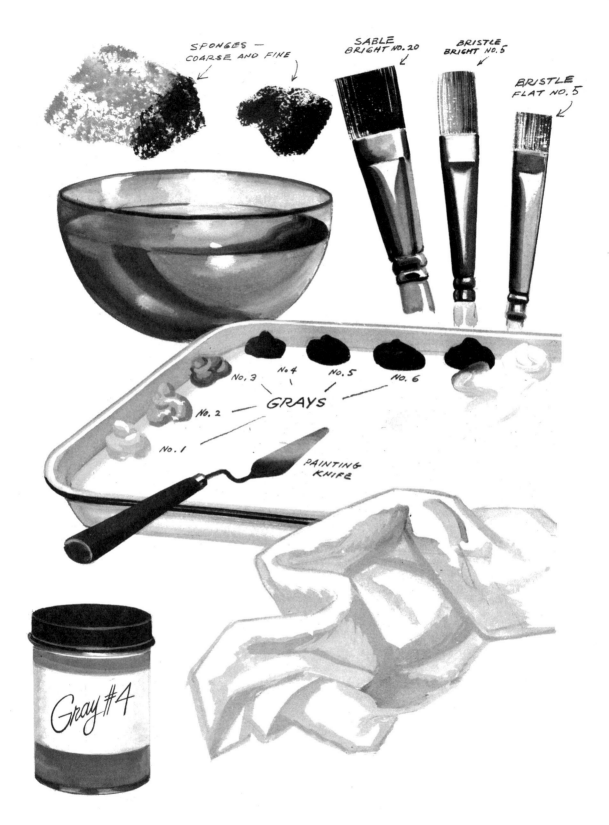

Figure A. *With the exception of the tray and the water bowl, the equipment pictured here can be added to the tools you've already acquired for working in wash. The sponges are torn off into manageable pieces. At this size they can be used for textural passages and for blending wet-in-wet tones.*

Opaque Techniques

I mentioned that I'd like you to try as many media as possible. It's the only way to find out which one best suits your temperament.

Opaque watercolor is my favorite medium. So much so that I even wrote a book exclusively devoted to its handling (*Painting in Opaque Watercolor,* Watson-Guptill Publications, 1969). However, there have been long stretches when I used nothing but inks in my work. Actually all the media are marvelous to handle; the more of them you master, the less risk there'll be of getting into a rut. The moment you begin to feel too comfortable in one, I'd suggest you change to another to avoid the possibility of sliding into mere slickness and virtuosity.

Characteristics of Opaque

As you've already discovered, wash is a spontaneous and sparkling medium. It lends itself perfectly to flat passages, as well as to smoothly graded washes. If you're so inclined, you can accurately render the minutest details with wash. It's also the medium for "happy accidents" when working wet-in-wet; when pressed for time, there's hardly a faster way of applying pigment.

However, when the white details of a subject are so intricate that it becomes painful drudgery to work your way around, say, filaments and filigree, then opaque is needed. Opaque watercolor (sometimes called *gouache*) is at best when rendering light traceries over a dark ground. Such subjects as delicate branches and twigs against a dark evergreen, a lace curtain against a dark shade, a flock of gulls against a stormy sky, in fact, any complex articulation that's to be light over dark is suitable for rendering in opaque.

Figure B. *Here's the great virtue of opaque: a light value can be painted over a dark one. The dark tones here were applied first. Then the lighter ones —all the way up to white—were painted on top.*

Figure C. *These are the six values—four grays plus black and white—that can be purchased already prepared. Should you need more of any of the values as you work, all you have to do with these pigments is to squeeze the tube containing that.*

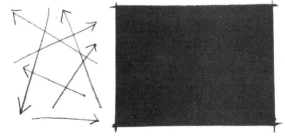

Figure D. *When working in wash the puddle of tone is brought down by zigzaging the brush, creating a flat tonal value. In opaque you can paint the borders first and then fill in the shape. Work the pigment in all directions (as the arrows indicate) to spread it evenly and smoothly.*

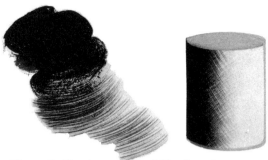

Figure E. Here's one type of blending that you can do with opaque. Demonstrated here is the drybrushing of an edge. Be sure that your tones always sweep toward the light area.

Figure F. With wet blending, one value is joined to another while both values are still wet. The tonal gradation is produced by overlapping the tonal values.

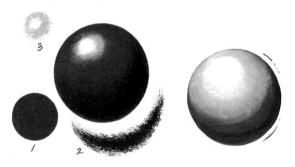

Figure G. For the drybrush approach, paint a flat disc in a middle value as in view 1. You can use a compass or do it freehand. When it dries, sweep the shadow over it, view 2. Then place the highlight at the top, seen in view 3. When the light gray is dry, drybrush the small white spot over it. For the wet-blended sphere on the right, begin with the white spot and then brush the light gray next to it. Add the darker grays until you get to the contour of the shadow. You can also work from the dark shadow toward the light spot if this is easier for you. Keep the tones wet as you overlap one slightly into the other.

Pigments

You'll need the same tube of Gamma Black that you used for the wash drawings, and a tube of Gamma White (Figure A). With these two extreme values—the darkest and the lightest—you can get any of the grays in between by varying the amounts of one with the other. Notice this distinction between wash and opaque. *Wash requires only water to create a light value, while opaque requires white pigment to make or lighten a value* (Figure B).

You can also get a set of six ready-mixed gray tones (Grumbacher) in tubes or jars (Figure C). There's also a set of five tones manufactured by F. Weber Co. called "Permogray." Together with Permoblack and Permowhite, these also form a most adequate value range.

Brushes and Drawing Surfaces

You can simply add to the stock of brushes you've already purchased for the handling of wash. In addition to them, you'll need a red sable bright #20, bristle bright #5, and a bristle flat #5. The surface for opaque watercolor can be the same as that for wash. You can use any illustration board with a surface (smooth, medium, or rough) of your own preference. For the exercises in this project, the cheapest, single thickness illustration board will be adequate. In fact, even mounting board or showcard board will do.

Accessories

Two pieces of sponge, fine and coarse, will be needed. They can be either natural or synthetic. A painting knife will also be useful. Finally you'll need a water bowl, rag, a butcher's tray, and pencils and paper for the working drawing. You may not use all of these materials in the exercises, but you'll need them for the still life and landscape drawings coming up shortly.

The exercises presented in the figures of this project will demonstrate how to apply a *light value over a dark one.* This procedure gives you the tremendous advantage of laying in the elements in flat shapes with *middle tonal values* upon which not only the *shadows* but also the *lights* can be rendered (Figure D).

Drybrush Blending

Opaque can be blended in two ways: by "drybrushing" an edge and by joining wet tones. Let's take the drybrush first (Figure E). Dip into a medium gray with a pointed watercolor brush. Flatten the brush as you "empty" it on a piece of scrap paper. Then, with *quick* movements using only the tip of the brush, sweep the surface of the board lightly in a northeasterly direction. Turn the drawing upside-down and repeat the strokes. Be sure that the strokes sweep *toward* the light area or toward a lighter tone. You can sweep the strokes past the contour of a shape and then trim back with white or with the adjoining value.

However, never forget that the *consistency* of the paint must be correct. Your pigment must be just thick enough to cover the paper or the tone underneath. If it's too thin it won't cover the surface; if it's too thick it becomes unmanageable.

Wet Blending

As the term implies, wet blending means joining a value while the preceding one is still wet. The graded band in Figure F was done by joining the four values, slightly overlapping one after the other. They went a bit past the top and bottom edges but then I trimmed them with white opaque, as I did the bottom of the cylinder in Figure E.

Practice both types of blending on a sphere, as I've done in Figure G. Both types of blending produce gradated tonal patterns. However, linear patterns can be produced on top of a wet-blended band (Figure H).

Working Toward Craftsmanship

Remember that these exercises aren't an end in themselves, but merely the means toward your goal of rendering a drawing in a given medium. The purpose of learning to handle any medium with ease is to let you concentrate on *what you have to say* as an artist, and to free you from thinking about *how to say it.*

Figure H. For this exercise I'd like you to use wet-blending on a band like the one in Figure F. When dry, take your #3 watercolor brush and work it to a point on your tray or scrap paper. Apply the linear pattern; begin with white at the left and end with a medium gray at the dark side.

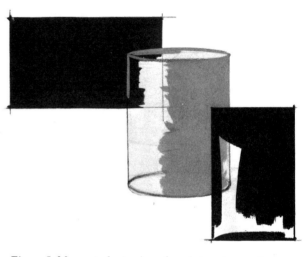

Figure I. Many students gingerly paint up to an edge of a tone, invariably leaving a white (paper) margin between one tone and another. To avoid this, I'd like you to practice drawing a rectangle in pencil overlapped by a cylinder that is, in turn, overlapped by another rectangle. The idea is to paint slightly past the edge, as shown. Then when dry, regain the shape of the overlapped object by painting back to its original contour.

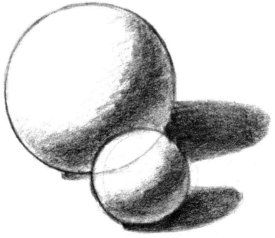

Figure A. *Concentrate on correct proportions, relationships, and the general distribution of lights and shadows when preparing a working drawing. Remember it's only a guide, not a drawing per se. Any meticulous detail should be left for the final rendering in opaque. I've used an Eagle "draughting" pencil #314 on thin paper so that the drawing could easily be traced later onto illustration board. Turn to pp. 146–147 to see how I develop the drawing in opaque.*

PROJECT 25
Still Lifes in Opaque

Now let's put the opaque techniques that you learned in the last project to work. The two still lifes demonstrated here will give you a chance to thoroughly explore this medium which allows you to paint both darks and *lights* on top of a middle tone.

Begin your opaque still lifes the way you've begun your wash studies—with a working drawing. I chose a vegetable still life for your first study. As with the branch done in wash, if a shape or detail is slightly off it won't really distort the appearance of the vegetables. The second still life will require more control.

Observe the form of the objects before you and how the light and shadow patterns fall. Unless you want to convey a sense of loneliness and isolation, it's better to let your elements dominate the picture's space and relegate the background to a secondary position.

Establishing the Large Shapes

Figure A shows that the head of lettuce and the tomato, with all their variations, are still based on the sphere. I keep reiterating this because I want you to be aware of the bulk and volume of objects; objects occupy a given space. As you draw the head of lettuce, "feel" the curvature of the surface. Observe how the leaves cling to that contour, even if they twist and curl.

Here, again, I suggest you concentrate on the main shapes, as I did in my working drawing (Figure A) and leave the minute details for the final rendering. At a later stage you can begin your drawing right on the illustration board. However, for now it would be better to use your Ad Art pad and then trace your drawing onto the illustration board, as you did when working in wash.

Balancing Textures

If there's no way of getting a head of lettuce and a tomato at this particular time, then find other vegetables, or even fruits. Keep an eye, however, on the textural qualities and see that one fruit's texture complements the other. Notice how the "busy" surface of the lettuce is balanced by the "quiet" and smooth texture of the tomato. Two smooth textured fruits or two "jittery" ones would get a bit monotonous.

Using Transfer Paper

Take your working drawing and again tape it to the top of your illustration board. Prepare a transfer paper by blackening a sheet of your Ad Art pad with black pastel, a graphite stick, or any soft pencil. Then rub the paper with a piece of cotton or a tissue saturated with rubber cement thinner or benzene. Slip the transfer paper under the drawing and trace it with a hard pencil.

Transfer paper can be used over and over again under many drawings. If you work in a large scale, all you have to do is shift the transfer paper from one section to another as you trace.

Paint Consistency

I've mentioned that the correct consistency of opaque should be just thick enough to cover the illustration board or any previous tone. As you discovered when doing the exercises, opaque watercolor—as it comes from the manufacturer—is too thick for easy manipulation and must be thinned. Once the paper is covered, any details and modeling can be done in *still thinner paint.*

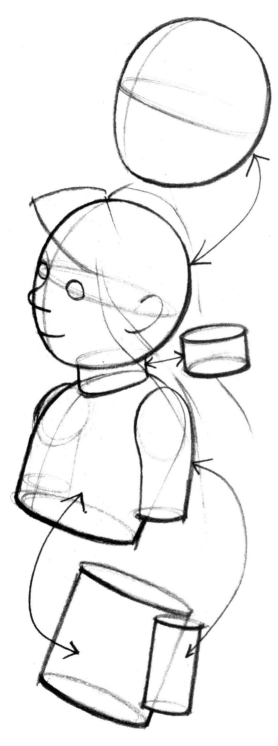

Support for the Hand

I don't know whether you prefer to work in a small or large scale. If you work in a size that requires your hand to rest on the drawing, slip a piece of paper under your hand so you won't disturb the traced line or the paint itself. Besides, it's easier to glide your hand over a piece of smooth paper than over the texture of the painted areas. Of course, you can rest your hand on a mahlstick or a ruler. Some artists wouldn't put down even the minutest stroke without one or the other.

Controlling Opaque

The subject of the second still life in this project is a doll—Pitiful Pearl. Engaging as she is, Pearl isn't a very popular doll. So, if you or your friends don't have her, use any doll with simulated hair and a patterned dress.

This demonstration, like the shell still life you did in wash, requires a more complete *control* of the opaque medium. In doing the lettuce and tomato it didn't really matter if some proportions or values were slightly off. However, any deviations here would be instantly apparent.

I know how easy it is to get absorbed in the handling of a medium. So don't lose sight of the fact that your main concern throughout this book is drawing. Even if the underlying structure of an object is hidden by outer coverings, always be aware that it exists and greatly affects the final shape and character of the surface (Figures B and C). When you draw with this type of understanding, your work will be convincing—whether you're rendering a fold on a garment, or modeling a form.

Suitability of Opaque

As you'll see in the final opaque rendering of Pitiful Pearl, opaque is the medium most suited to the subject. With opaque you can easily render the light strands of Pearl's hair over the shadow of her neck and especially the white pattern of her dress over a medium gray ground. Can you imagine rendering this in wash and working your way all around the white design? Unthinkable.

Figure B. The shadows on Pearl's face will only be convincing if you're aware of the modified sphere that shapes her head. When you observe the cylinder shape underlying her neck, you'll have no trouble in making the collar of Pearl's dress "go around it." By the same token, knowing that her rib cage and her arm are cylindrical will help you in the execution of the fabric pattern, the rendering of its folds, and the placement of its shadows and cast shadows.

Figure C. *Set your doll up in a sitting position, preferably under artificial lighting so that the shadows remain the same. Look for the size relationship of her head to her body, and in turn, the length, thickness, and position of her arm. When you draw her features be aware of the slant of her head. Put down the guideline for her eyes and the middle line for the placement of her nose and mouth, just as you did when drawing a human head. If the pattern on her dress is light on dark, as Pearl's is, do it dark on light in the working drawing as I've done here. Then reverse the values in the opaque drawing. See pp. 148–149 for the demonstration of Pearl in opaque.*

Vegetables, Step 1: I've traced only the main outline of the elements in the working drawing onto illustration board. The lights and shadows—the detail—will be rendered on top of a flat tone. Leave your drawing taped to the top of the illustration board; just flip it over behind the board. Begin applying the middle values to the objects.

Vegetables, Step 2: When the middle values are dry, flip the working drawing back over the illustration board and trace the important details over these flat, painted areas. Find out how thin the paint can be without disturbing the flat tone underneath. The tendency of the student is to handicap himself with paint that's too thick. Try to find out how thin you can make your paint and still get the desired effects.

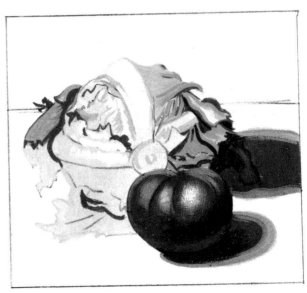

Vegetables, Step 3: As you begin the articulation of details, work with both the values that are lighter as well as those that are darker than the middle tone. By comparing the light with the dark passages, you'll be better able to judge the proper tones of both. From here on, it's a matter of checking the values of one area against another. If a spot turns out too dark or too light, you can easily correct it by letting it dry and then painting over it with the correct value.

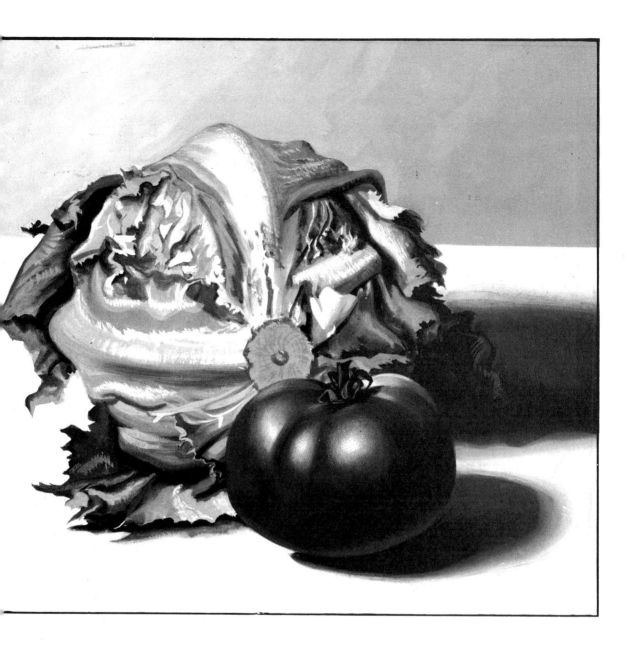

Vegetables, Step 4: This is as faithful a transcription of the objects before me as I could make. It's a drawing in opaque that employs both methods of blending that you practiced in Project 24. It's not, and doesn't pretend to be, a work of art. However, it's the result of sound craftsmanship, and this you must acquire before you can aspire to be a creative artist. Notice the background; as you can see, it's a wet-in-wet blended tonal band.

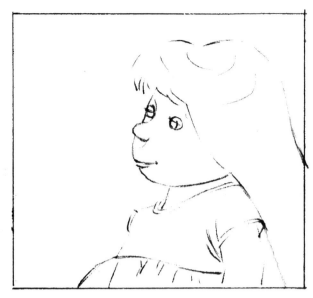

Pitiful Pearl, Step 1: *Unlike the transferring of the lettuce and tomato, here I've traced not only the outline but also the main details of Pearl's face and dress. I've drawn the shape and position of the light on her hair. I've done this opaque drawing on Grumbacher #150 illustration board, 10" × 15", with a medium texture surface.*

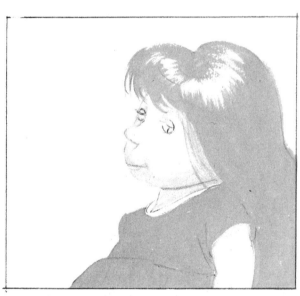

Pitiful Pearl, Step 2: *The reason for transferring all the important features of Pearl's face is that I'm going to use the illustration board itself for the white of her face and arm. It's a matter of common sense; if any white area is quite large, it's not practical to cover it with a tone, only to have to bring it back to white by painting over it. Here the paint is just thick enough to cover the paper, but not thick enough to obliterate the pencil lines indicating the folds on her dress. If your paint covers them completely, just flip your working drawing back over your illustration board and retrace the lines on top.*

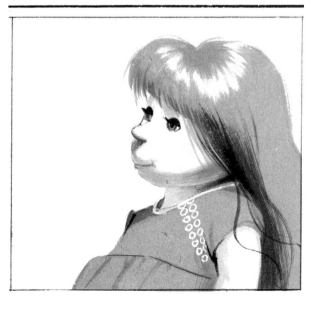

Pitiful Pearl, Step 3: *Note the lighter gray on her face, compared to the middle value of her dress and hair. With the lightest value and the middle tone already established, it's now a matter of going down the scale all the way to black. Before you apply the darker modeling to her hair, dampen a pointed brush in clear water. Following the direction of the hair, work your brush across the light area to "kill" the bare paper. This brings the entire tonal mass closer to the hair's local color. Flip your working drawing back again and trace the pattern of her dress.*

Pitiful Pearl, Step 4: *I've used all three—#3, #5, #7—watercolor brushes on this drawing. I've used a #5 for the modeling on the face, a #7 for the dress and the hair, and a #3 for the definition of the single strands of hair over her neck and behind her arm. I've also used it for the pattern on her dress. When rendering thin lines, work your brush to a point on the butcher's tray or on a piece of scrap paper. Hold it perpendicular to the surface of the paper.*

Figure A. *I've used the same procedure for this drawing that I've used in the demonstration for this project. First, I do a simple pencil outline of the big shapes, followed by a thin layer of light gray over the entire picture area. Over this flat wash the promentory, the two projecting rocks, and the beach are layed in with #5 gray. Then I paint the lighter gray of the water. A few dabs of black at the base of the cliff and some white for the surf become the extremes of the tonal scheme. On the beach I use the sponge to create a pebbly texture. Finally, I add the dark edge of the beach against the surf and the reflections on the water.*

Figure B. *Barns have always held a fascination for me; I don't know why. It pains me when I can't stop and do even the simplest rough sketch of them. This one was done from my car somewhere in Nova Scotia. The detail in the left corner shows how I use the side of my brush for the ground textures. Notice how the pebbled surface of the paper on the Grumbacher pad plays its part.*

PROJECT 26

Outdoors
with Opaque

Let's go outdoors now and sketch in opaque. The one distinction I'd like you to keep uppermost in your mind is that in *opaque* you use *white paint* to lighten a value as opposed to adding *water to black paint* when working in *wash*. With opaque you use the same consistency of paint; you lighten or darken a tone by dipping into lighter or darker grays respectively.

Opaque Watercolor and Nature

As I've mentioned before, opaque watercolor allows you greater flexibility in rendering than wash. Along with its ease of correction and manipulation, opaque let's you build up your drawing quickly or slowly, as you choose.

This medium is particularly suited to drawing outdoors because it's both speedy and versatile. Opaque dries quickly and is easily corrected, allowing you to work rapidly and spontaneously. These are important attributes when you're trying to capture a fleeting mood of nature.

Materials to Take Along

For your first outdoor sketch in opaque, take the Grumbacher watercolor pad #7182 R and a set of pre-mixed grays. You'll also need the butcher's tray and a water bottle (a plastic bottle with a screw-on lid is ideal). Some rags, #3 and #5 watercolor brushes, and an office pencil should also go into a particular box that you've labeled "opaque." Last, but never least, take along barrels of confidence so that you can bring back a terrific sketch.

Choosing a Subject

Let me repeat that you don't have to draw the same subjects that I've done here. Choose whatever you find appealing. At this time, if you happen to find opaque too difficult to handle on location by all means use pencil or charcoal. Go out and draw at every opportunity and bring back your sketches for finishing in the studio. If you're confined to quarters because of inclement weather, then look out the window and sketch whatever you see.

Country Church, Step 1: *I begin by drawing the big shapes in dark pencil line with no detail anywhere. I make the line definite and dark so that it shows through the first, thin layer of opaque which I've applied to the entire picture area. Notice that I'm working from the background forward, overlapping the background shapes into the ones in front. Since I'm using opaque, I can put a lighter shape on top of a darker one—as I'll do with the church and the grass.*

Country Church, Step 2: *Now I begin working my way to the foreground. Starting with the church, I put in the white of its front, the light gray on its side, and the dark gray on its roof. I've chosen opaque for this sketch because I can easily superimpose the white of the church upon the background. More importantly I could render the tall, light grass over the dark mass behind it. The white of the church and the black evergreen are my "key" tones.*

Country Church, Step 3: *When the big shapes are done (as in Step 2), you can begin the smaller details. I've put in faint guidelines in pencil for the windows, so that they would conform to the perspective of the church. Then, in sweeping upward strokes using the point of the #3 sable brush, I did the tall grass. Its value, checked against the pure white of the church, turned out to be a #1 gray. Finally, using the same gray and the same brush, I flicked in the tombstones of the cemetery in the distance.*

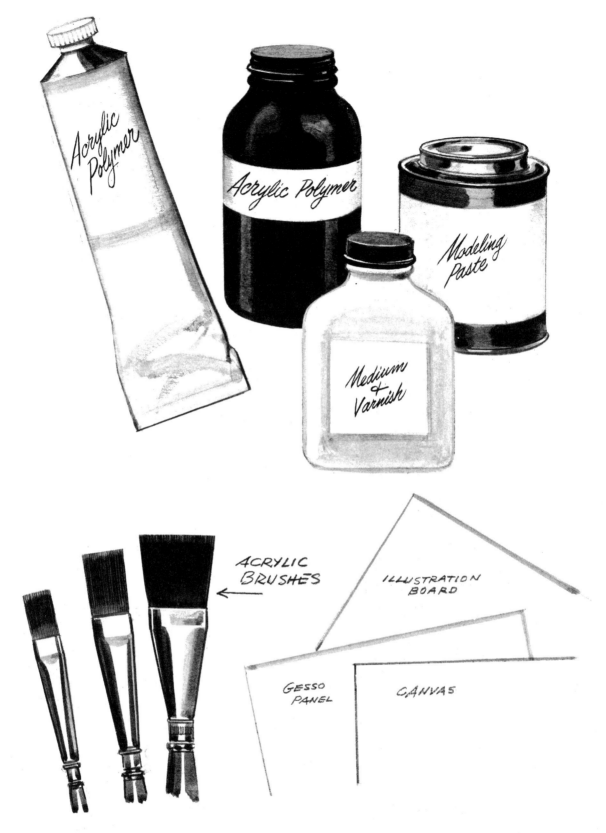

Labels within the illustration:
- Acrylic Polymer
- Acrylic Polymer
- Modeling Paste
- Medium & Varnish
- ACRYLIC BRUSHES
- ILLUSTRATION BOARD
- GESSO PANEL
- CANVAS

Figure A. *You owe it to yourself to investigate this newest of all media. I can think of nothing that you can't do with it, no matter what type of subject you may choose as your speciality or what technique you may find most congenial.*

PROJECT 27
Acrylic Techniques

This is the newest of media we've been exploring and one of the most exciting. There are marvelous books covering the subject. Among them in the *Complete Guide to Acrylic Painting* by Wendon Blake and another, *Painting with Acrylics* by Gutierrez and Roukes. Even though I have only a nodding acquaintence with this medium, I think it's great. Within the scope of this book—concerned only with drawing—I couldn't possibly do it justice. The best I can do is only to bring it to your attention.

Brushes, Pigment, and Surfaces

For your purposes here, all you need is a tube of black acrylic and a tube of white. Being water soluble, you won't need any added equipment, except, if you wish, the special nylon brushes—both flat and round-pointed—manufactured by Grumbacher. You can also add canvas and gesso panels to the drawing surfaces you've been using. Like opaque watercolor, acrylic comes in tubes and jars, with its adjuncts in tins and bottles, as I've shown in Figure A.

Characteristics of Acrylic

Acrylic has much to recommend it. Acrylic lends itself to the spontaneity and directness of watercolor without running the risk of color fading (Figures B and C). Acrylic dries quickly, allowing you to underpaint and then to glaze (to apply thin washes of color over a previously painted surface) without having to wait for days, as you would if you underpainted in oils (Figures D and E).

You can apply the thickest impasto without fear of cracking, especially if your support is wood or gesso panel. You can render the most meticulous "hard edge" with it. The most delicate and intricate as well as the roughest, most vigorous, and impetuous brushwork is possible with acrylic (Figures F, G, and H).

The acrylic medium can be used as a gluing agent if you're sympathetic to "collage" (fancy word for pasting). After you learn how to draw, you can explore this technique of gluing paper or other things to your drawing surface. It's an approach much favored by many contemporary artists.

Versatility of Acrylic

Although acrylic is water soluble in its application, it becomes waterproof when it dries! Acrylic can be used like transparent watercolor or wash when you mix it with water. When you use a specially prepared medium, you can get the glossy glaze of an oil. Straight from the tube you can achieve thick, matte effects reminisent of opaque.

On the negative side, acrylic is rather harsh on sable brushes. You must be sure to rinse your brushes thoroughly as you work, and never let them dry with any pigment on them.

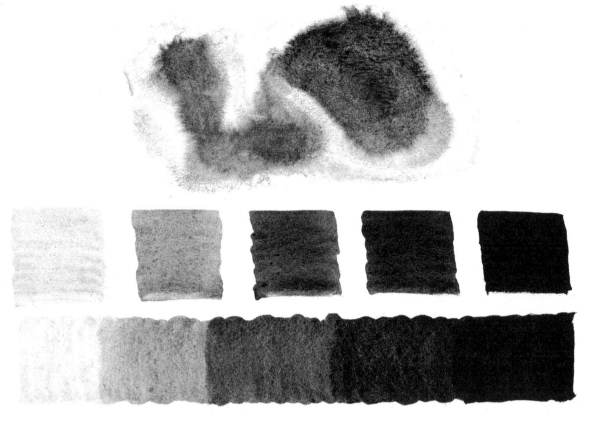

Figure B. *With water as a medium, you can use acrylic paint like watercolor and really splash away on a wet surface as shown here. Used as wash, you can prepare four gray values from light to dark gray plus black. With these plus the white of the paper you'll have a value range wide enough to render any subject.*

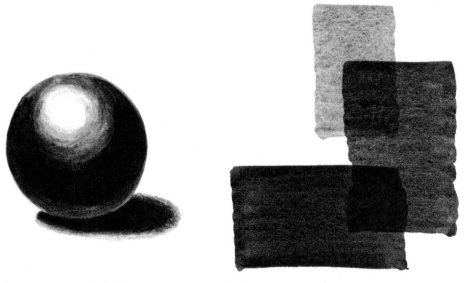

Figure C. *Begin by indicating the contour of the sphere in pencil, either freehand or with a compass. Use the paper itself for the highlight; circle it with clear water, and begin adding pigment as you get into the darker areas. When you're done with the sphere, begin by circling the cast shadow with clear water and then add pigment as you work your way to the sphere's base. When you can execute a sphere properly, go on and lay in the flat washes, partly superimposing them as shown in these squares. These flat washes are executed in the same manner as those done with wash.*

Figure D. *One of the tremendous advantages of acrylic is that you can glaze any number of tones over a painted texture or pattern without in the least disturbing the work underneath. Practice rendering this texture of wood, or any pattern you wish. Acrylic dries so quickly that you can begin glazing the moment you're done with your pattern.*

Figure E. *This impasto of white acrylic is applied with the palette knife. You can either squeeze the tube right on the illustration board or you can pick up the undiluted paint from your butcher's tray and spread it on the board with your painting knife. The thicker the paint, the longer it takes to dry, so test it with your fingertip before you apply the glaze, shown at the right.*

Figure F. *You can raise a tone's value by glazing it with white, instead of having to render the tone all over again. The original tone here is at the left, which I've "veiled" with lighter tones as I move right. With a thick enough consistency, I could have completely covered the black drybrush strokes with white.*

Figure G. *Another way to achieve textural effects is to apply a flat wash over an area. While still wet, dab the area with a damp sponge, a dry paper towel, a piece of cloth, or anything that will give you the textural effect you need.*

Figure H. *You've seen that you can use this medium as a wash, and that you can apply it straight from the tube to produce a thick impasto. You can also render the most delicate lines with it—either light on dark or dark on light.*

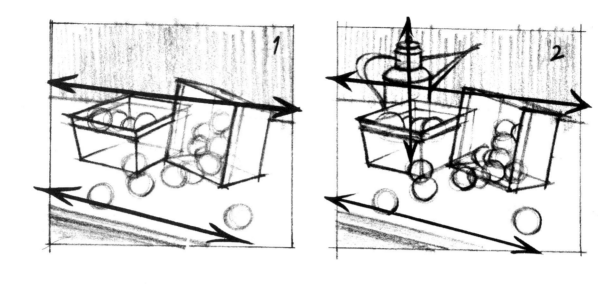

Figure B. *This working drawing establishes the proportions and the placement of the ele-ments in the picture. See the finished drawing in the demonstration which follows.*

Still Life in Acrylic

Never get so engrossed in the properties of the particular medium that you forget the basic fundamentals of drawing. I became so involved in rendering the shapes, textures, and values of my cherry tomato still life that I failed to see the drawing's faulty composition. In fact, I didn't see my error until I'd transferred my working drawing to the illustration board.

I've mentioned before that you shouldn't begin tracing a drawing until you're absolutely sure it can't be improved. However, I guess I should amend that rule to say that you should consider change, even after you've finished your drawing. Countless times an artist will change something in a finished picture to improve its composition or to heighten its mood. Study the composition of your drawing to be sure it has the proper rhythm and flow.

Composition and Movement

It would take an entire book to do justice to the subject of composition, but I'll touch on some rudiments here. When arranging your objects, consider the picture area. Notice the rectangle I'm using in the still life of this project. It has two horizontal (top and bottom) and two vertical (left and right) boundaries. With nothing drawn within these borders, the spectator's eye is already influenced by the movement they generate: sideways and up and down. The moment you place anything, even one line or a single dot within this area, you've set in motion a direction that the viewer's eye will follow.

With the vertical line you've started an up and down movement that's further reinforced by the vertical edges of the picture area. When you place a dot anywhere in the picture area, you've riveted the viewer's attention to that particular spot. The moment you interject a mark into any blank area, you've set things in motion.

Considering Picture Space

Specifically, if I'd used only one basket in my still life and placed it in the center, there'd have been no problem. The viewer's eye, with nothing else to distract it, would have gone right to it. But since I used two baskets, the overall shape immediately became horizontal. The horizontal thrust (even though slanting a bit) of the top and bottom edges of the counter, plus the top and bottom edges of the picture area itself, caused the horizontal movement to become strong (Figure A, view 1).

This movement was so strong that no other movement in the picture—the diagonal thrust of the tomatoes which have rolled out of the basket, for example, or the "bull's eye" of the single tomato at the right—was strong enough to serve as a counterthrust. To modify this relentless horizontal movement, the only answer was to create a strong vertical, provided by the oil can (Figure A, view 2).

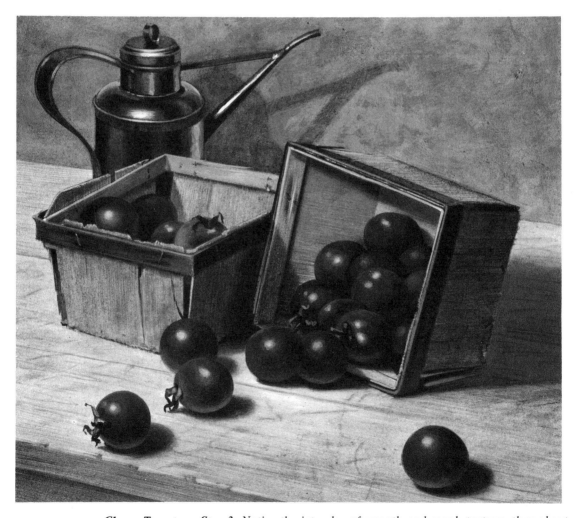

Cherry Tomatoes, Step 3: *Notice the interplay of smooth and rough textures throughout the picture. As I mentioned, there's a nice balance of forms. Since the focal point consists of two cubic shapes, I feel they should be relieved by the spherical forms of the cherry tomatoes and the cylindrical structure of the oil can.*

Outdoors with Ink and Mixed Media

I've mentioned that all media are exciting and worth investigating. Among them is India ink. It's waterproof and capable of producing the densest blacks. It can also be used as a wash as well. With ink you can produce an incisive line. It has a freshness and crispness whether you work on rough or smooth paper.

Ink and Additional Equipment

You can obtain India ink in one ounce bottles, pints, or even quarts if you're going to dedicate yourself to it exclusively. For the figures demonstrated in this project, you'll need a one ounce bottle of black ink. The rest of the necessary equipment you probably already have: #3 and #5 pointed sable brushes, a slant-and-well palette, a couple of sponges, and some rags. You can use a #1171 Aquabee pad or any watercolor pad for your drawing surface.

Water, of course, is necessary. Carrying it on location can sometimes be a problem. However, I find that an empty plastic bottle, such as the kind that contains cider, is the perfect carrier and can be found in any supermarket. The stopper of such a bottle fits snugly when not in use; you can even place the bottle on its side without fear of leakage. The bottle can carry enough water to last through a whole day of sketching.

Two Ink Techniques

One approach to drawing in ink consists of two distinct phases. First, you do a line drawing in ink using a pen or brush. Then, you apply washes of gray over the line drawing. Since the ink is indelible, the original line drawing isn't disturbed.

First, the artist's only concern is that the line drawing is correct. Then, since the correct drawing is already set down in ink, the only remaining problem is the tonal scheme. This you can begin tentatively with light washes. You can obtain such a wash by pouring a few drops of ink into the slant-and-well palette and adding clear water, exactly the way you did when working in wash. When the ratio is more water than ink, the value is light. When the process is reversed, the values are darker, until you reach the pure black of the bottle ink.

Another approach is to begin your drawing directly on watercolor paper or illustration board. Here you establish proportions and relationships in a very faint line produced from mostly water with a drop of ink. Then, you can begin the execution of any textures or modeling in deeper and deeper tones as the subject requires. In addition to brushes, you can use sponges, paper towels, and any other tool to apply the ink (Figures A and B).

Outdoors with Mixed Media

Although I've discussed various media in separate projects and demonstrated their use in separate drawings, several *different media* can be used in the *same drawing.* You should try and match the various elements of your drawing to the medium in which they can be executed most easily and effectively.

When I saw the trees of Figure C I knew instantly that wash would be the best medium to capture their texture. But let me quickly add that I not only knew the proper medium, but also *the kind of surface that would give me the desired result.* The same medium on a smooth paper or board wouldn't have produced the same effect. On this drawing, as well as in *Twin Trees*, I used a "Harmony" Grumbacher watercolor pad #7182 R. It has a sort of pebbled surface that gave me the texture of the bark.

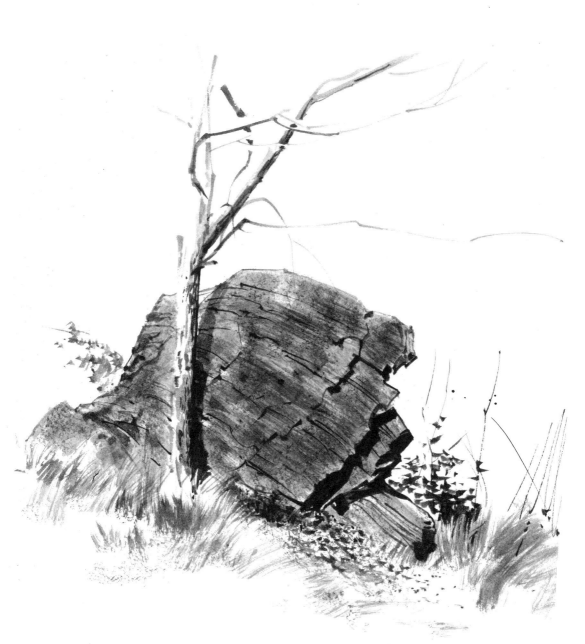

Figure A. *I'd like you to try your hand at doing trees, weeds, grass, and rocks in ink — if you're lucky enough to have them around. Don't neglect to use the piece of sponge to render foliage. By tapping the sponge you can achieve a grassy effect. You can also sweep the sponge in the direction in which the grass grows. Weeds are better done with the #3 pointed sable brush. Always be on the alert for other unorthodox techniques for creating textures: applying a tone with crumpled tissue paper, scratching a wet tone with a knife, stick, or even the handle of your brush.*

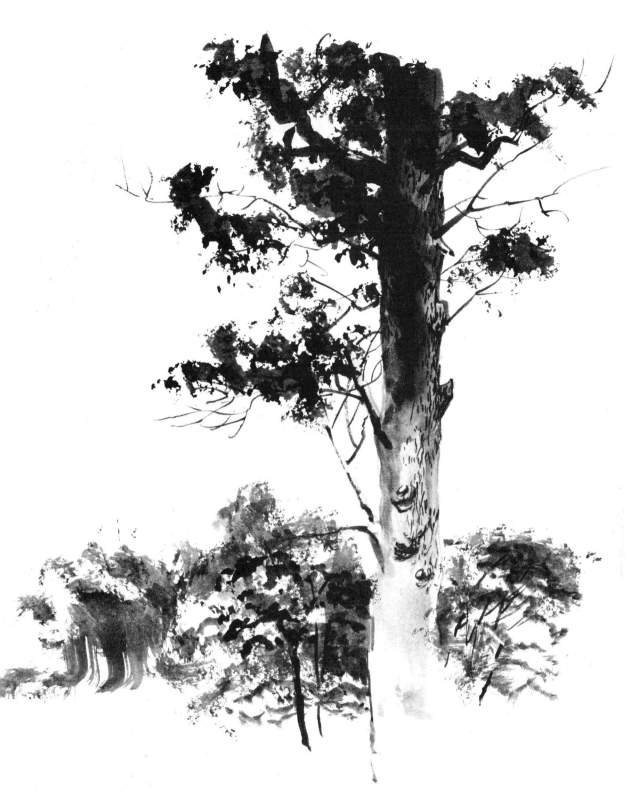

Figure B. *For this tree done in ink I've followed the wash technique—working from the very lightest value to the darkest. I begin by laying in the faintest indication of objects with mostly water and just enough ink to make them visible. Remember that the charm of a sketch is its freshness and spontaniety. Try not to destroy these qualities by getting too finicky in your handling of detail. On this and Figure A, I've used an Aquabee Bristol pad #1171, Higgins India ink, Winsor & Newton brushes #3, and #5, and a piece of sponge.*

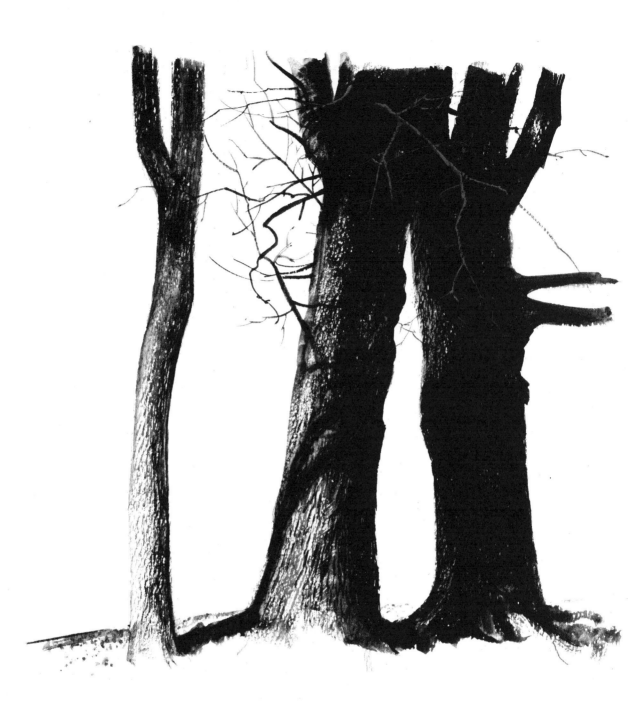

Figure C. *Everything in this drawing is done in wash, with the exception of the light branches which are done in opaque. It just doesn't make sense to laboriously work around their lighter values with the dark tones of the trunks behind them, as I would have been forced to do if I had done the drawing completely in wash.*

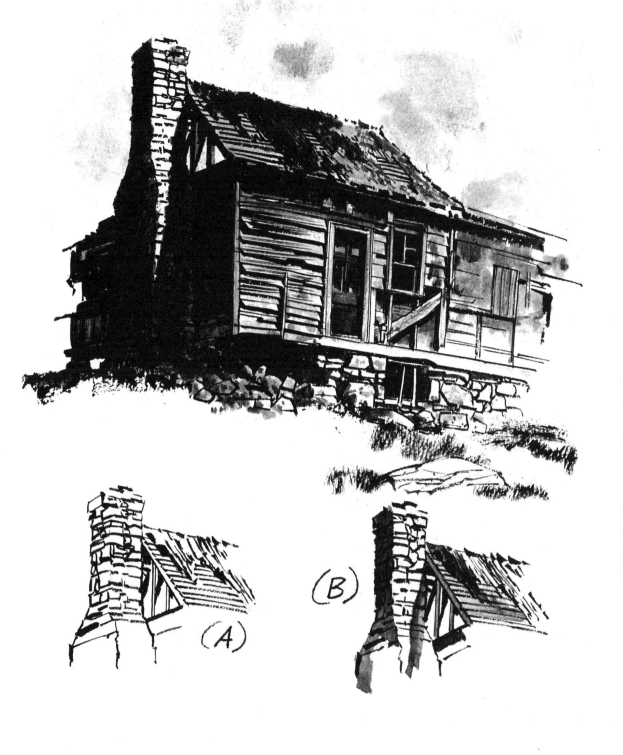

Figure D. *I had to come up close to this weatherbeaten house to give you this demonstration in India ink. The most usual approach with this medium is to first do a line drawing (A). Then superimpose washes (B) in their respective tones onto the line drawing. Find a subject and sketch it in ink following the procedure indicated here. Be sure to have water in some type of container to dilute the ink, a rag, #3, and #5 watercolor brushes, and thick paper or illustration board.*

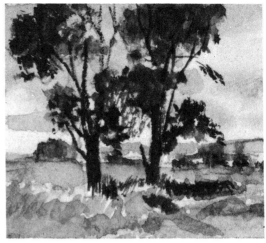

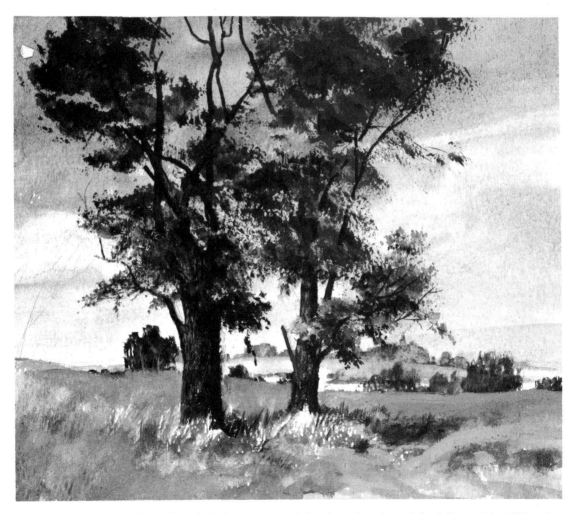

Twin Trees, Step 3: *A few spots are defined on the edge of the foliage with a #3 brush to relieve the monotony of contour produced by the sponge. Wash and opaque used together here produce better textures and more faithful values than either technique alone.*

PROJECT 30
Drawing Children in Various Media

I've been talking about observing and drawing the proportions of everything you see. Hopefully this attention to the fundamentals of drawing (observing basic shapes, lights, and textures) has resulted in a faithful reproduction (that is, realistic) of what you see around you.

Nudes versus Children

You've explored the general divisions of the head as they apply to adults and children. As you now know, these proportions may vary from individual to individual. Yet, they'll be an invaluable aid in doing the last two demonstrations in this final project.

You may very well ask: why not draw the entire figure to demonstrate all the things already learned about it? I admit it would have been a very impressive closing to this book, and frankly I was tempted to end it with just such a thunderous volley of nude and glamorous figures. But then I realized I would just be showing off without really being much help.

Children in Opaque

As you perhaps discovered in the project dealing with life drawing, it's no easy task to find a model, especially if you don't yet have a proper studio. My guess is that you would have enjoyed looking at such nude studies, closed the book, and for actual practice you'd have gone back to either still lifes, landscapes, clothed figures, or portraits.

I posed the question to all my neighbors. Would they rather have a nude drawing, or a drawing of one of their children? Need I tell you their answers? Unanimously they chose the latter. On that premise then, let's do two more portraits of children in opaque (see the demonstrations) and who knows, you may become famous for them.

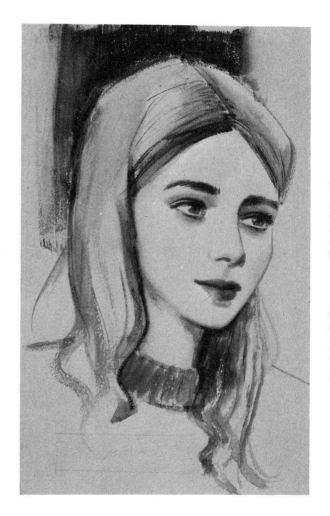

Figure A. *Try drawing children from life. Select your best drawing and transfer it to gray illustration board, as I've done here. I've tapped any dark pencil lines with a kneaded eraser so that they won't show through the wash that I'll be using. I've used #3 and #5 Winsor & Newton watercolor brushes on the girl's head, and a #20 flat sable brush, made by Simmons, for the background.*

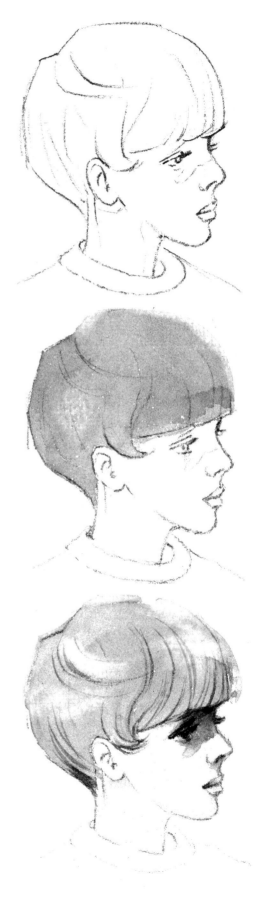

Steve, Step 1: As I've done so many times before, I've transferred from my working drawing to my illustration board only the large shapes of the boy's head and features. I've indicated in line the shadow created by the child's deep bangs between his eyes and over the bridge of his nose.

Steve, Step 2: Here I apply #1 gray to the child's face in a flat manner. The application is thin enough to allow his penciled features to show through. I use #2 gray on his hair, also applied in a flat tone.

Steve, Step 3: Here I go back and touch base with the working drawing in order to be able to refine the details. I apply the darker tones for the cast shadow on his face. With a pointed sable, I delineate the strands of his hair as well as his eyebrows and lashes. I use my kneaded eraser here to lift out some highlights in his hair.

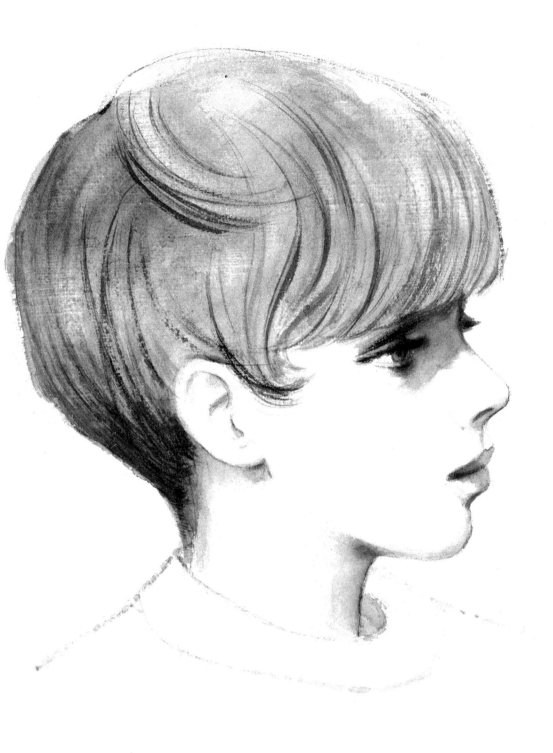

Steve, Step 4: *Notice that I've left the child's shirt unmodeled. I've used a bit of drybrush in his hair. The shadow on his face becomes light as it runs down from his forehead and nose and blends eventually into the tone of his cheek.*

Nancy, Step 1: Once more, I've traced only the main shapes from my working drawing onto my illustration board. I'll be doing this adolescent girl's portrait in opaque.

Nancy, Step 2: Here I've laid in the main tonal values in flat, gray washes. Notice that both the tone for the hair and that for the face are close in value. This is an attempt to faithfully reproduce her local color in terms of black and white.

Nancy, Step 3: Here the darker tones have been rendered on top of the flat washes. In this three-quarter pose, the shadows are deepest in her hair next to the contour of the right side of her face.

Nancy, Step 4: *Note that the type of blending that I've done on her face is drybrush. I've also used it in her hair. The shading always sweeps from dark toward the lighter tone. I've used Grumbacher Gamma Grays on Grumbacher's #150 illustration board with medium texture.*

A Parting Word

I hope your enthusiasm and dedication, plus the instruction I've advanced throughout these projects, will make the road toward becoming an artist a bit easier for you. I've tried to stay in the background and suppress any personal technique. It hasn't been my intention to show you the way I swing a pencil; these techniques, for better or worse, are mine and mine alone. If some of my mannerisms have crept in, ignore them completely. Render everything you draw in a style that *you* find beautiful and appealing.

My only purpose here has been to acquaint you with what I consider the clearest, the most practical, and the most enjoyable way of learning to draw. For this reason I've stressed the fundamentals of the craft.

Oh, I know the old saw advising you not to worry about *drawing* what you see, but *seeing* what you draw. Very witty, indeed. But this advice should be flung at the experienced artist, not the art student. First, I believe that you must learn to imitate the object; then you can depart from it.

It saddens me to come to the last project in this book. I've said everything on the subject that I've wanted to say. Before I close, remember than an artist is a perennial student; there are other books and other teachers to be consulted. Yet, I hope that I've given you the equipment to develop your skills further. If I've made you realize that art is not so bloody sacred—more a matter of developing your gifts through determination and industry—then I'll put the period on this last sentence without regret.

Index

Edited by Diane Casella Hines
Designed by James Craig and Robert Fillie